500

COTTAGES

DOUGLAS KEISTER

The Taunton Press

DEDICATED TO THE COTTAGE HOMEOWNERS
WHO PRESERVE THE PAST TO BETTER THE FUTURE.

The Taunton Press

The Taunton Press, Inc.
63 South Main Street, PO Box 5506
Newtown, CT 06470-5506
e-mail: tp@taunton.com

Editor: Pam Hoenig
Jacket/Cover design: Chika Azuma
Interior design: Chika Azuma
Layout: Cathy Cassidy
Photographer: Douglas Keister

Library of Congress Cataloging-in-Publication Data

Keister, Douglas.
 500 cottages / Douglas Keister.
 p. cm.
 ISBN-13: 978-1-56158-843-5
 ISBN-10: 1-56158-843-1
 1. Cottages--United States--Pictorial works. 2. Architecture--United States--
20th century--Pictorial works. I. Title: Five hundred cottages. II. Title.
 NA7208.K45 2006
 728'.370973--dc22

 2006006818

 Printed in China
 10 9 8 7 6 5 4 3 2 1

The following manufacturers/names appearing in *500 Cottages* are trademarks: Formica®

CONTENTS

INTRODUCTION

2

STORYBOOK COTTAGES

4

CASITAS

122

BUNGALETTES

176

PERIOD REVIVAL COTTAGES

246

VICTORIAN COTTAGES

290

ECLECTIC COTTAGES

414

Scholars tell us that cottages are small, romantic dwellings that are usually scaled down and less formal counterparts of larger, more ostentatious residences. Thus, looming, gingerbread-festooned Victorians become Queen Anne cottages, Carpenter Gothic gems, and Italianate mini-palaces. Rambling Spanish-style mansions become casitas; Arts and Crafts extravaganzas are compressed into bungalows; and European castles become charming storybook style cottages. The allure of the more relaxed cottage lifestyle is so strong that even 19th-century titans of industry built 70-room "cottages" that lined the streets of fashionable Newport, Rhode Island. To be sure, their Gilded Age mega-cottages were hardly the simple romantic homes most think of when we dream of these tidy houses, but strictly speak-

ing, the summer cottages of the Vanderbilts and Astors were scaled down and less formal interpretations of their over-the-top urban mansions.

I grew up in a cottage. My boyhood home sits on a quiet tree-lined street in Lincoln, Nebraska. The construction and architecture of my family's postwar cottage was absolutely unremarkable, although if one squinted just right, the house had the vague look of a Cape Cod cottage. For three young boys it was more like a playhouse, far different than our relatives' larger, ranch-style homes with their off-limits-for-kids areas. No areas of our home were off limits; we used every square foot with abandon. And that's what makes a cottage so wonderful. It's a home that gets used. It's family, it's mom and apple pie—it's home.

—Douglas Keister, Chico, California

STORYBOOK COTTAGES

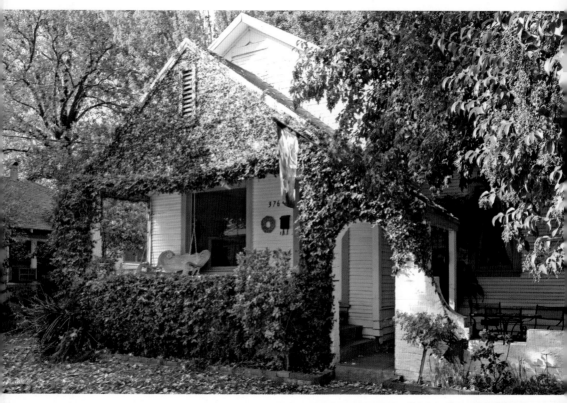

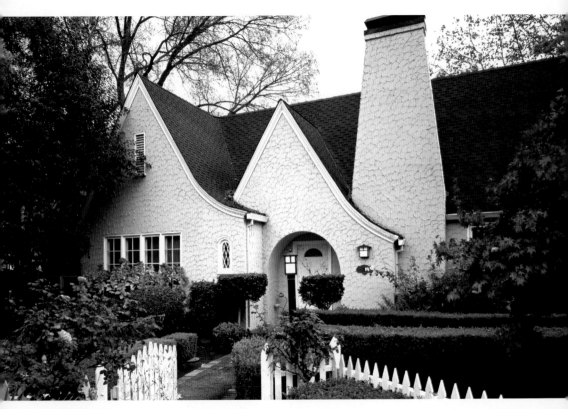

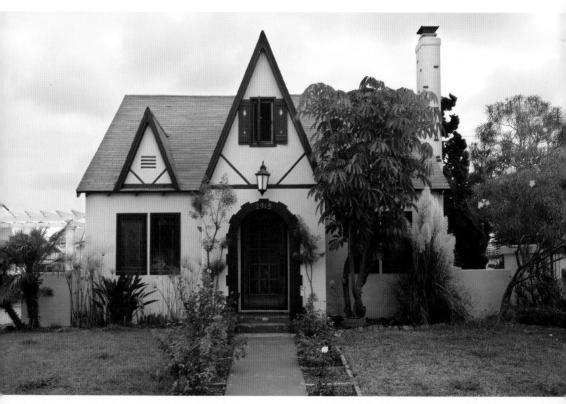

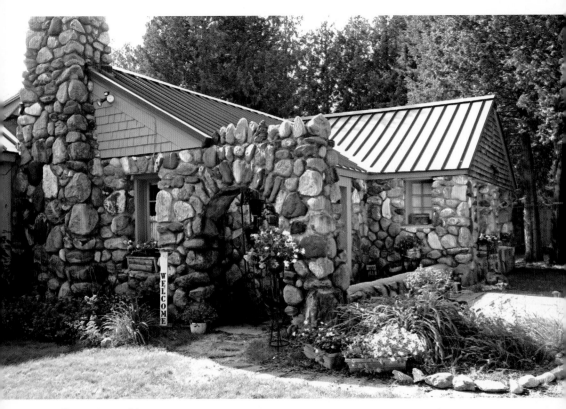

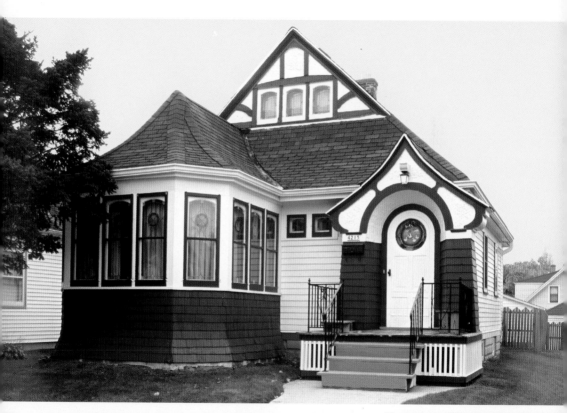

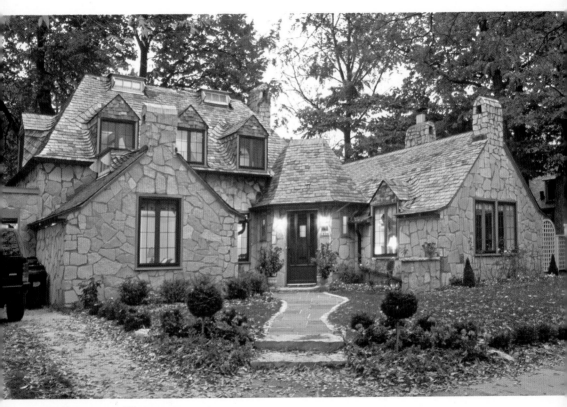

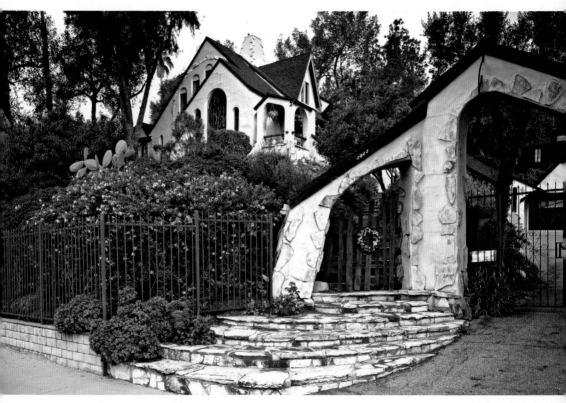

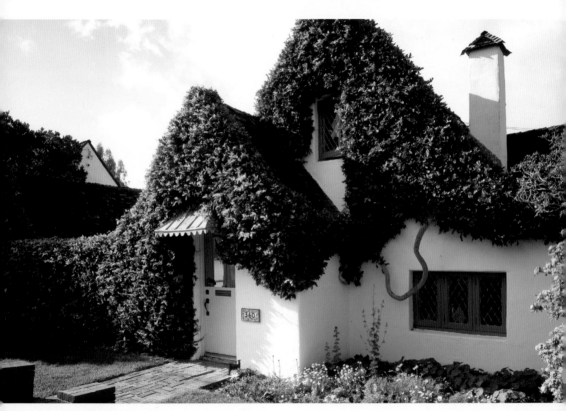

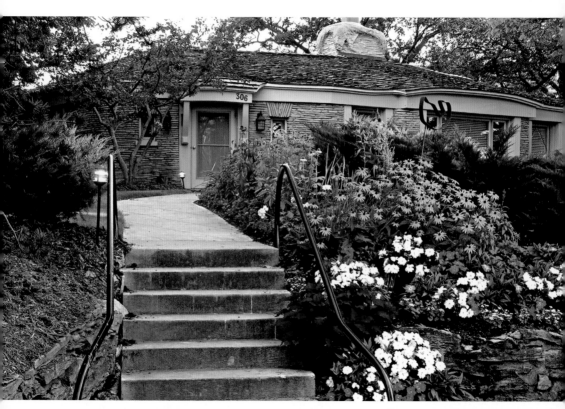

CHARLEVOIX, MICHIGAN 13

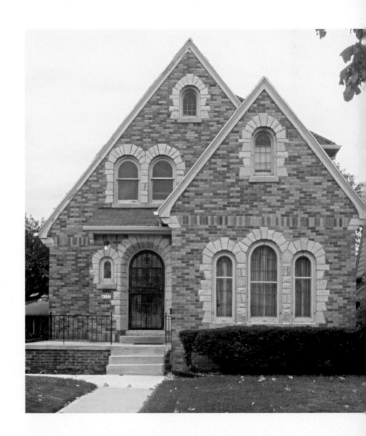

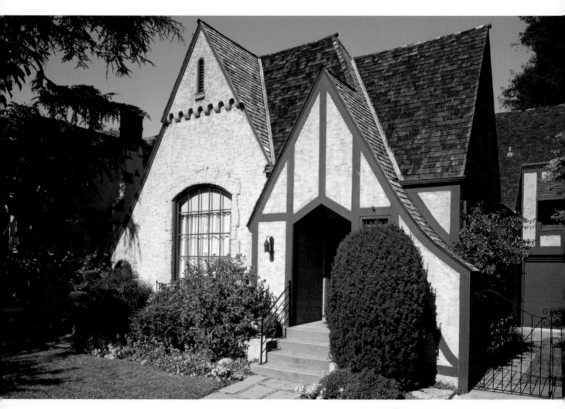

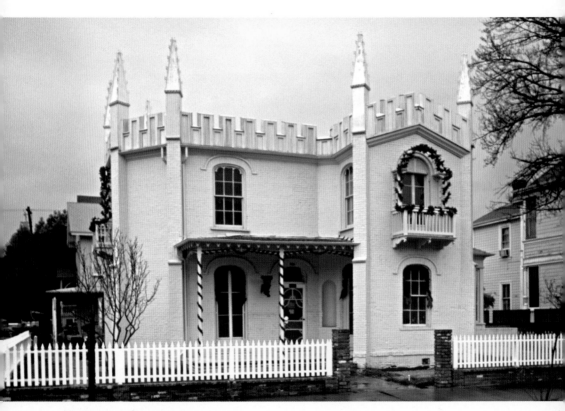

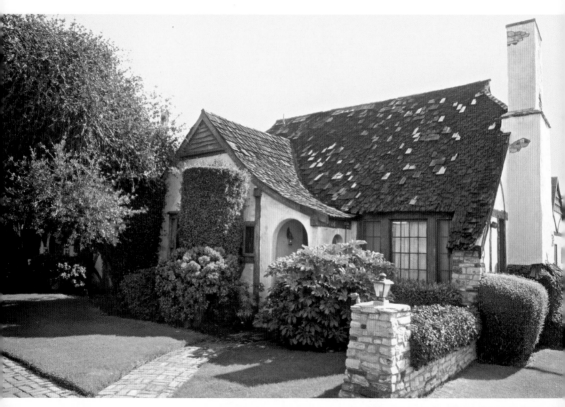

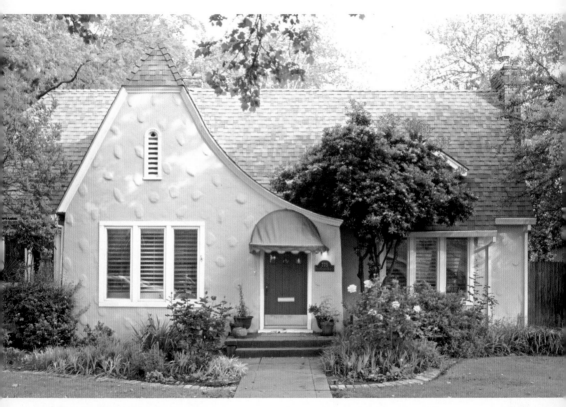

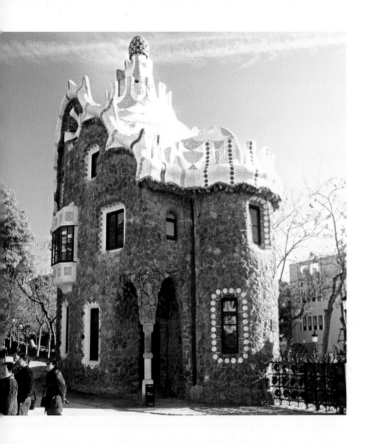

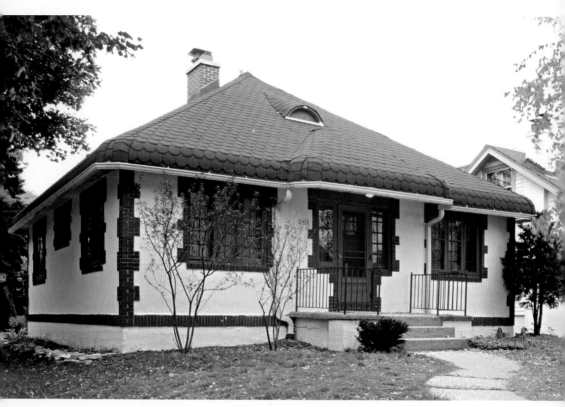

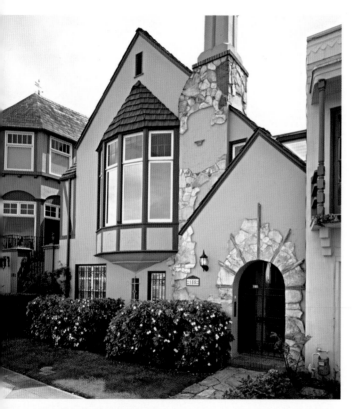

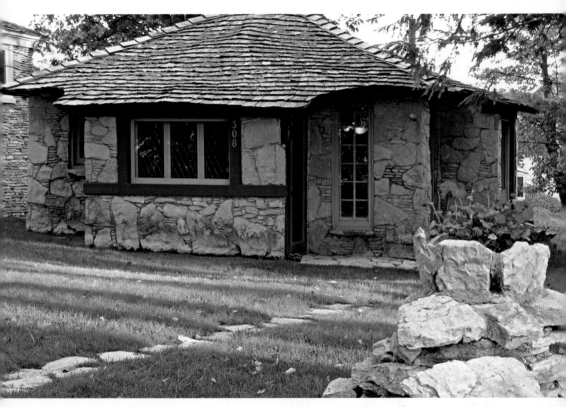

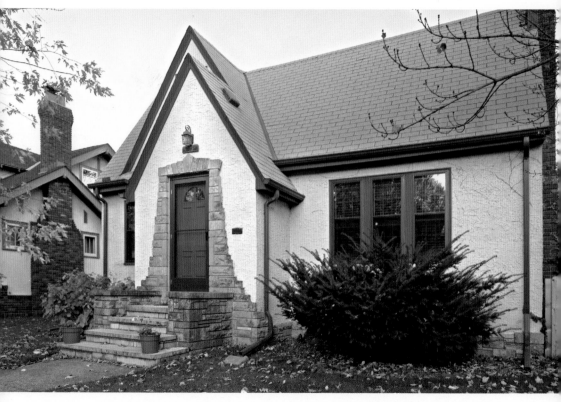

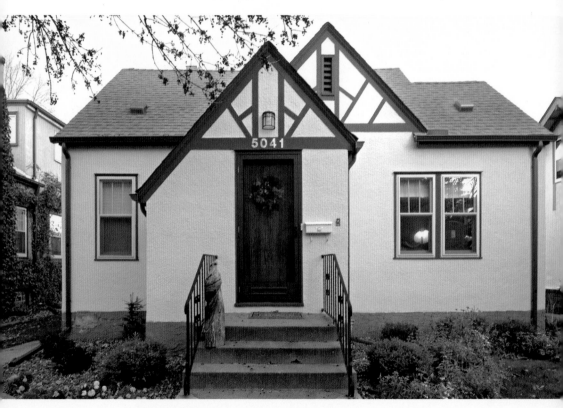

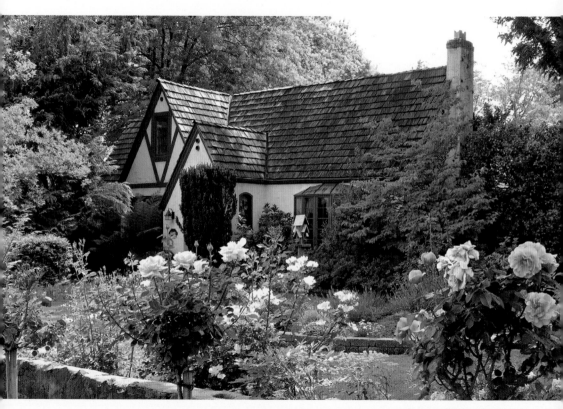

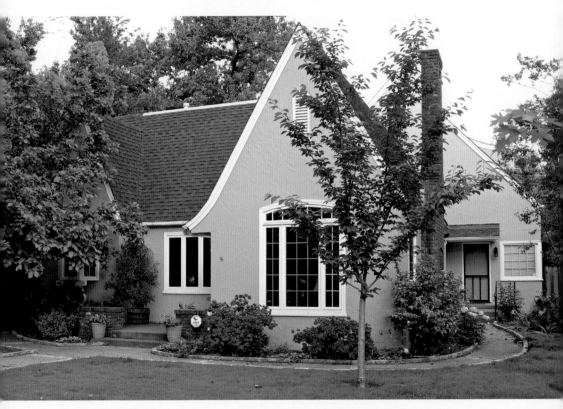

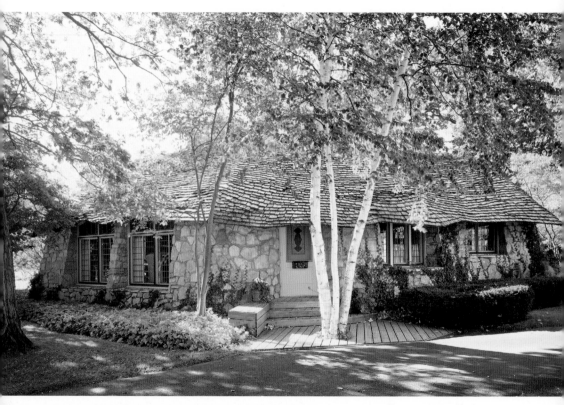

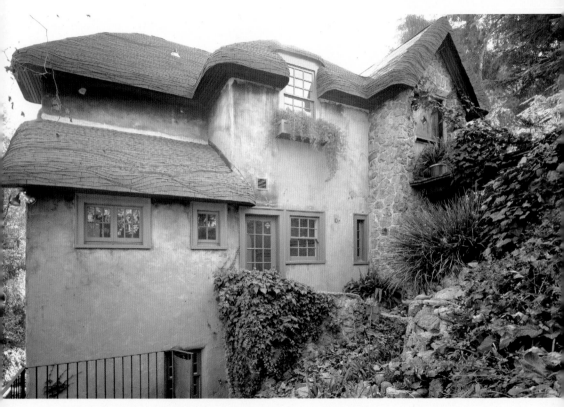

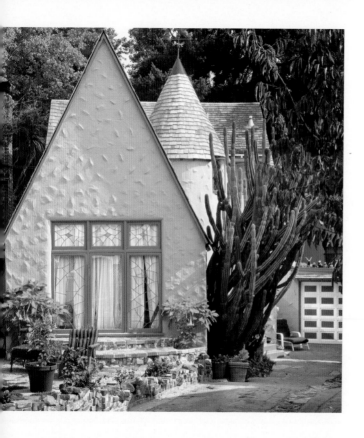

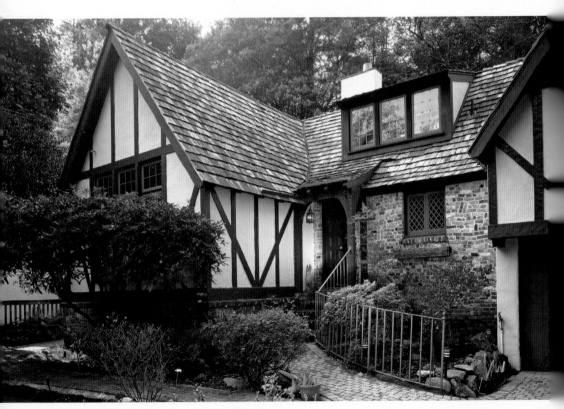

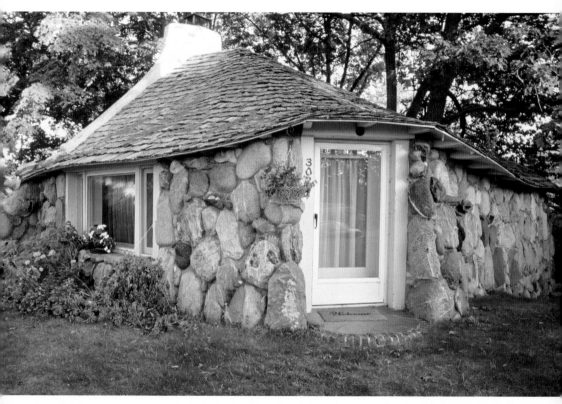

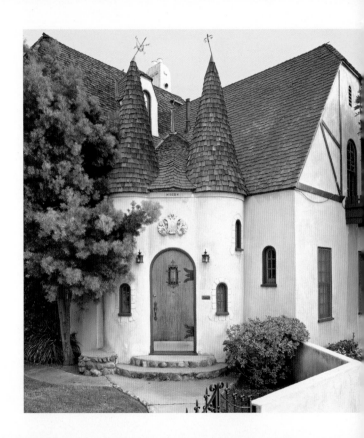

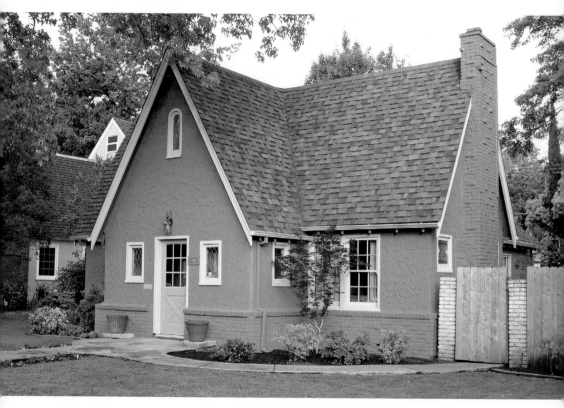

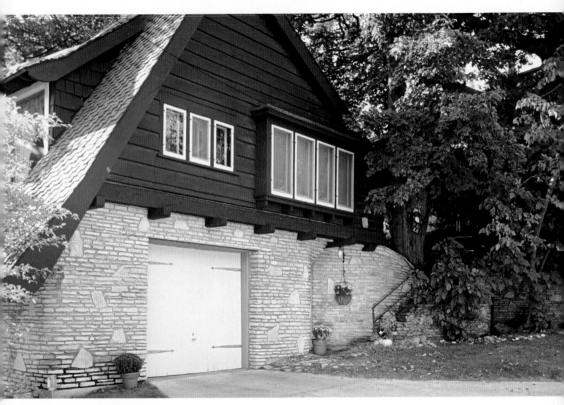

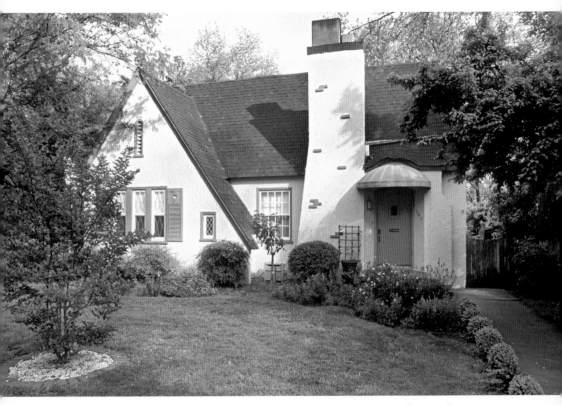

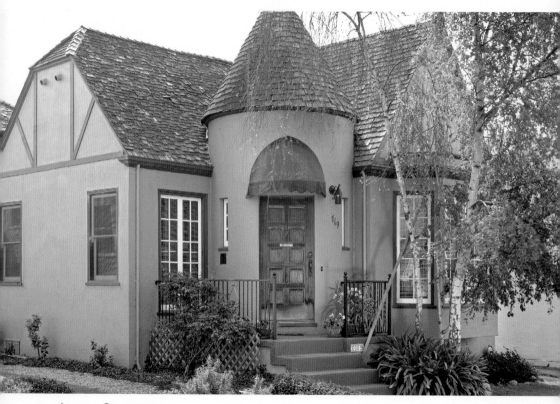

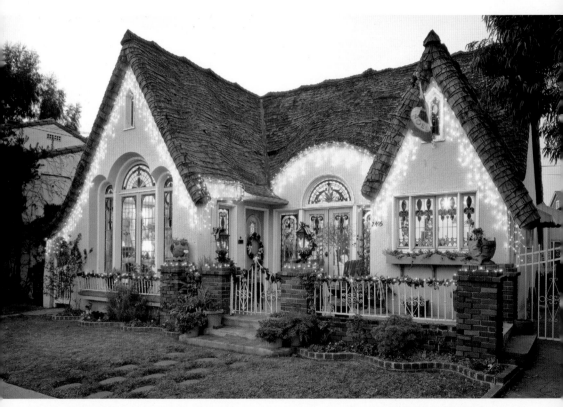

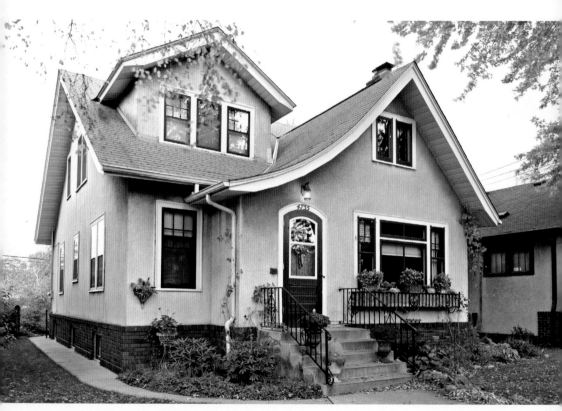

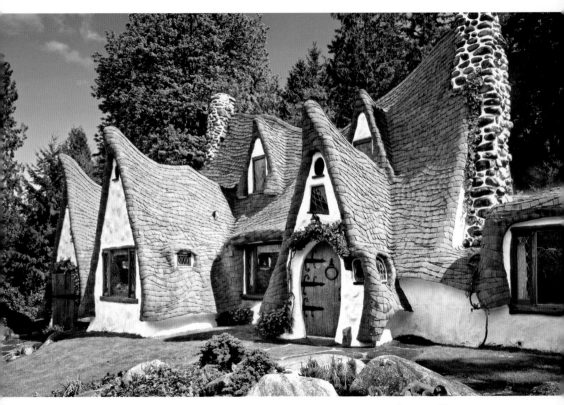

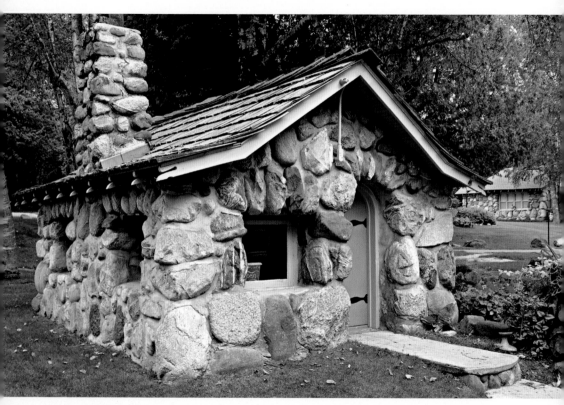

40　CHARLEVOIX, MICHIGAN

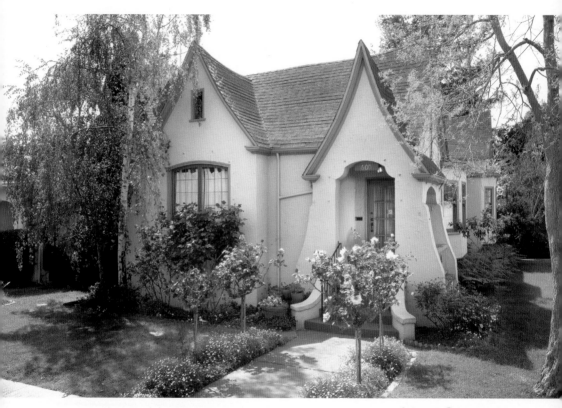

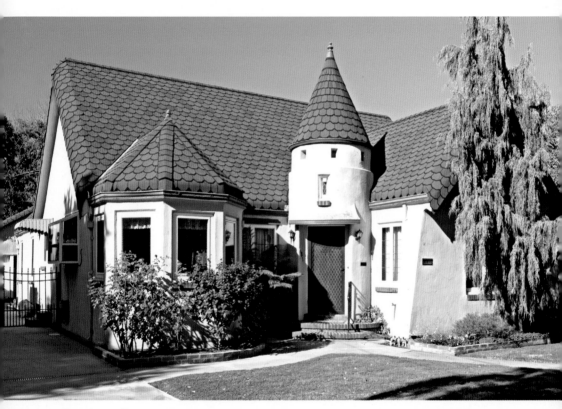

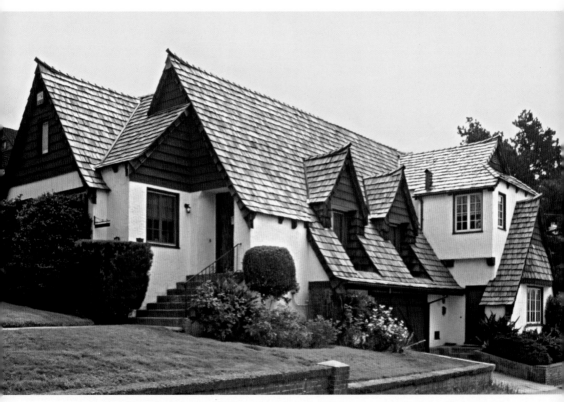

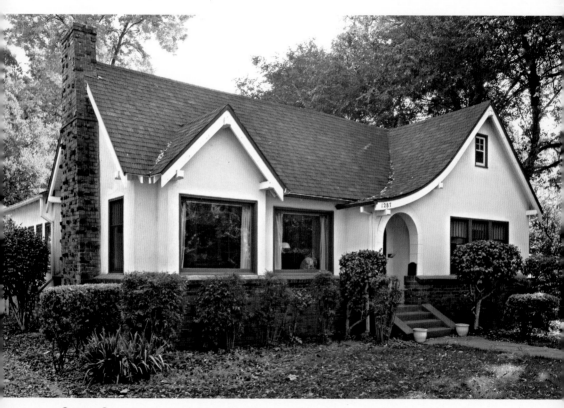

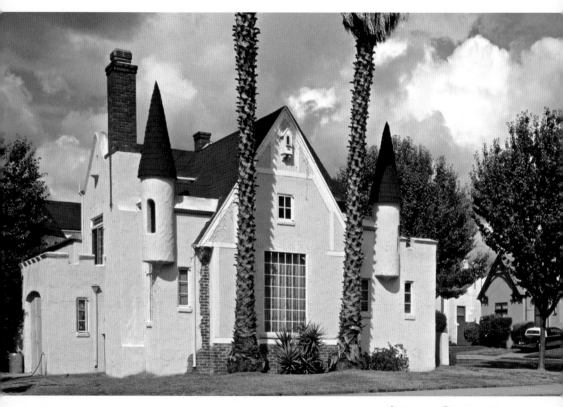

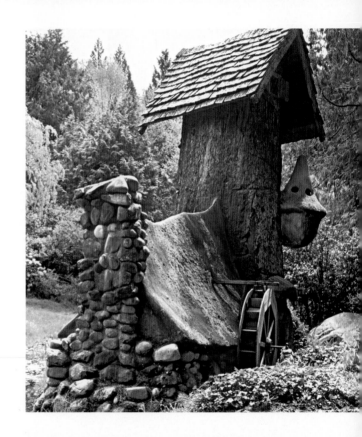

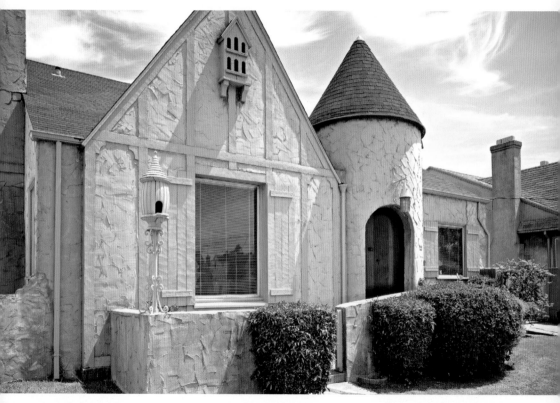

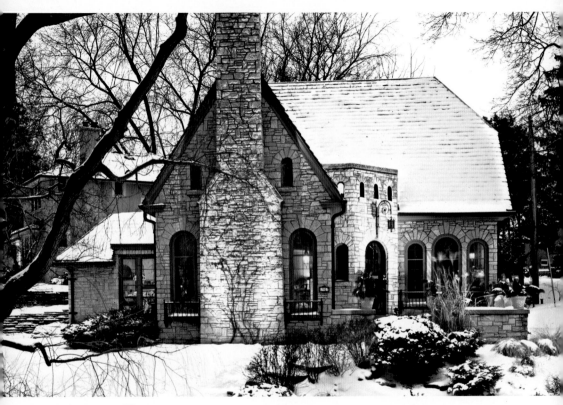

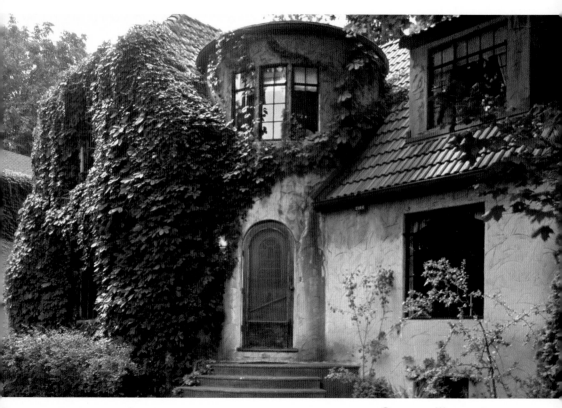

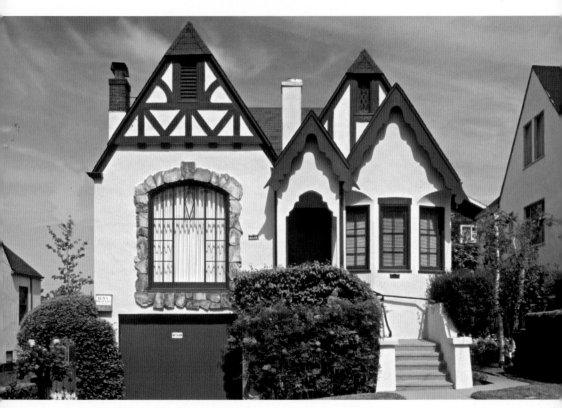

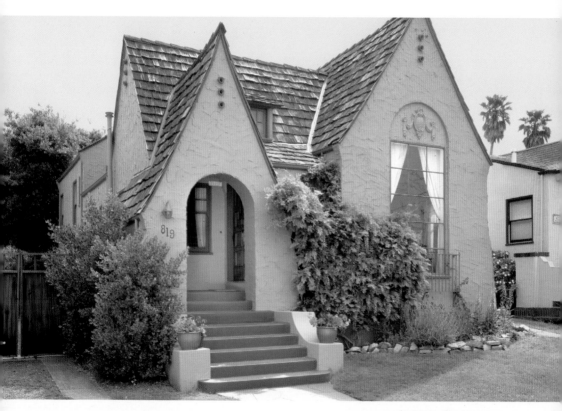

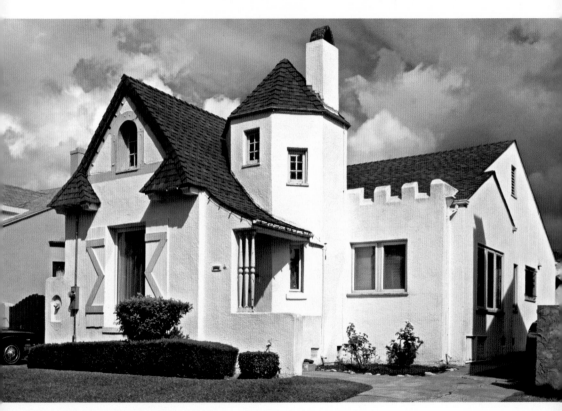

52 OAKLAND, CALIFORNIA

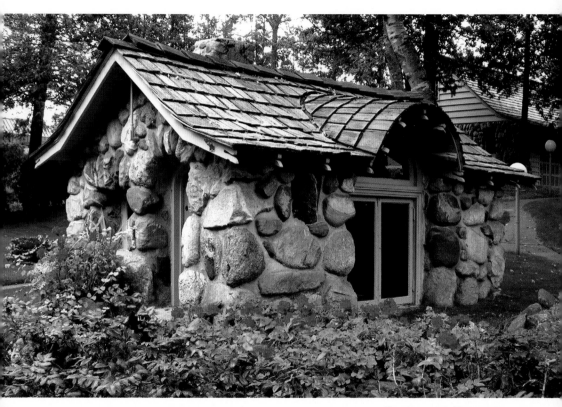

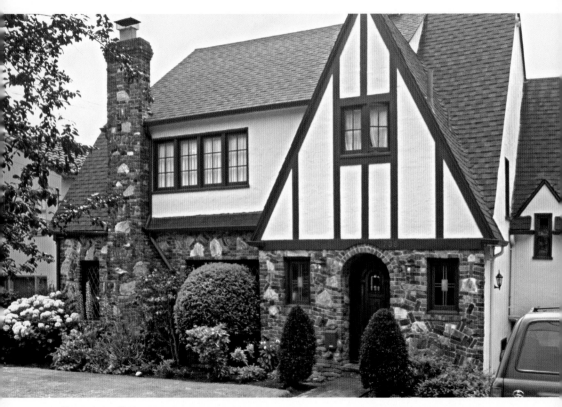

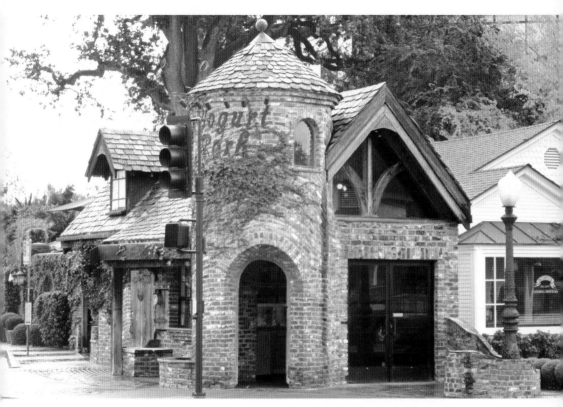

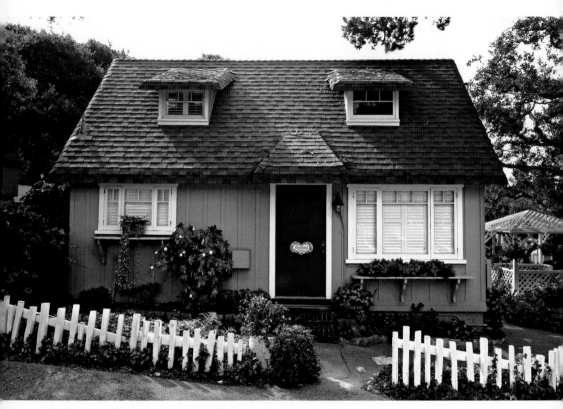

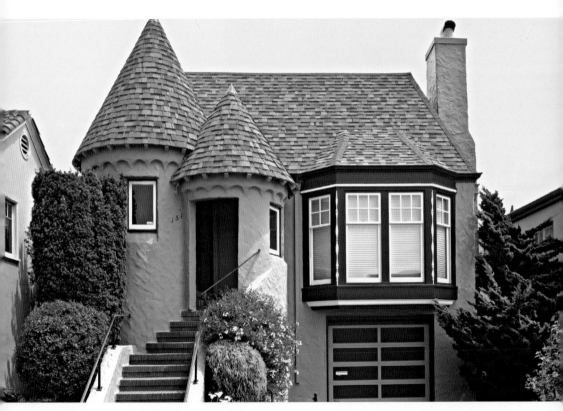

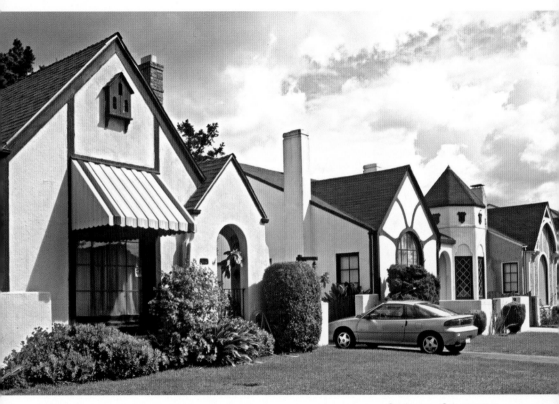

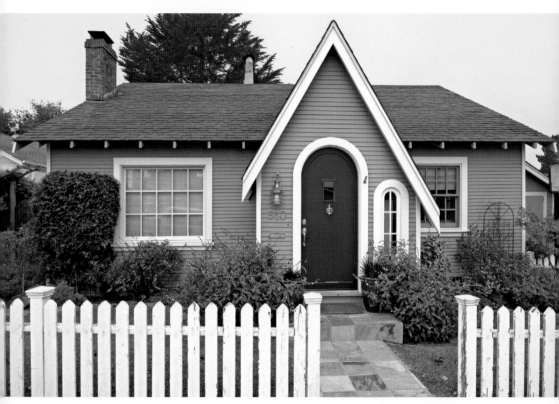

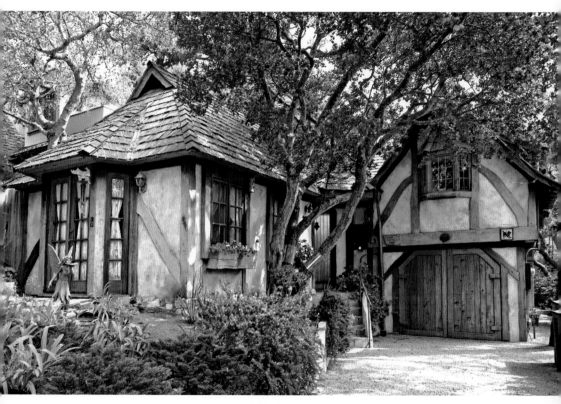

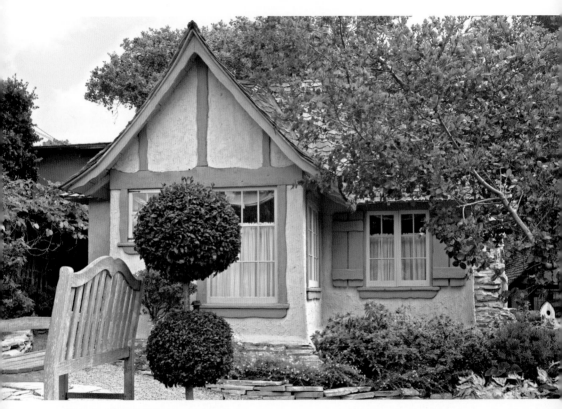

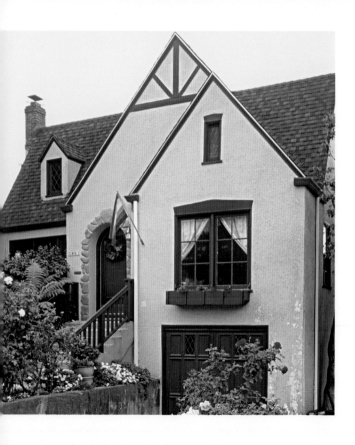

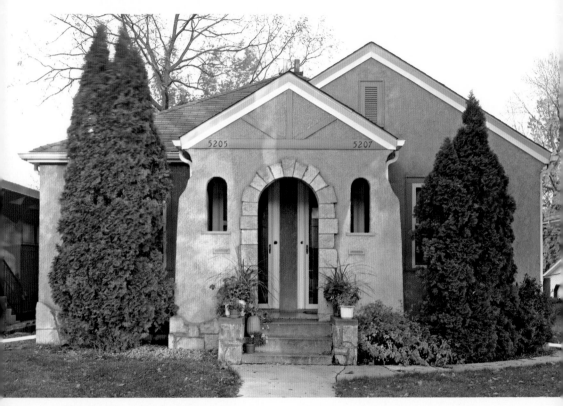

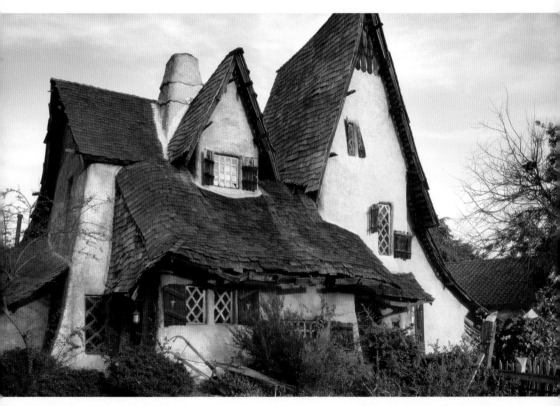

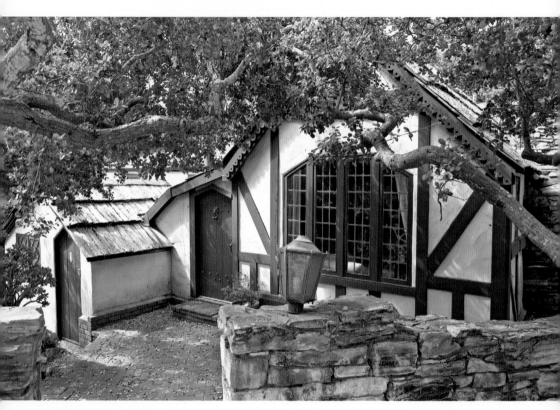

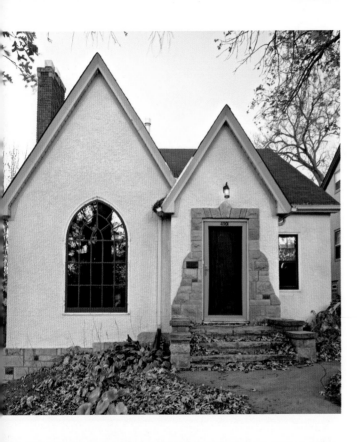

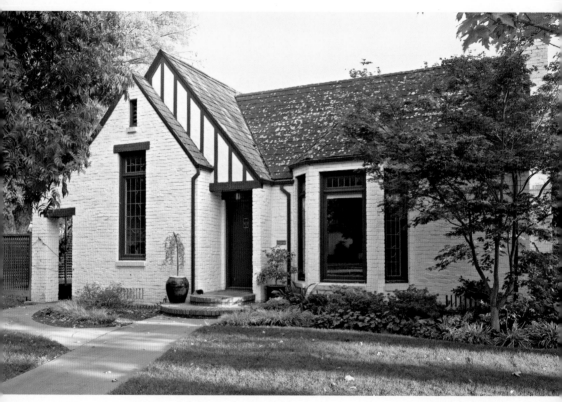

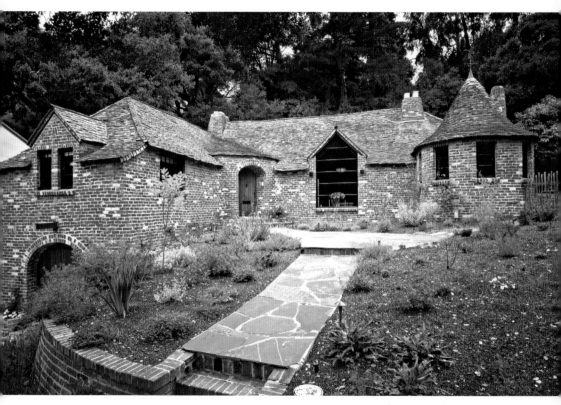

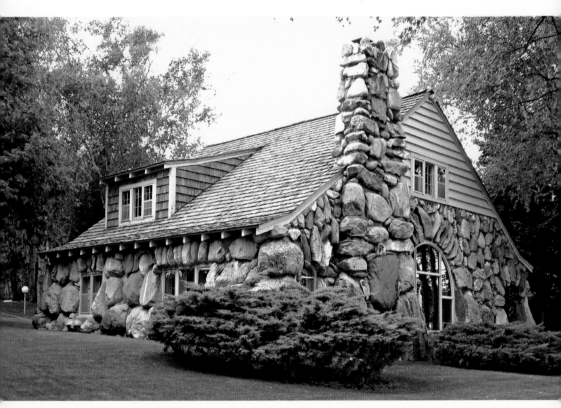

70 CHARLEVOIX, MICHIGAN

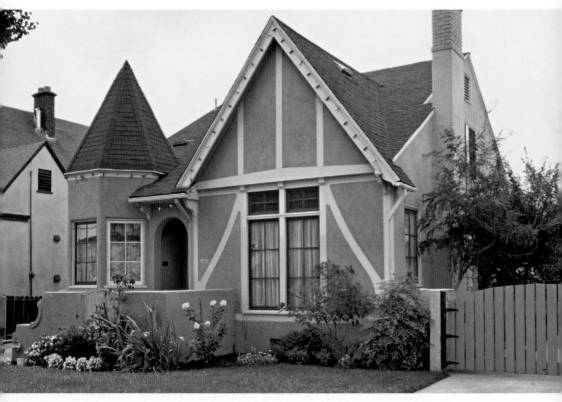

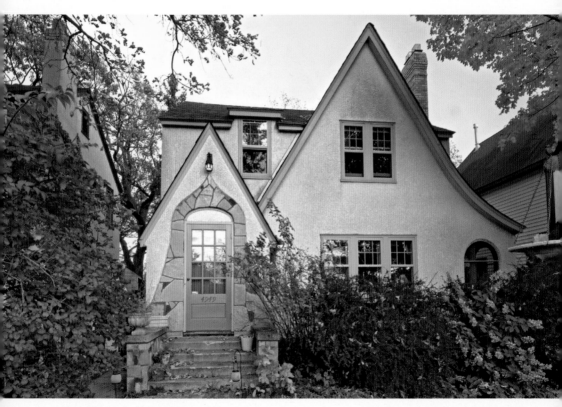

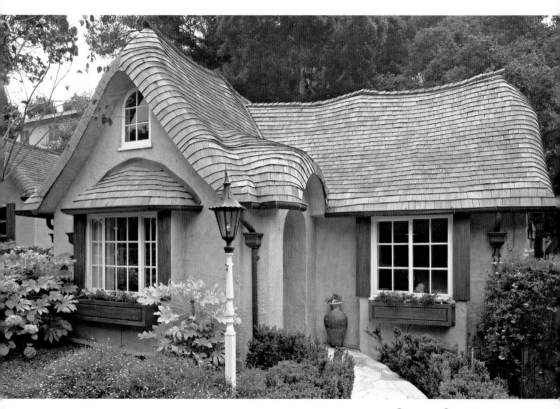

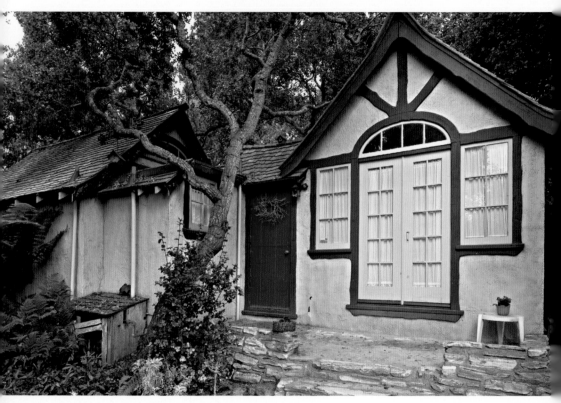

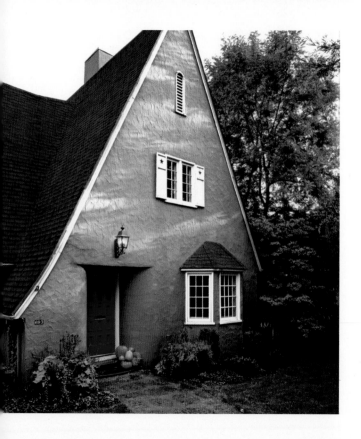

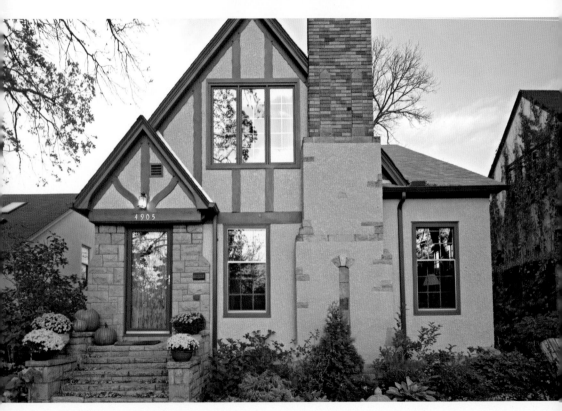

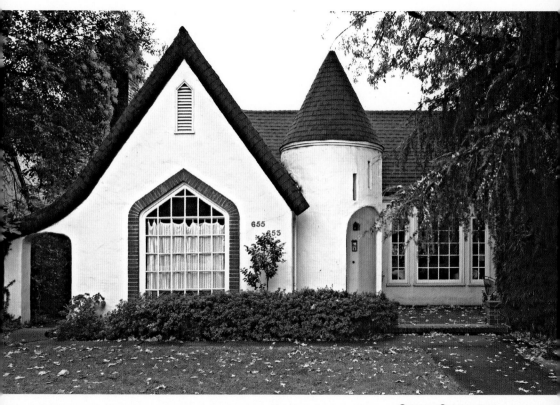

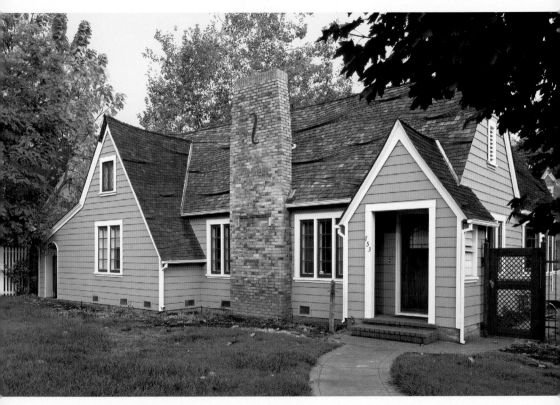

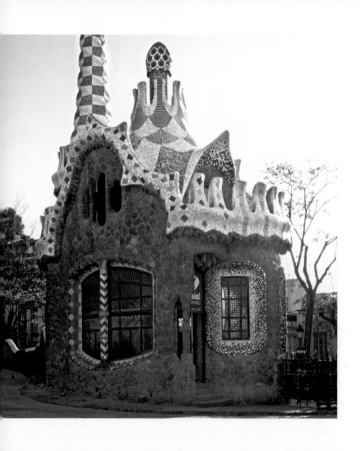

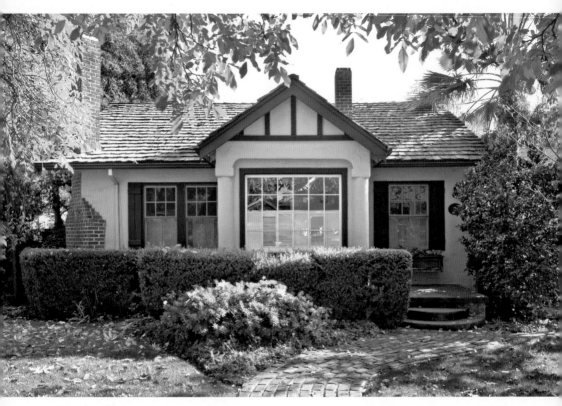

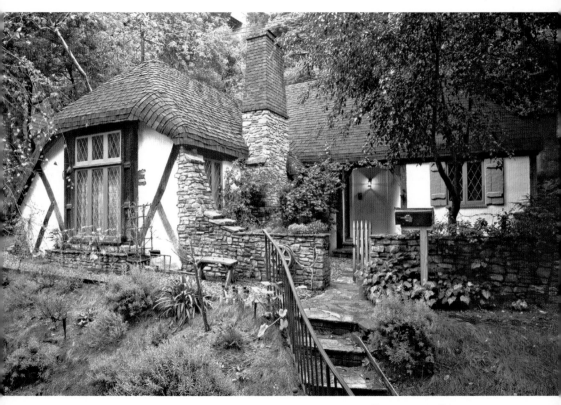

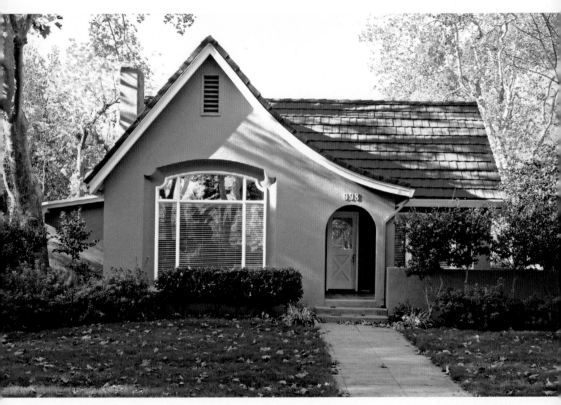

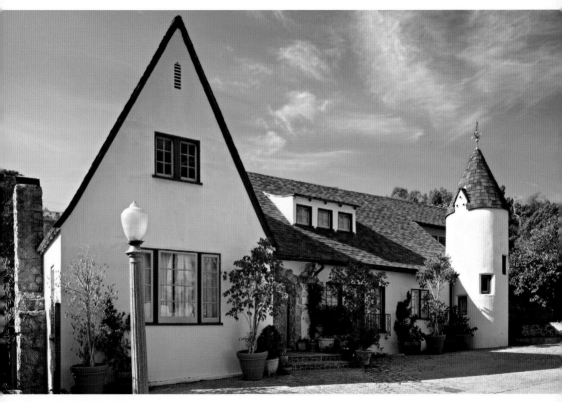

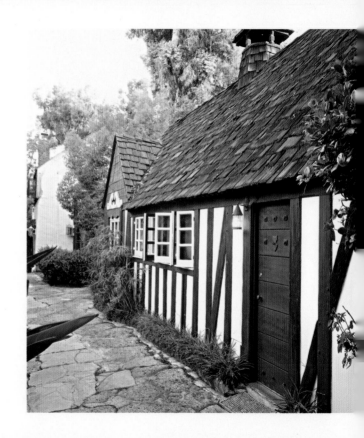

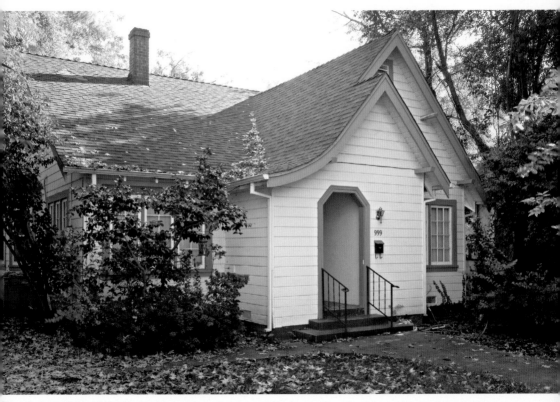

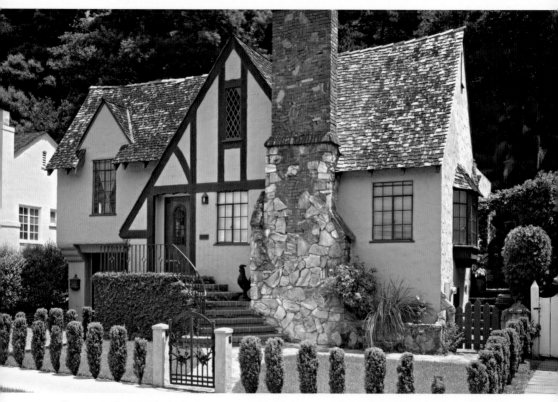

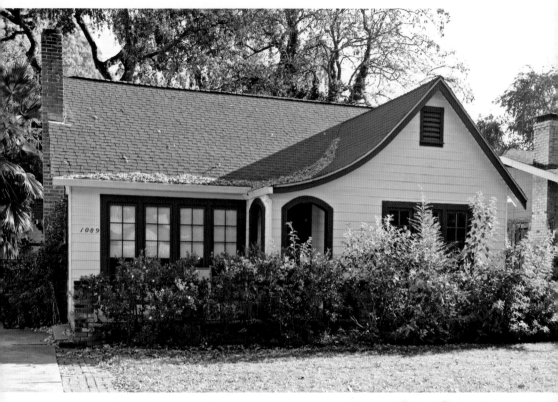

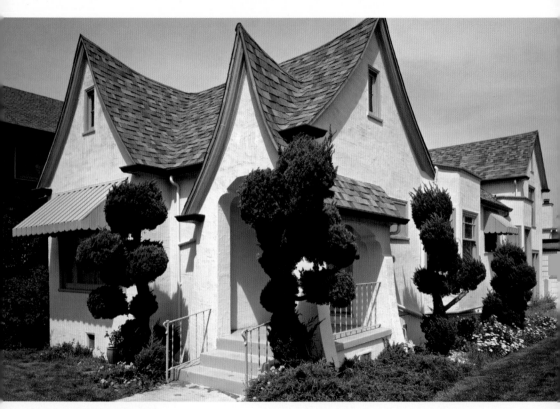

88 ALBANY, CALIFORNIA

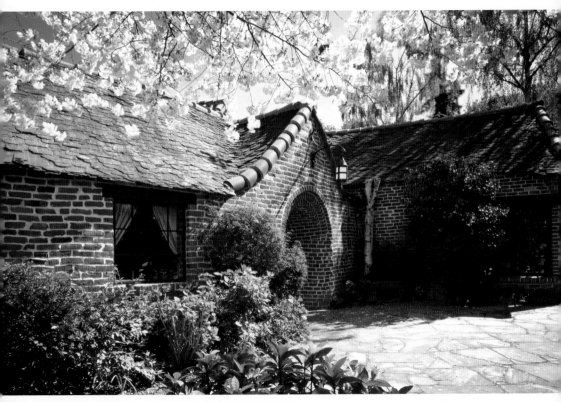

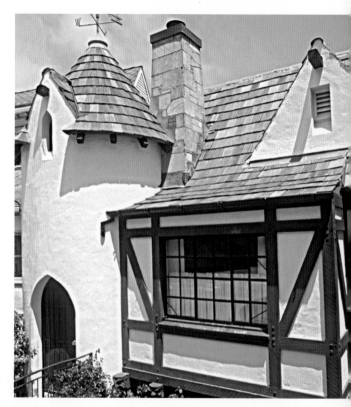

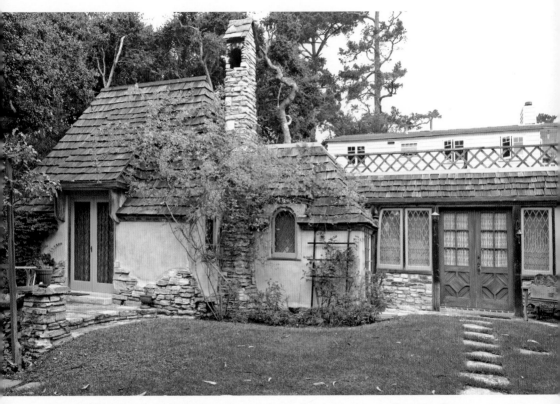

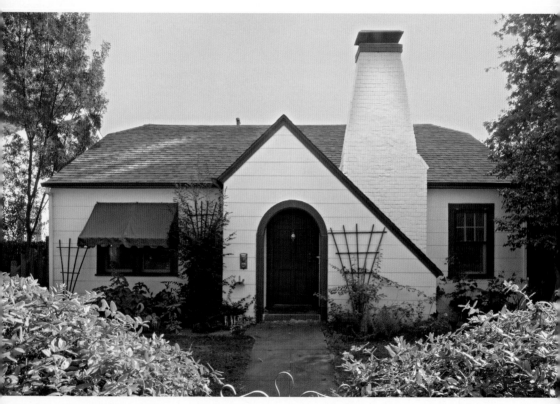

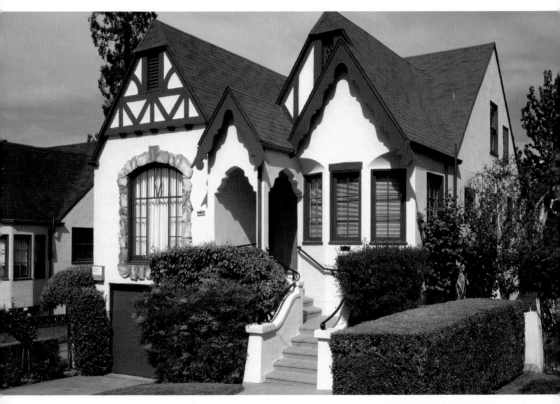

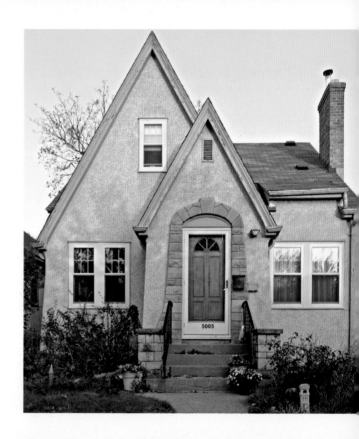

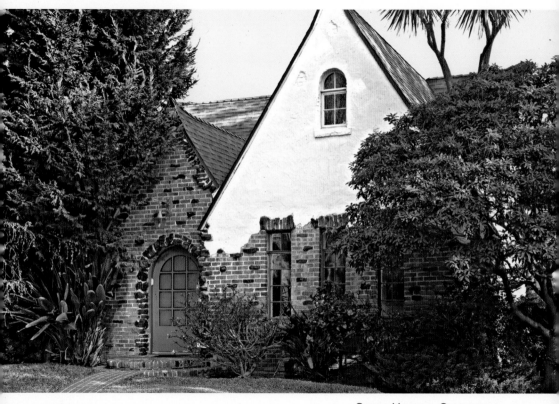

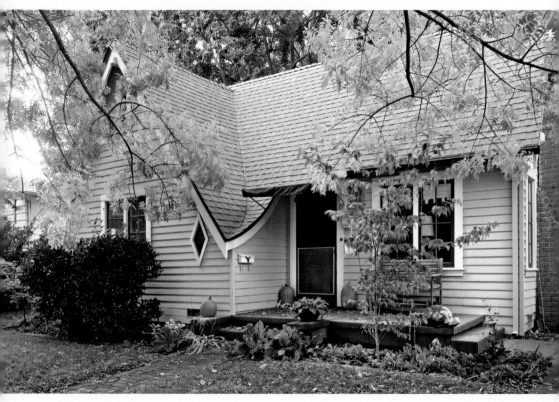

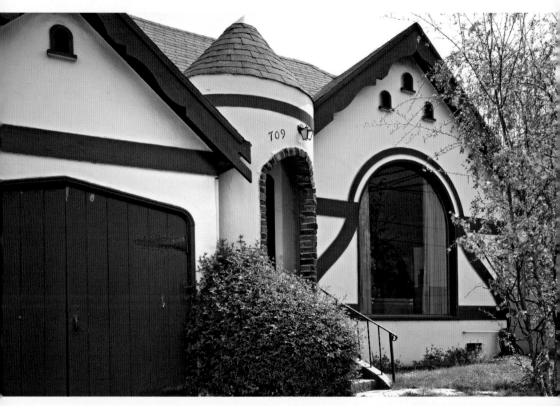

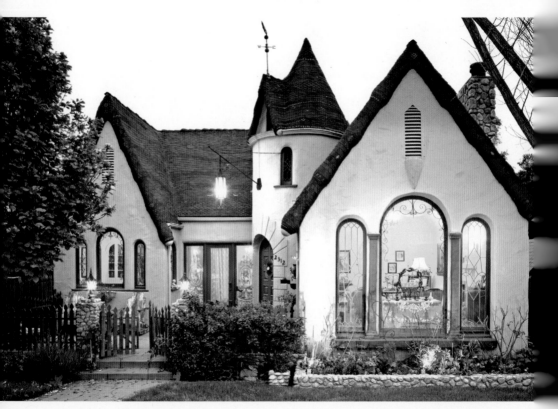

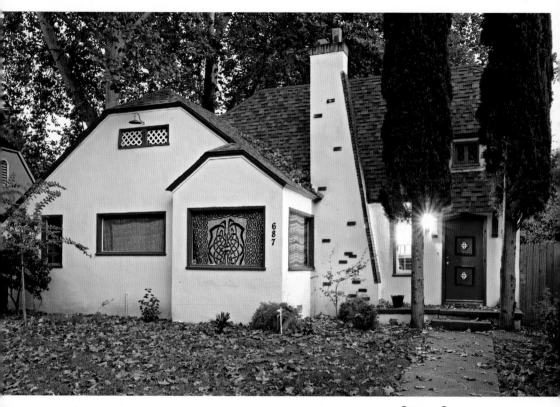

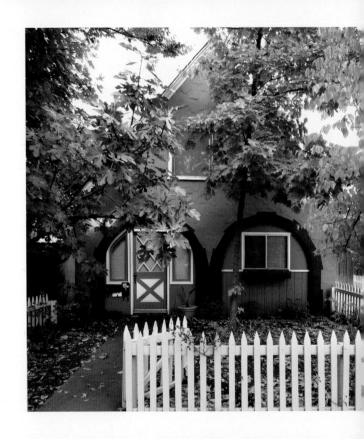

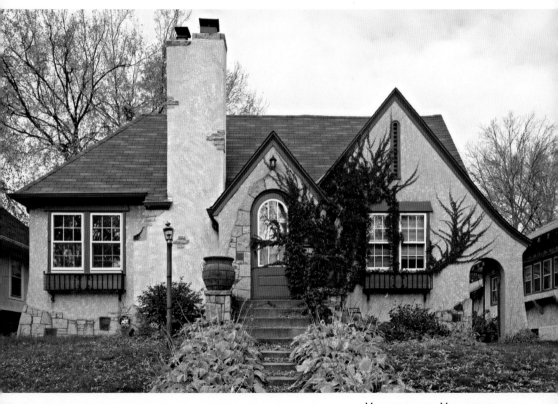

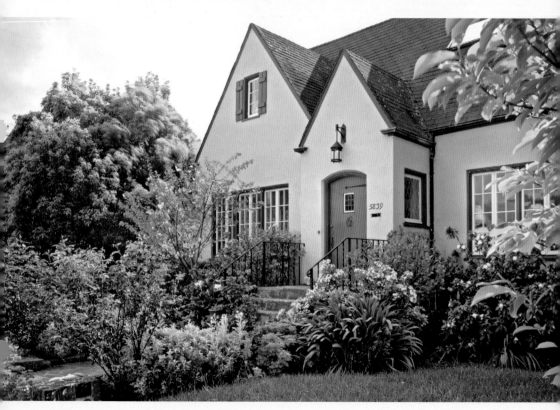

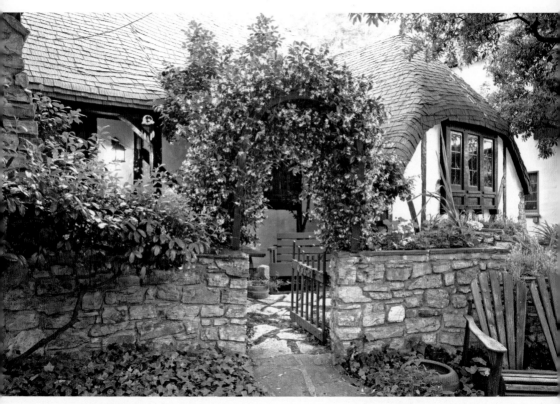

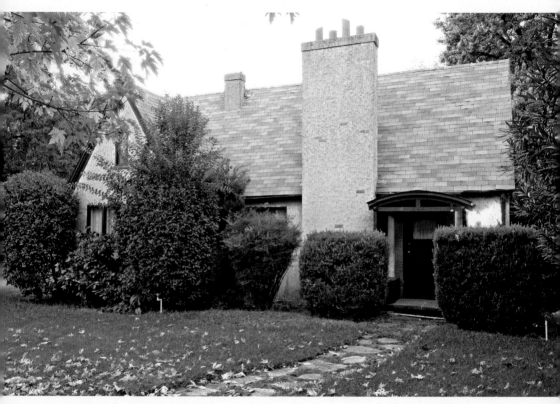

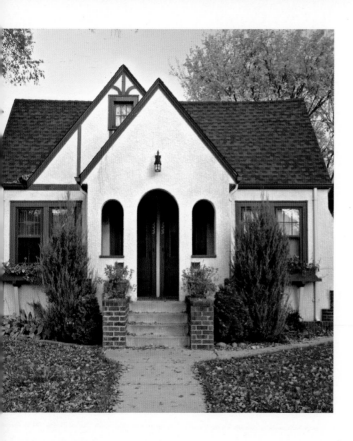

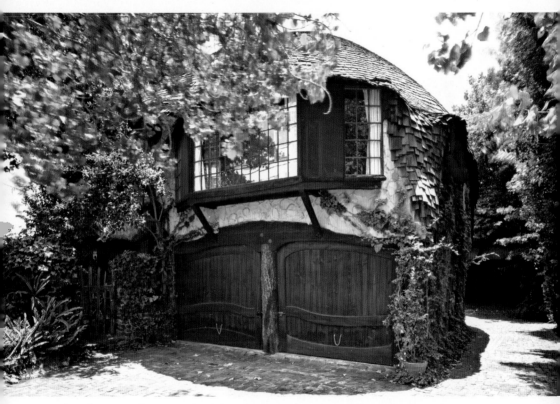

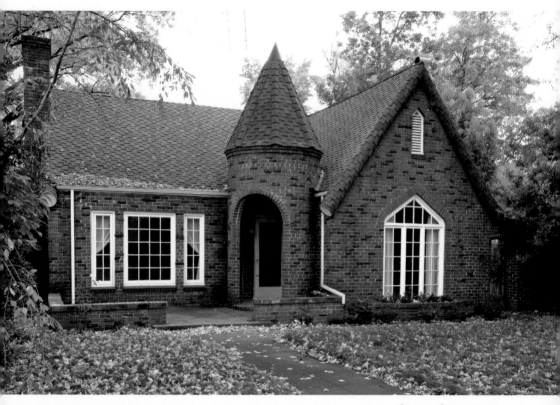

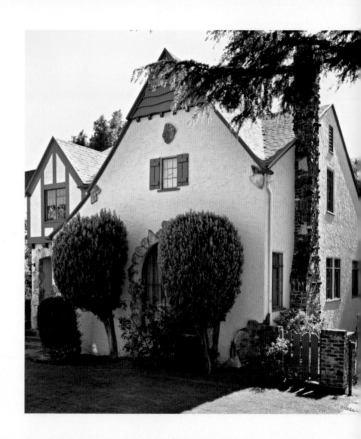

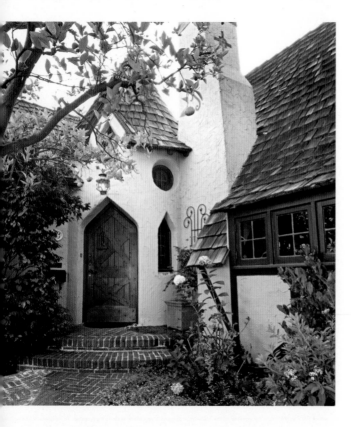

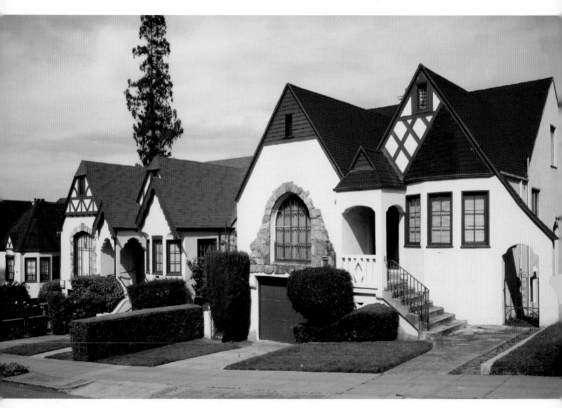

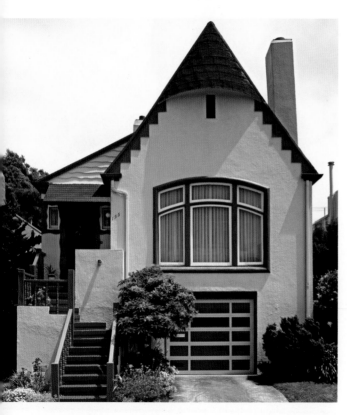

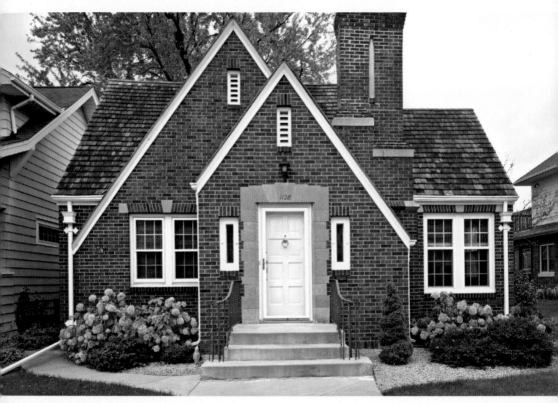

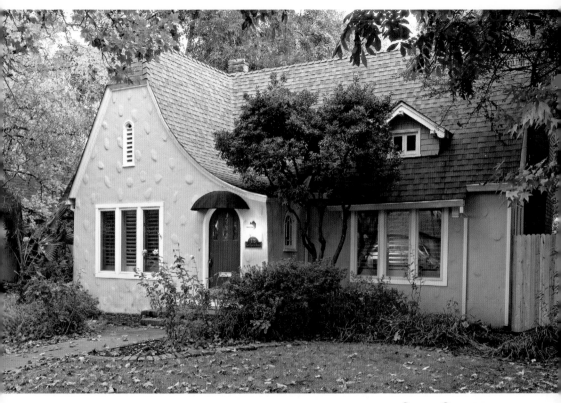

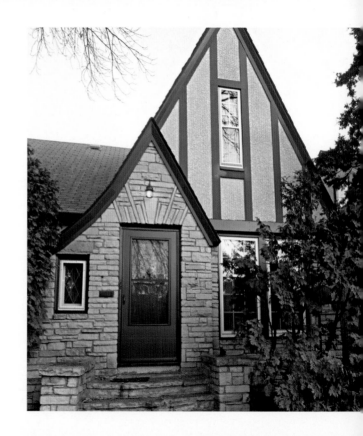

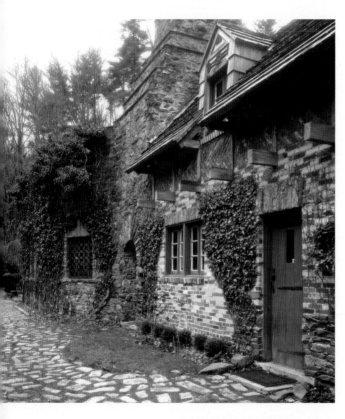

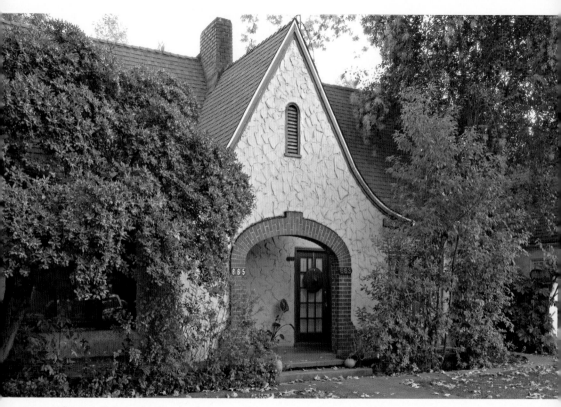

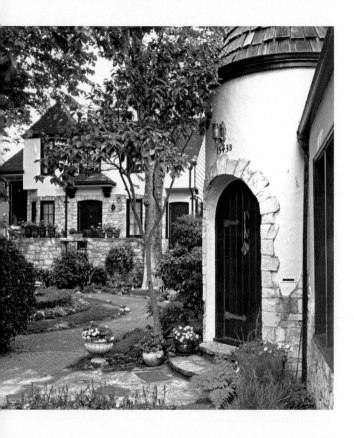

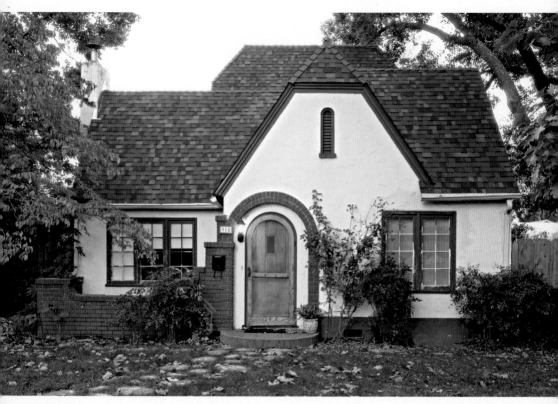

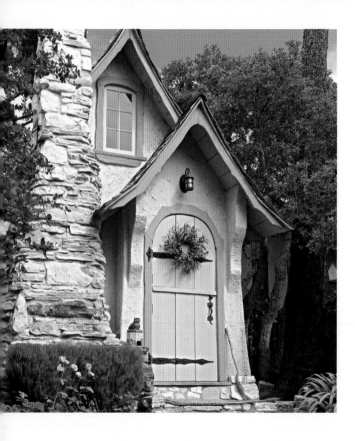

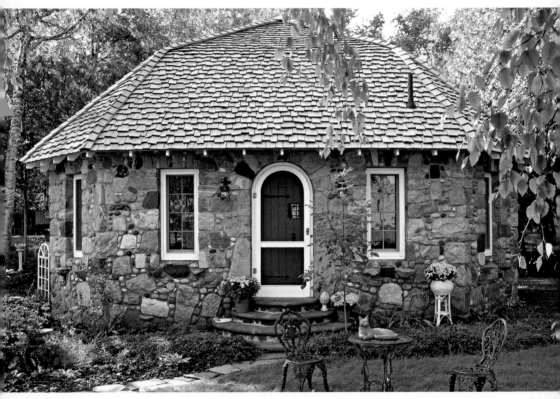

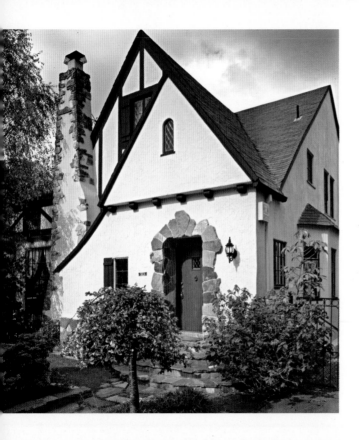

CASITAS

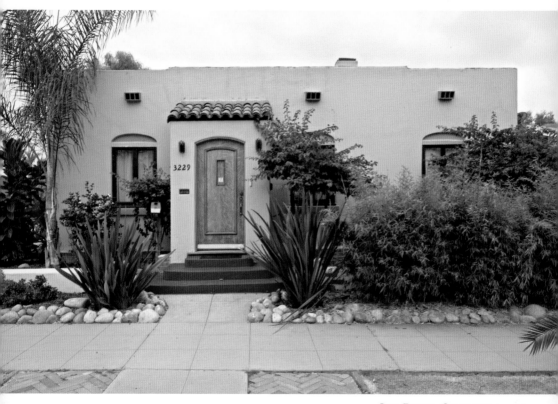

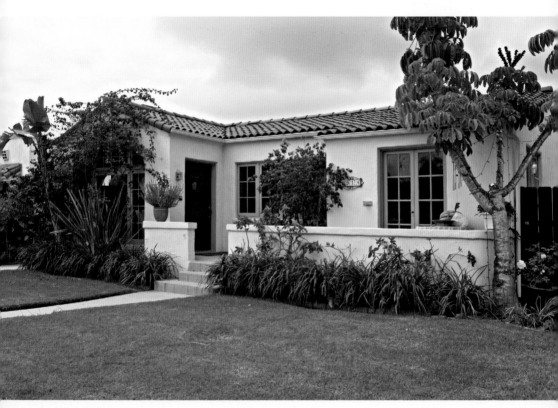

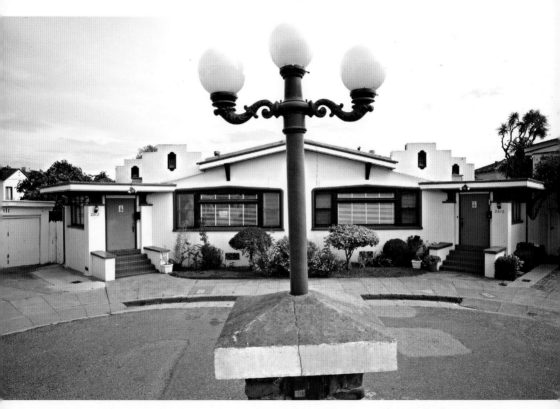

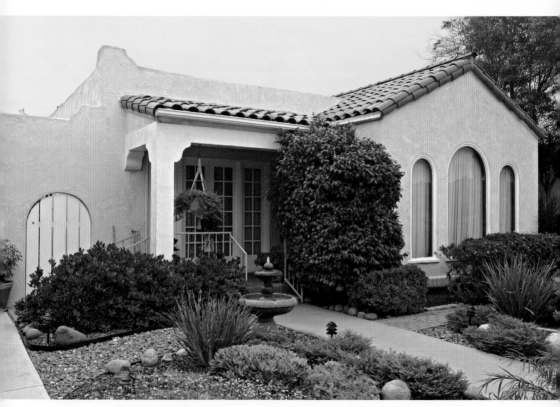

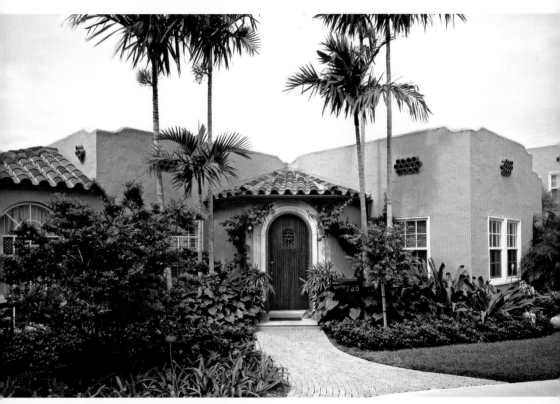

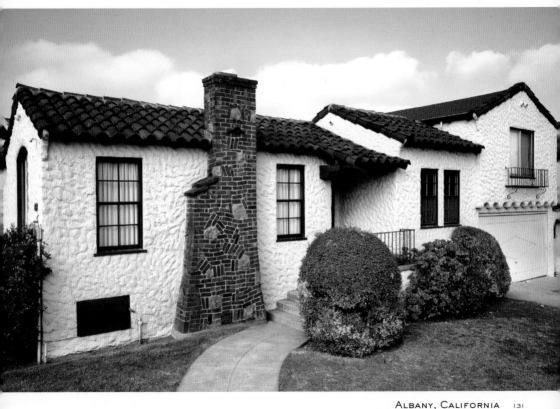

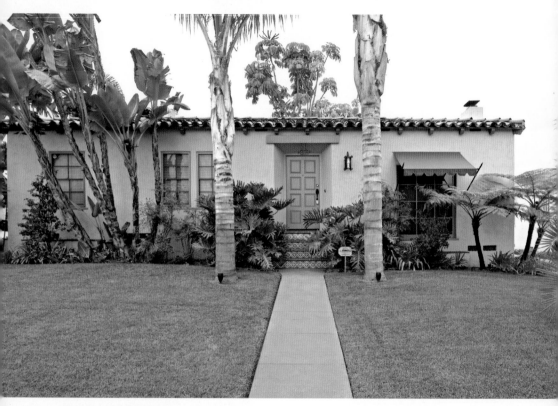

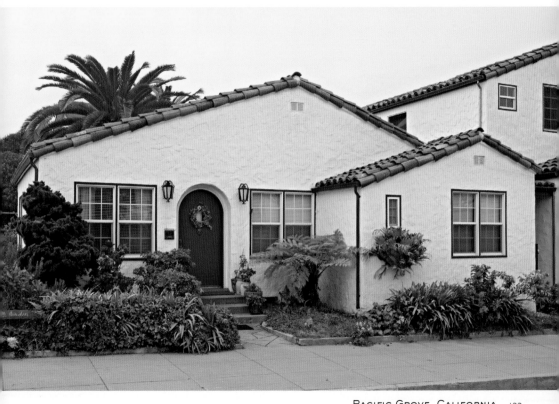

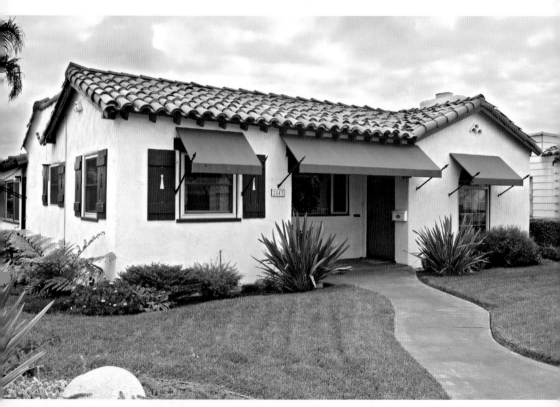

134 SAN DIEGO, CALIFORNIA

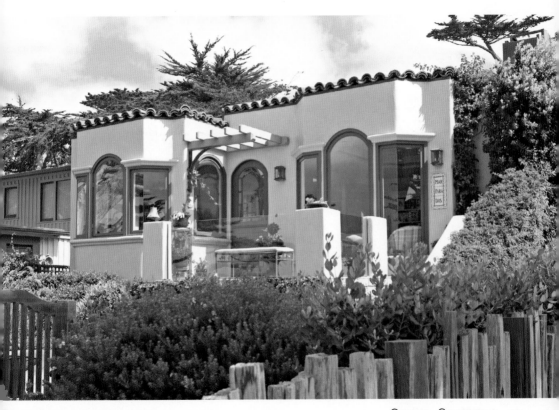

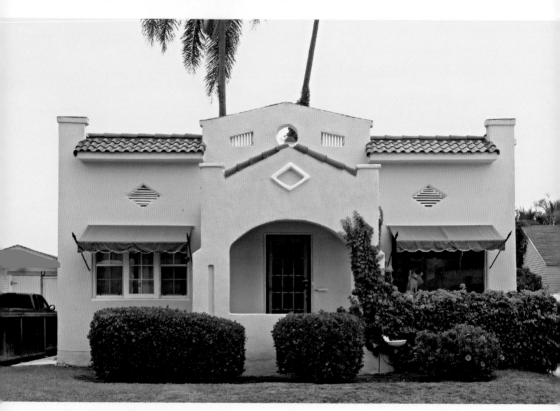

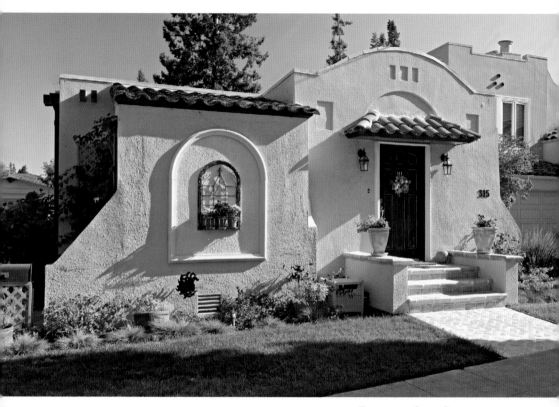

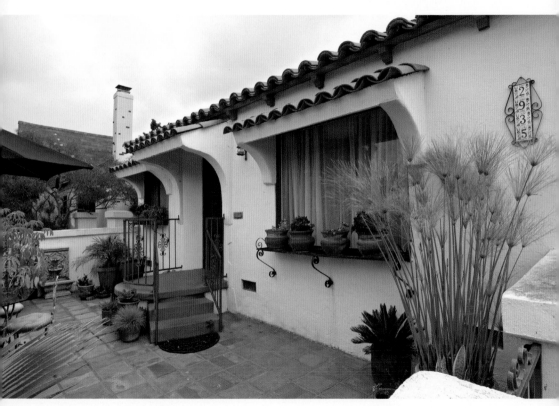

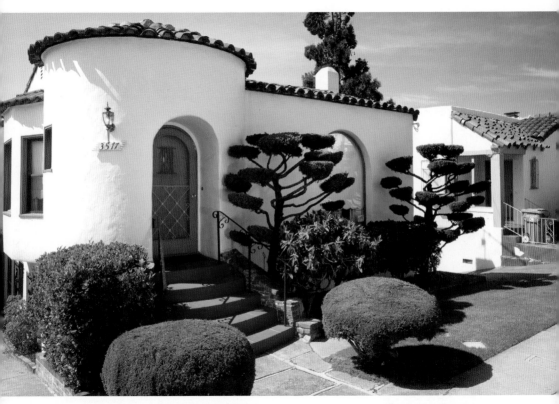

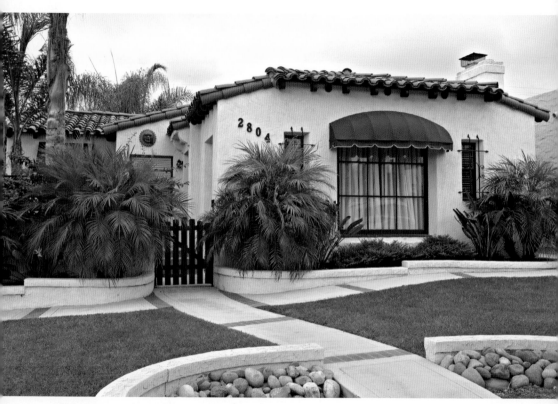

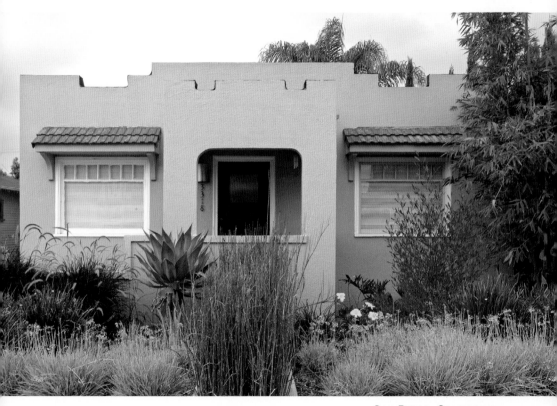

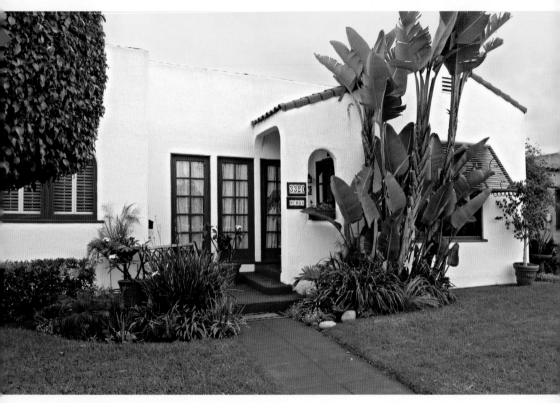

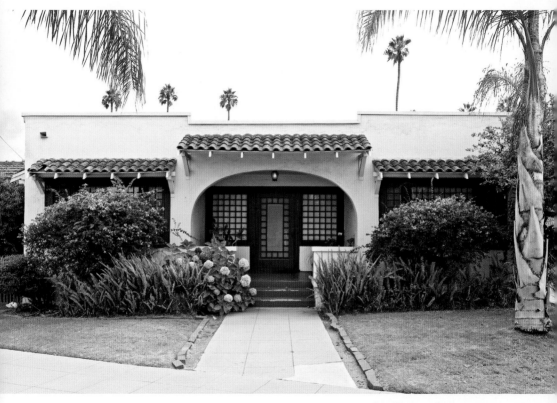

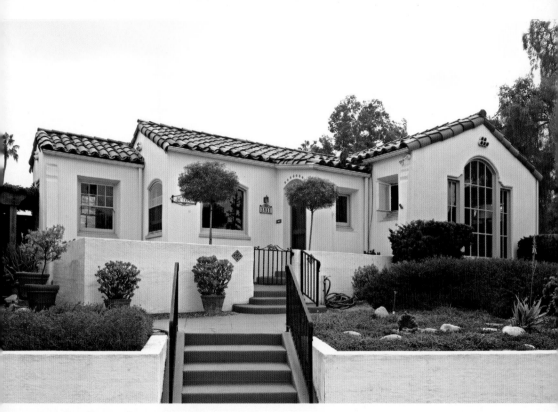

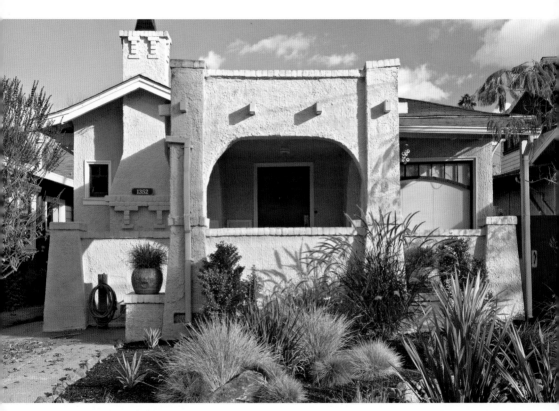

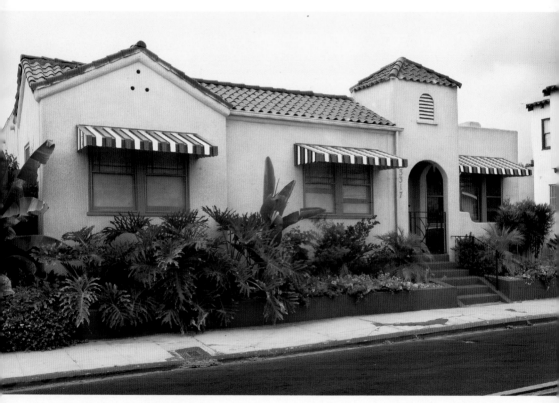

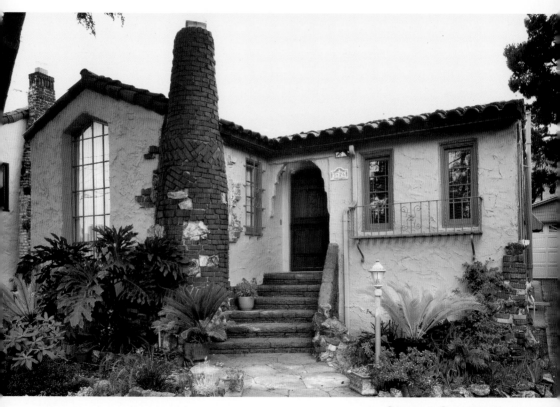

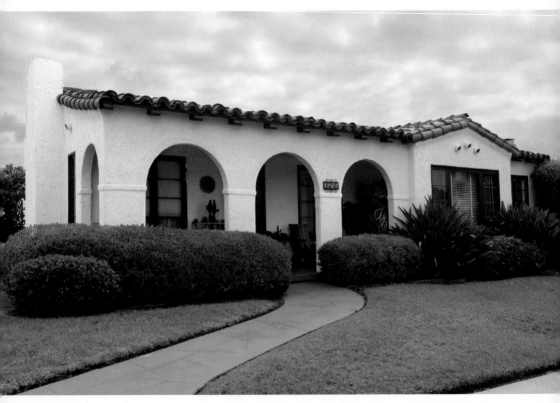

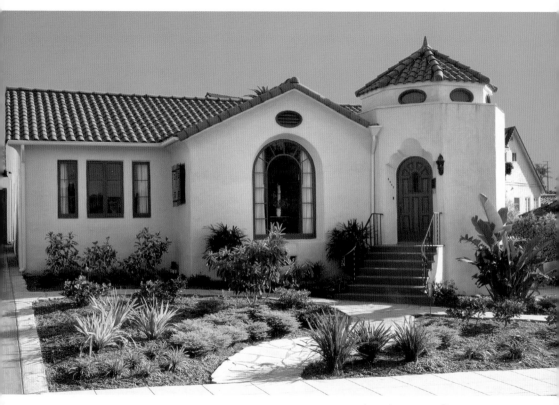

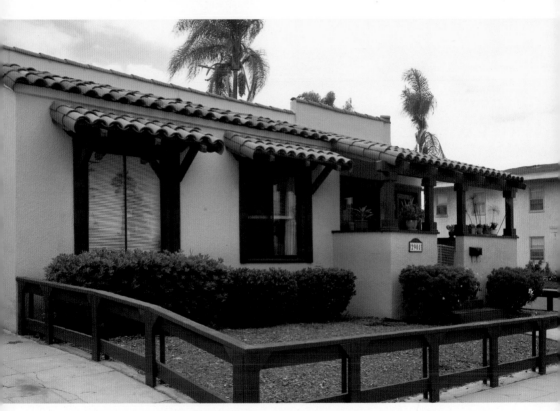

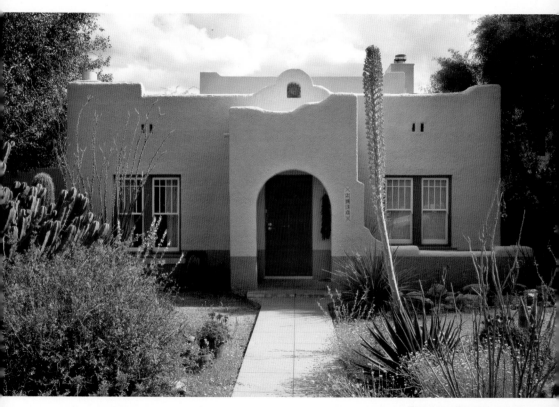

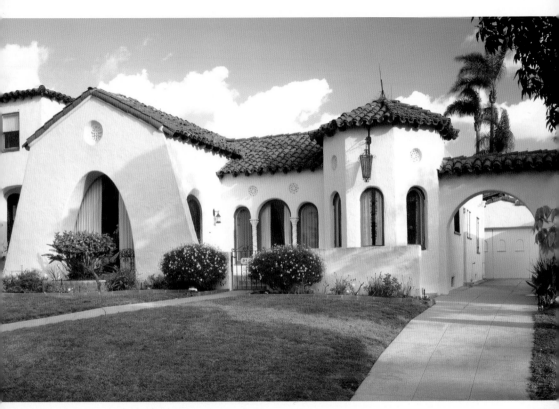

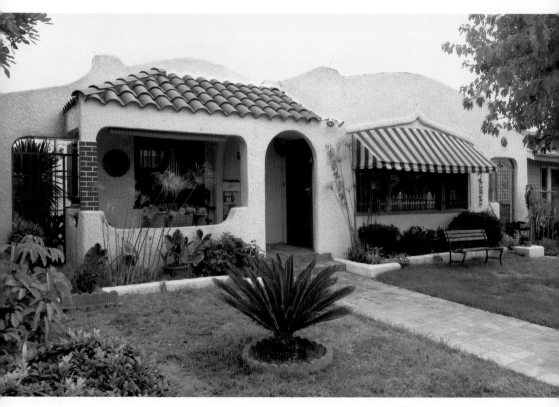

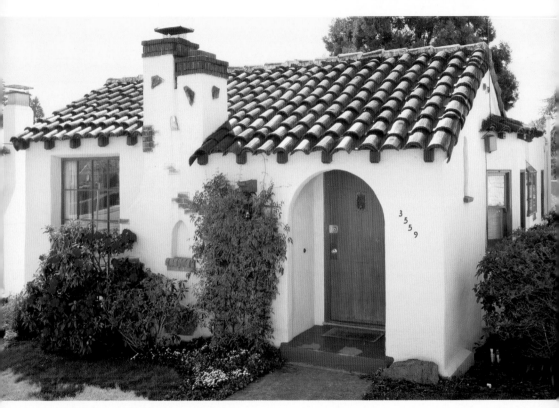

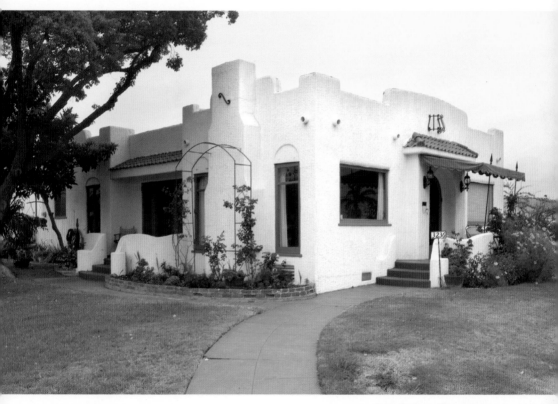

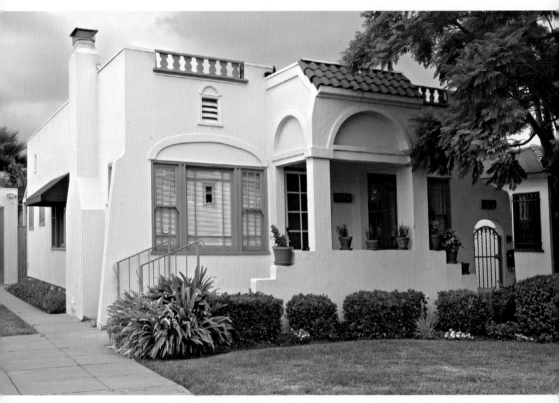

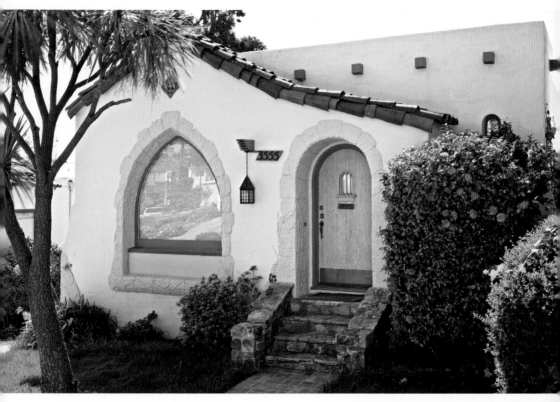

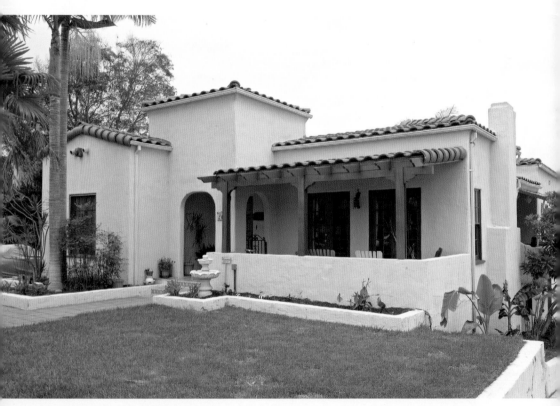

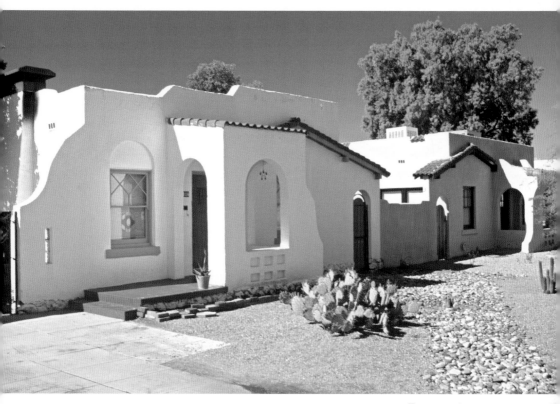

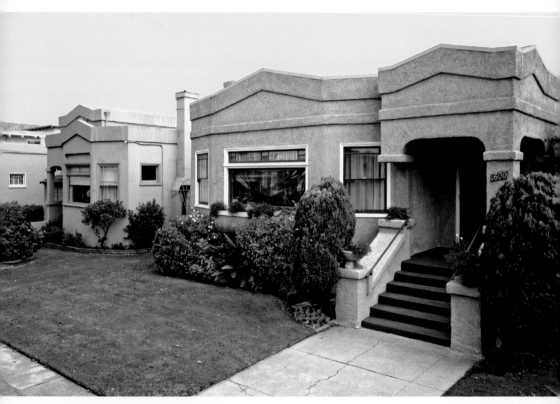

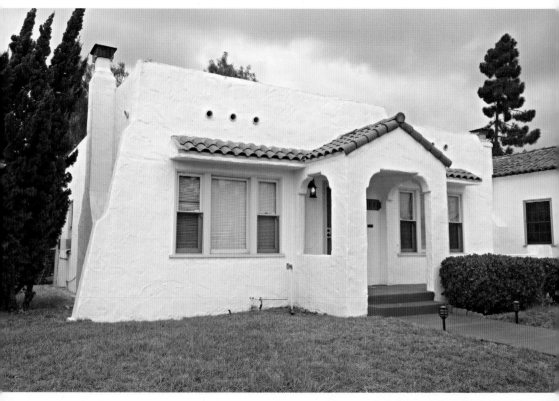

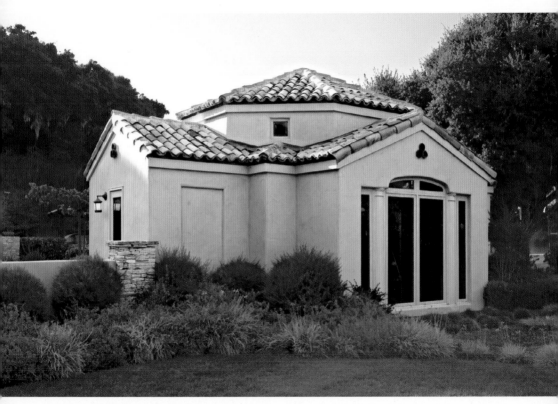

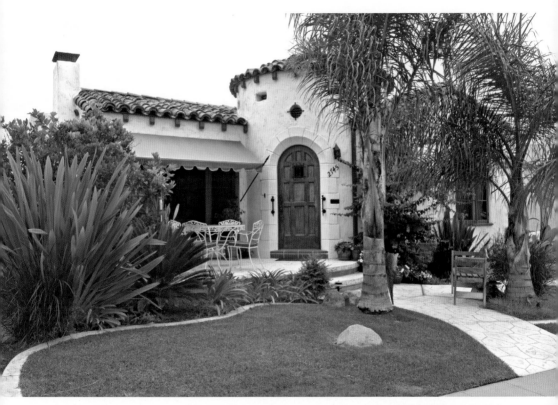

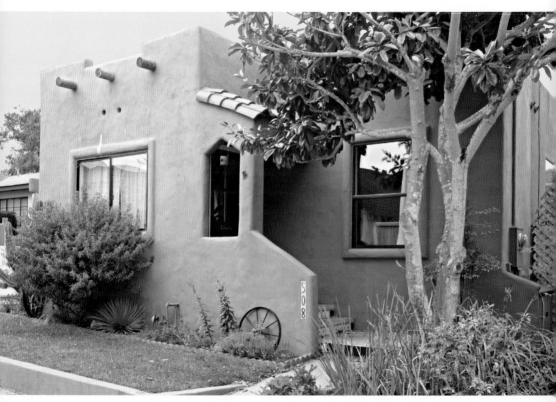

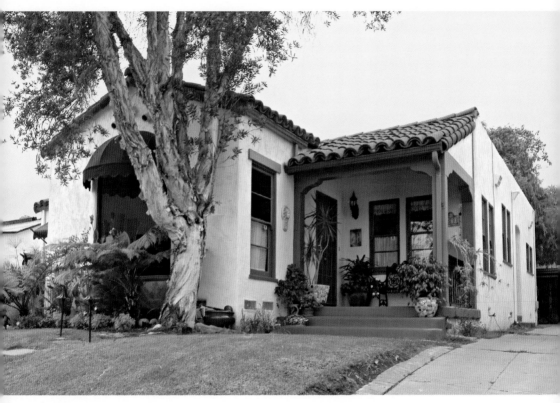

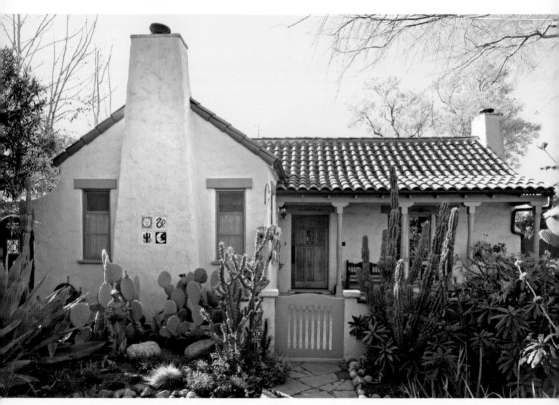

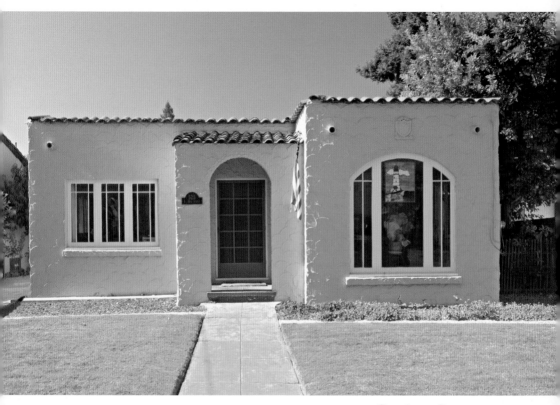

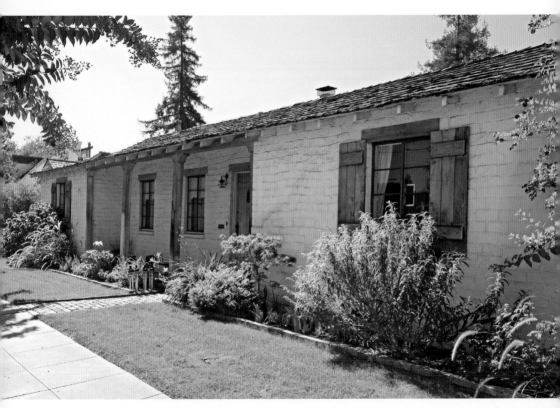

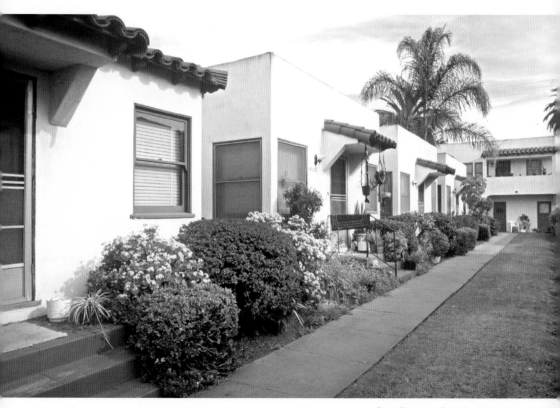

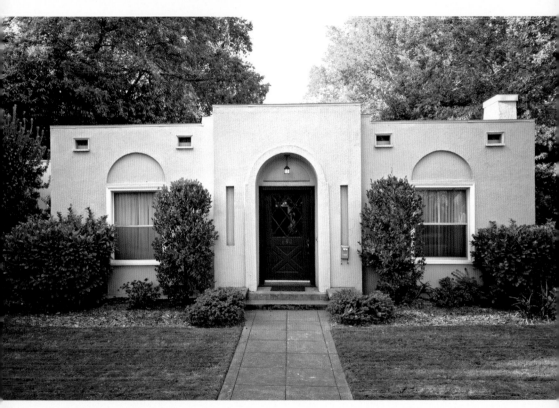

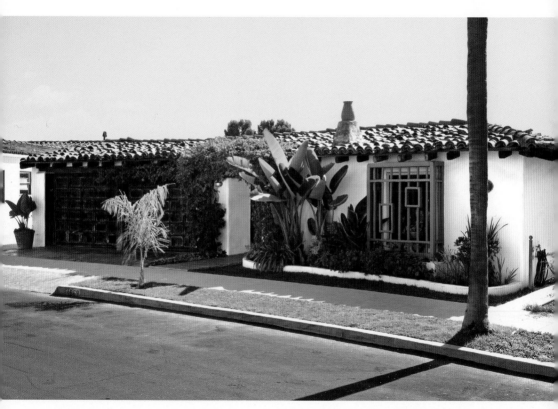

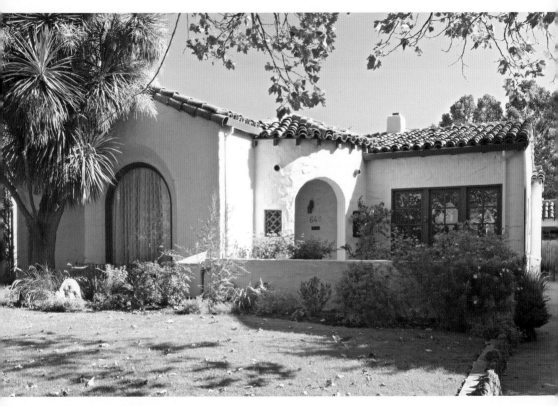

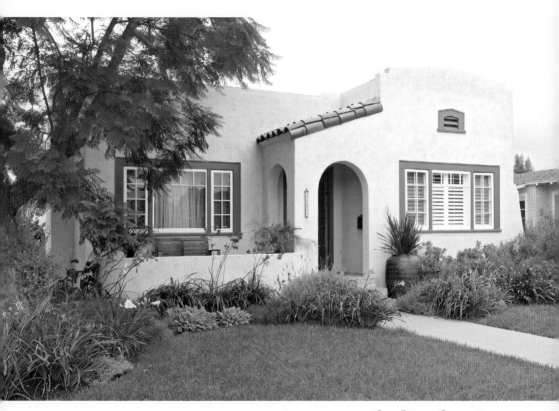

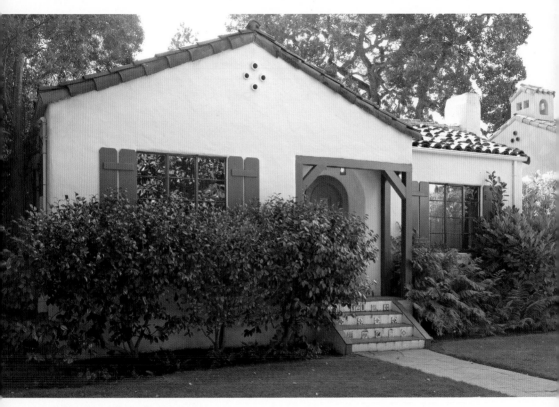

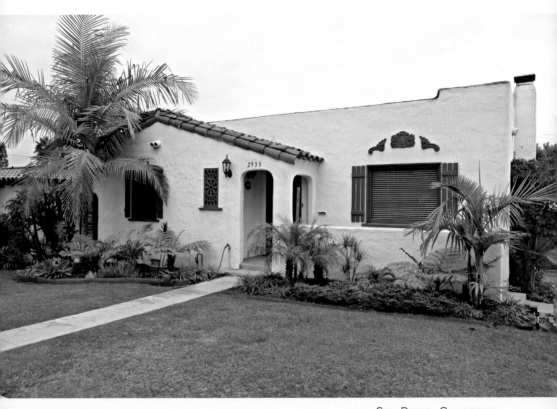

BUNGALETTES

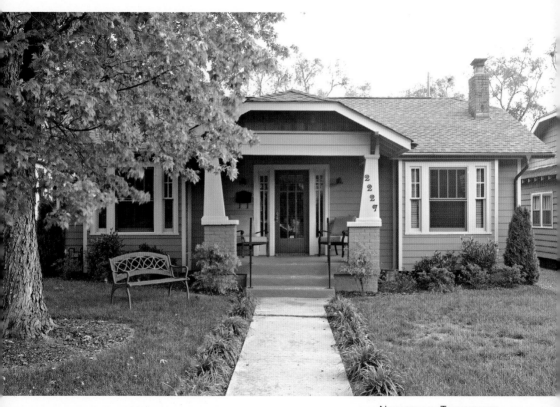

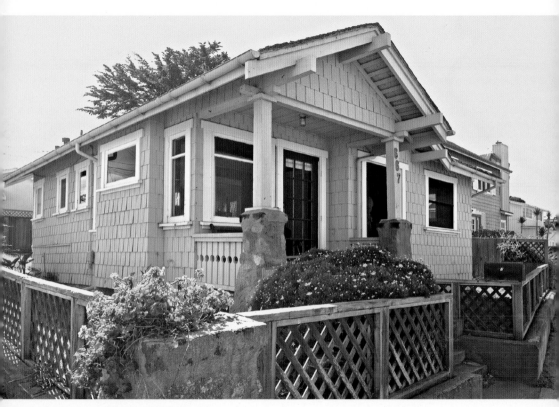

PACIFIC GROVE, CALIFORNIA

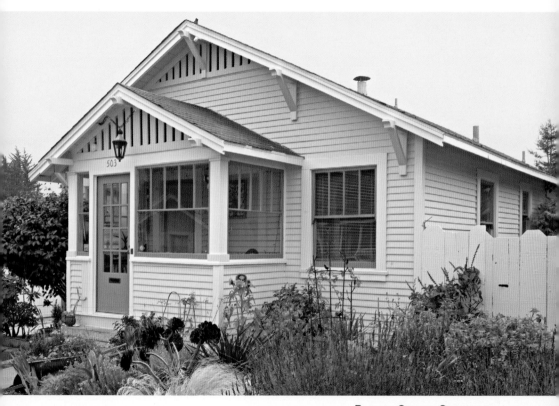

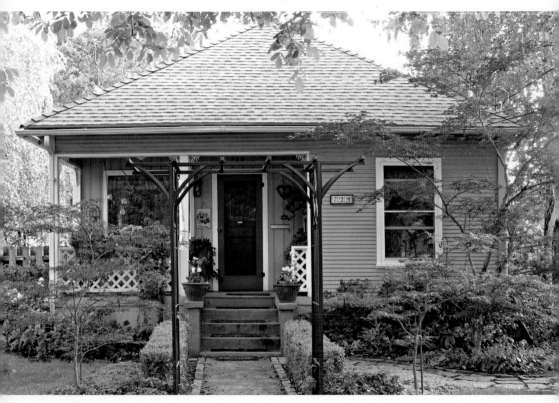

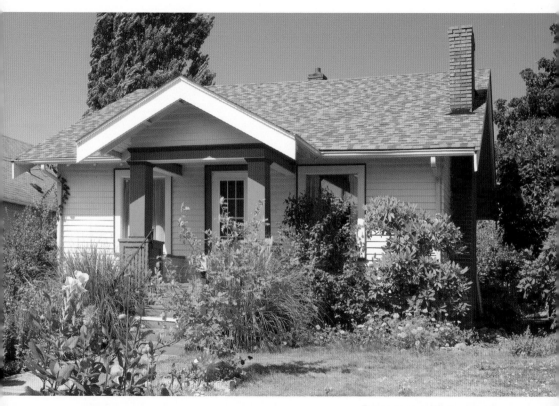

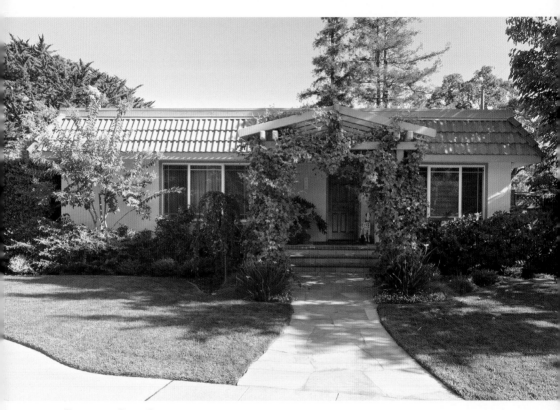

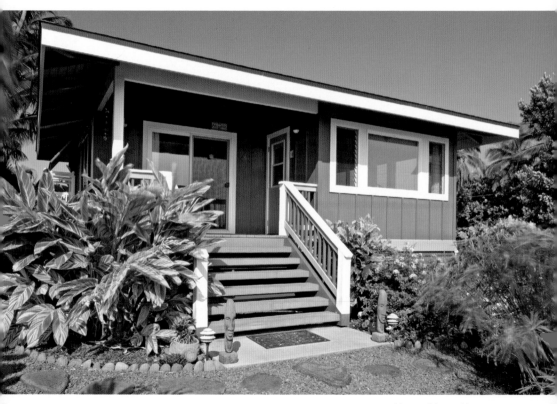

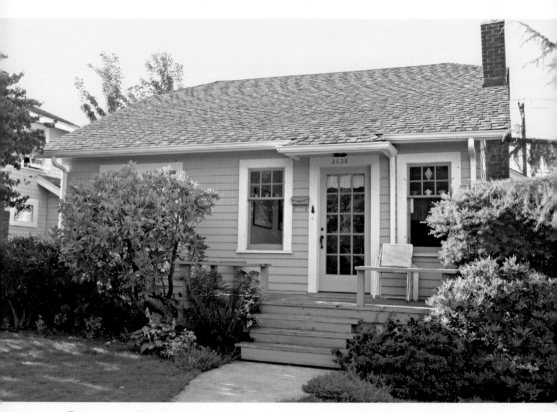

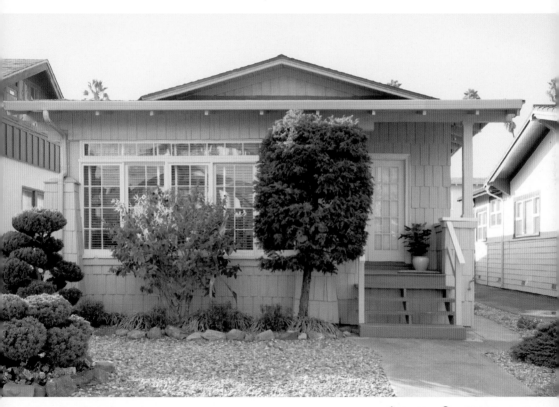

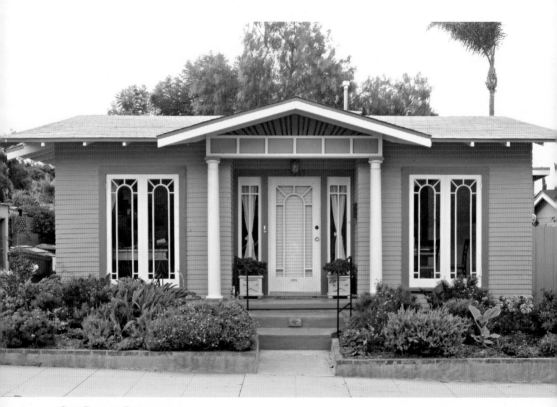

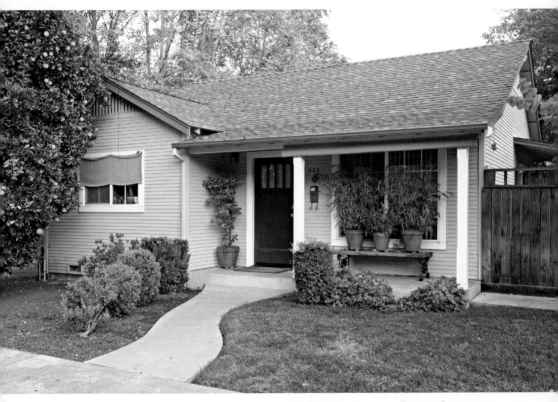

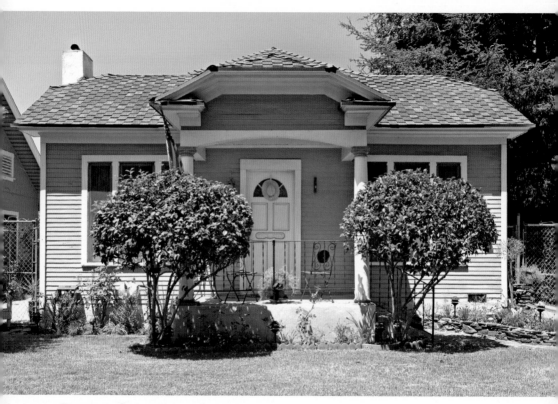

188 PASADENA, CALIFORNIA

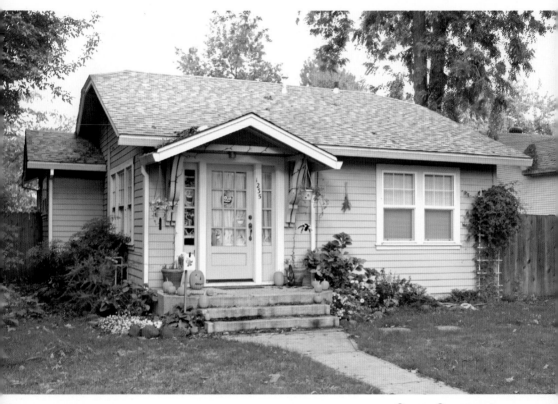

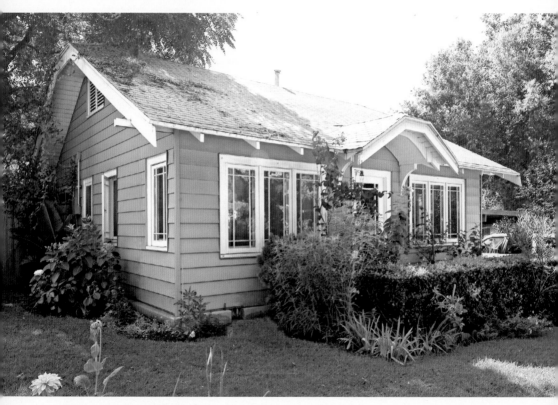

190 PASADENA, CALIFORNIA

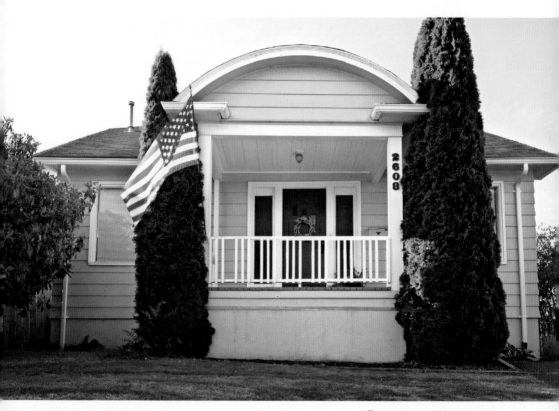

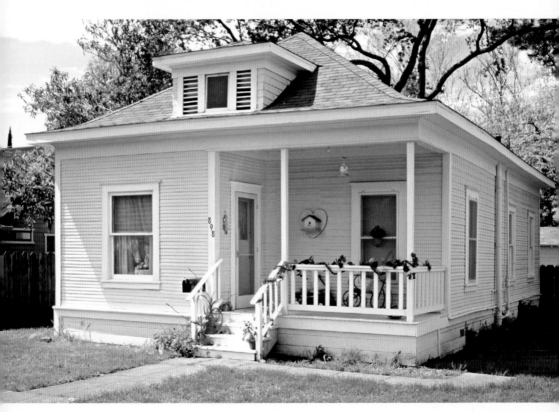

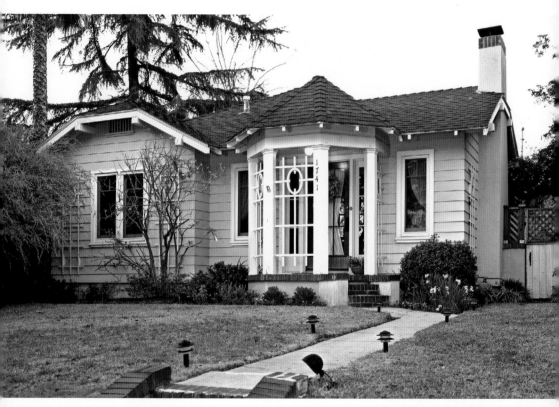

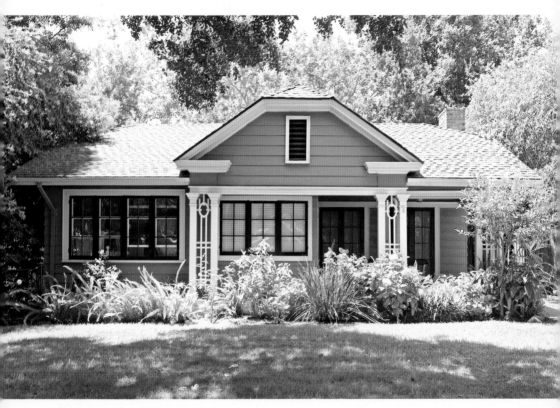

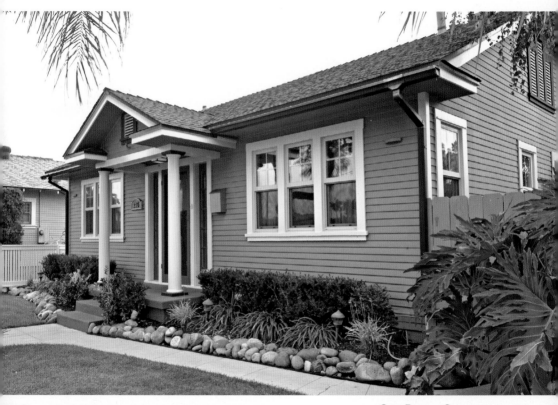

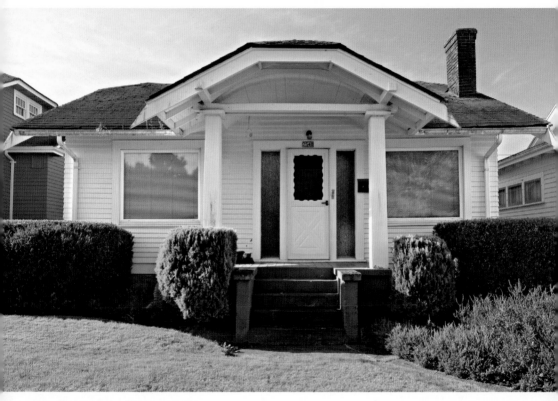

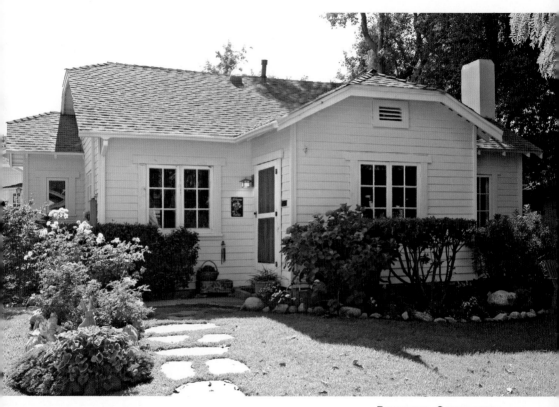

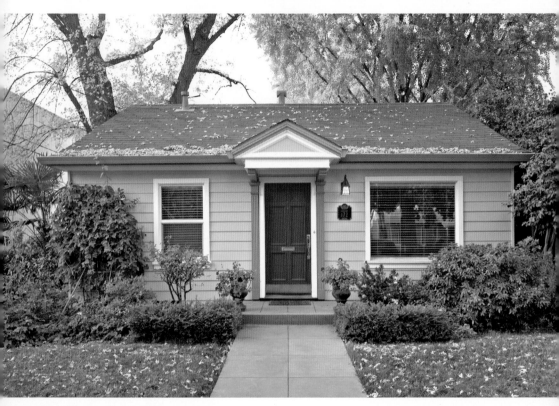

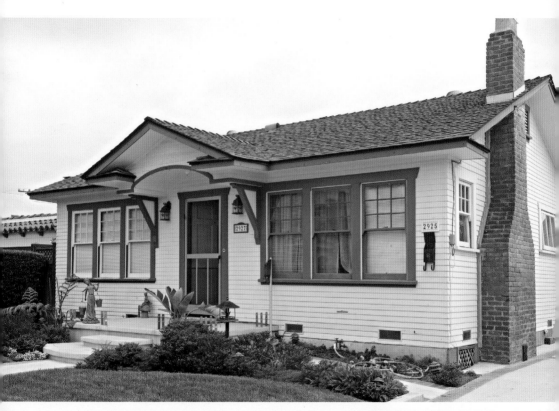

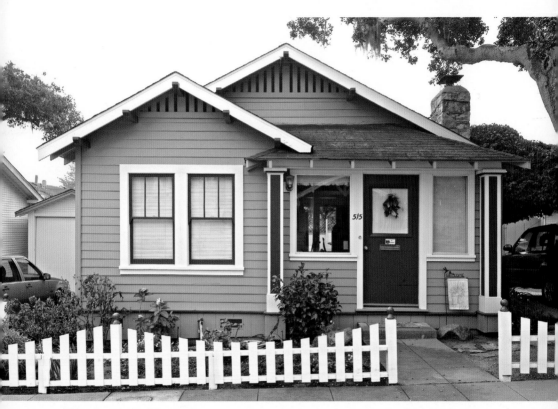

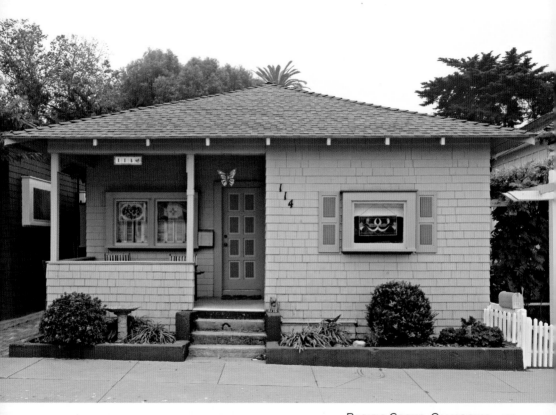

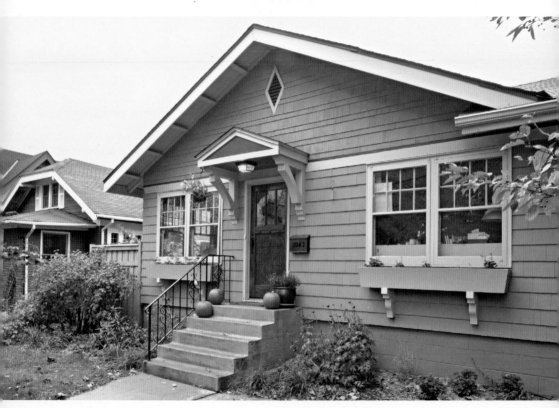

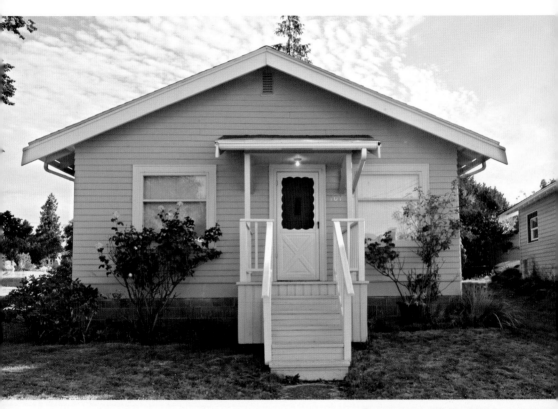

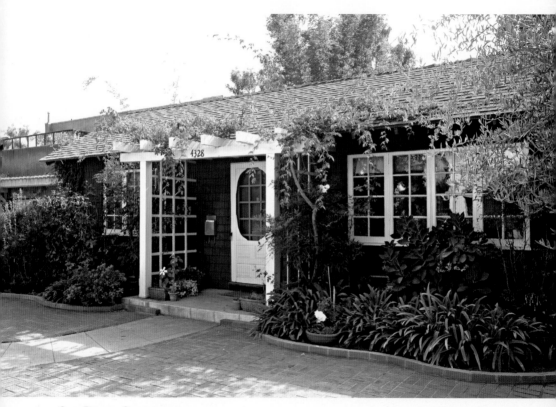

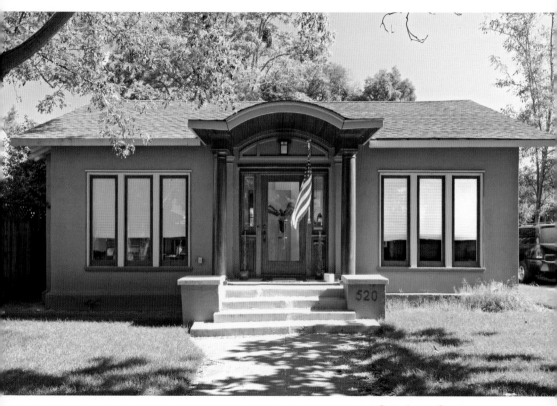

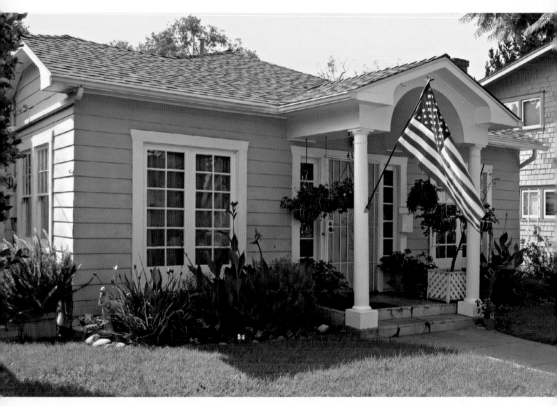

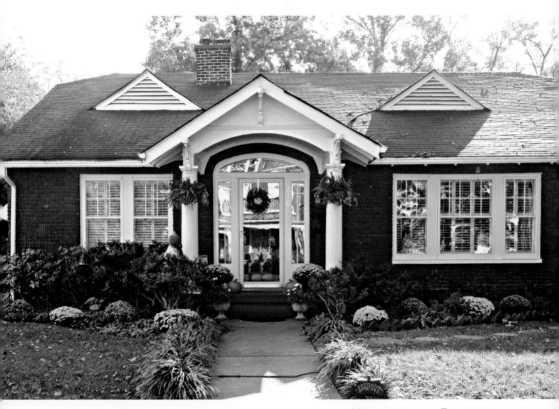

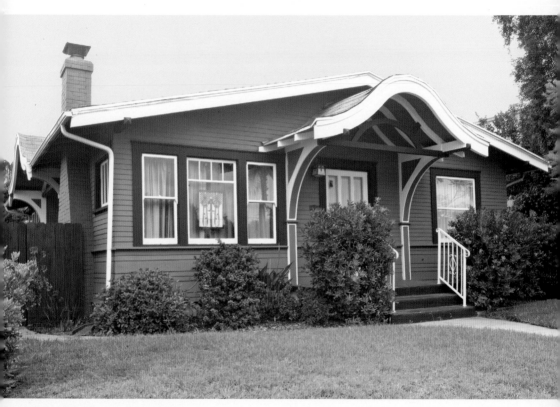

208 SAN DIEGO, CALIFORNIA

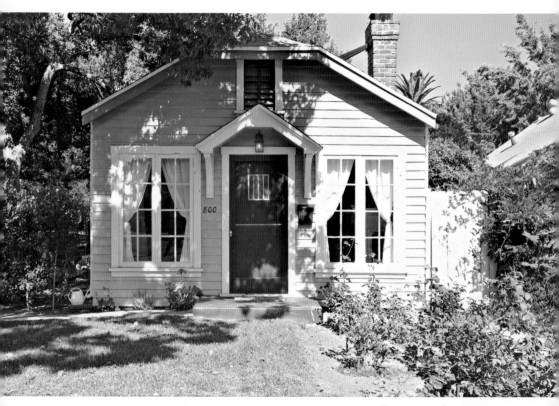

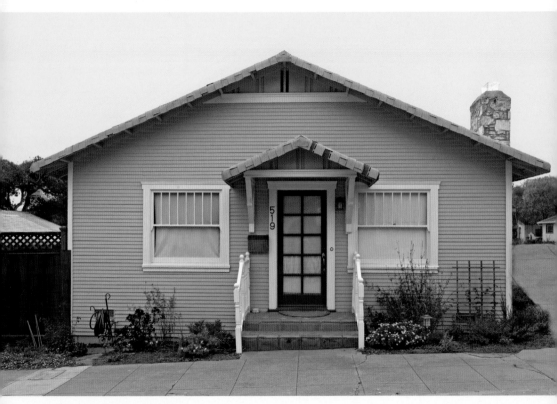

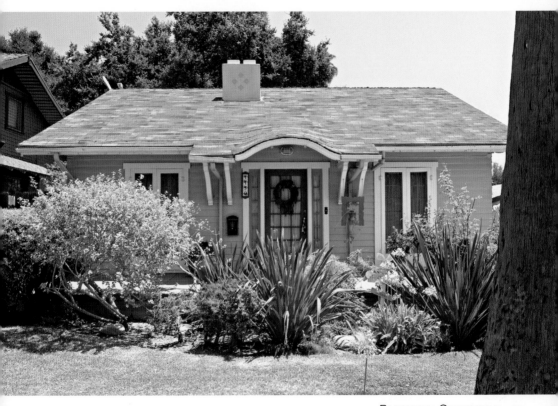

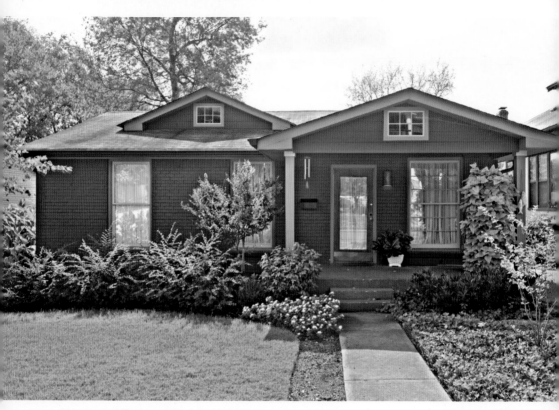

212 NASHVILLE, TENNESSEE

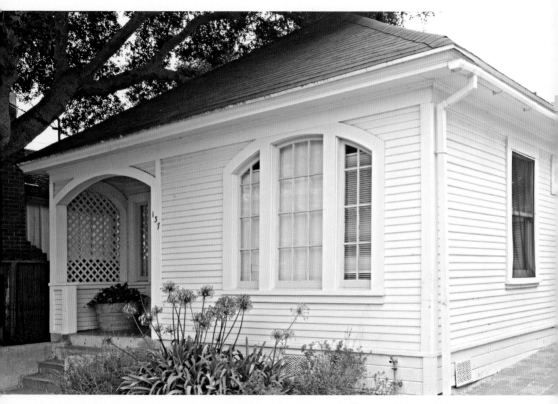

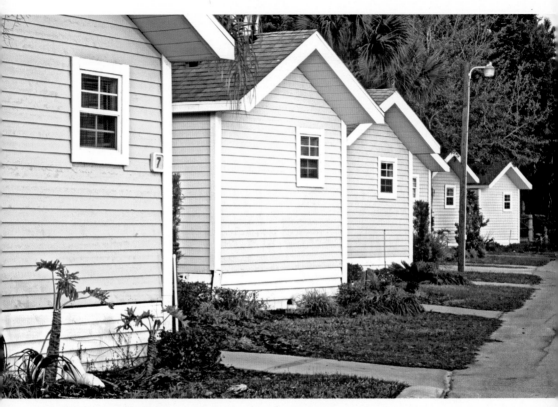

214 KISSIMMEE, FLORIDA

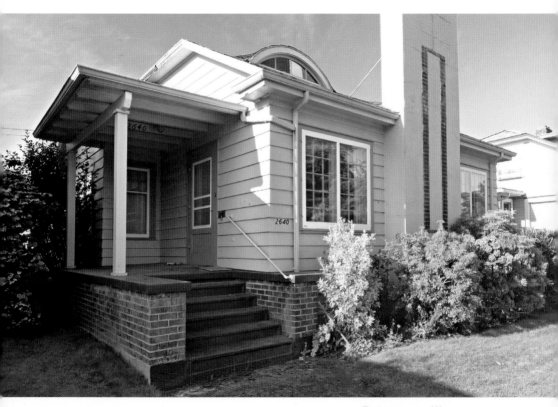

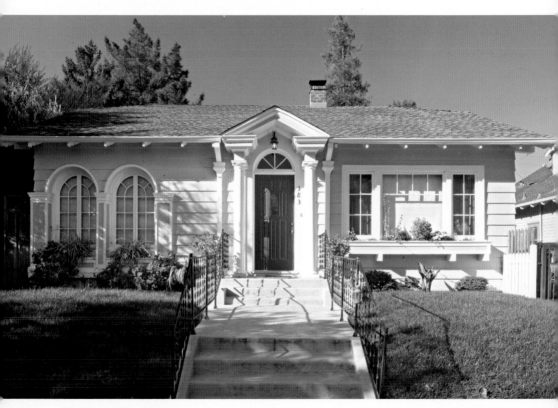

216 SAN JOSE, CALIFORNIA

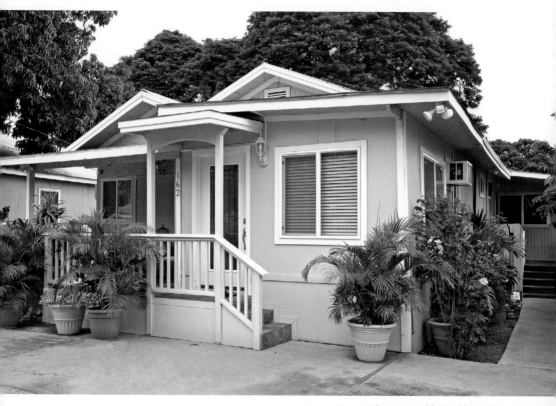

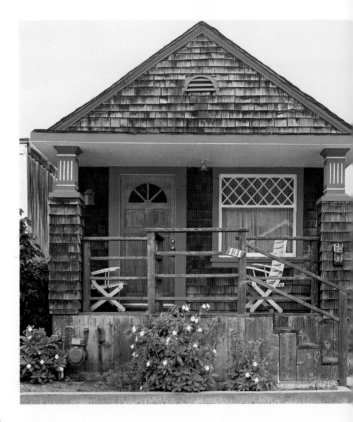

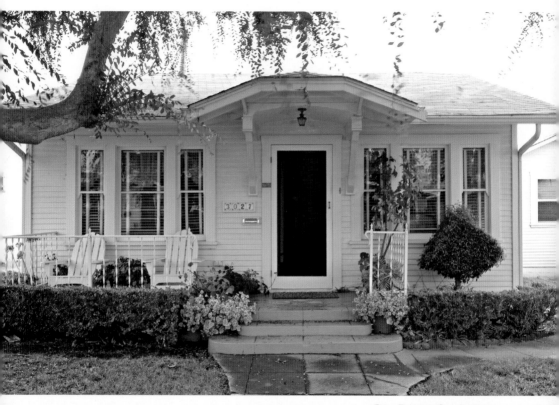

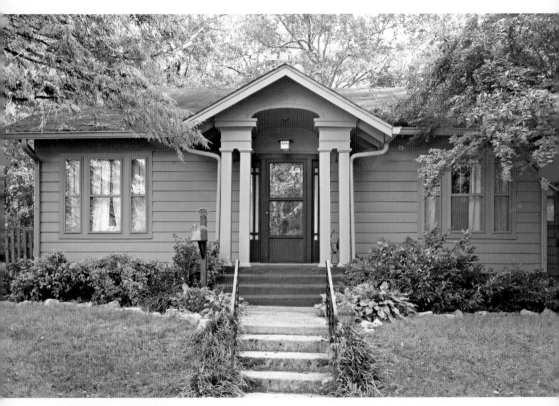

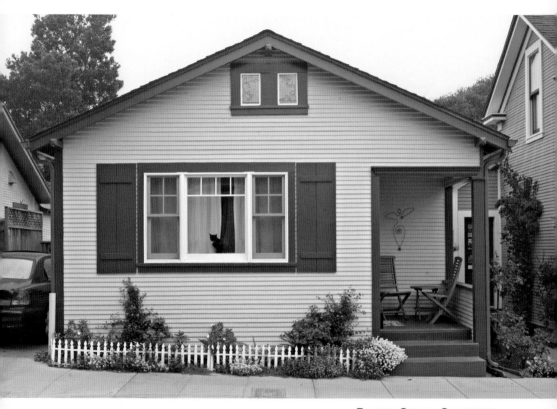

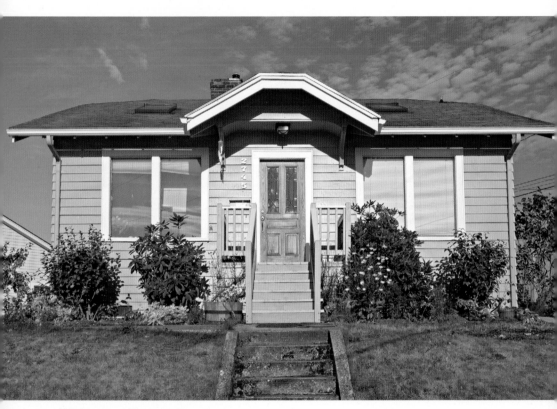

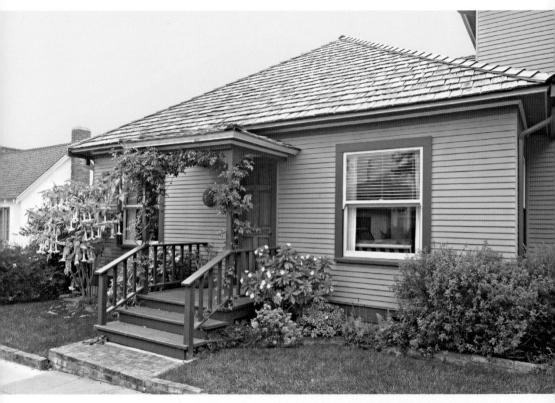

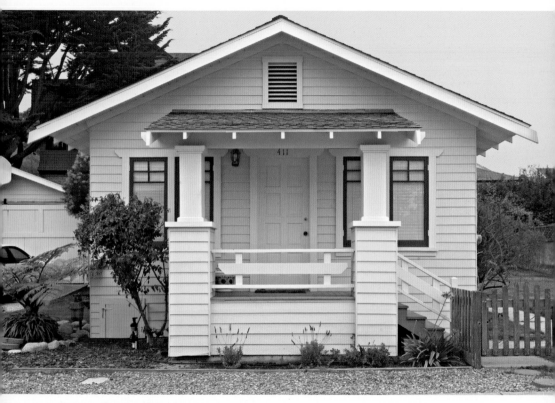

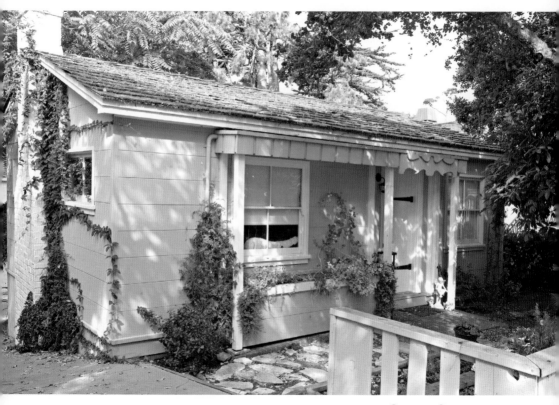

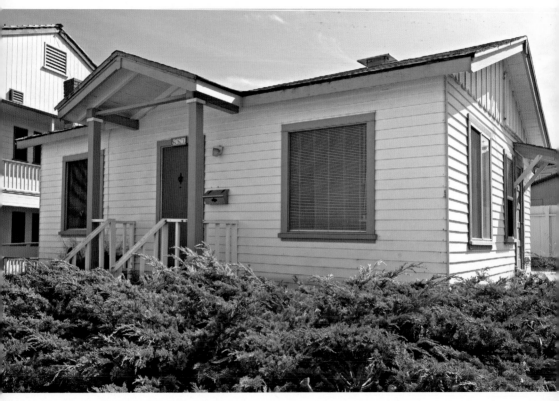

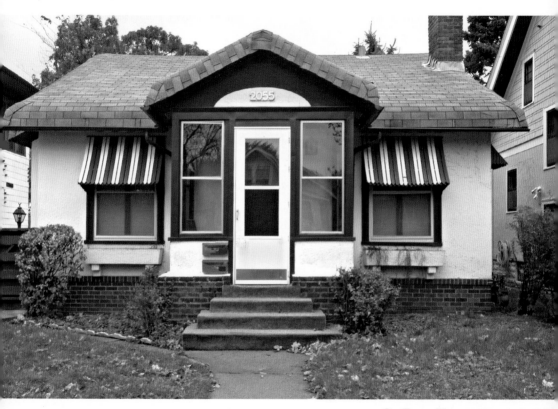

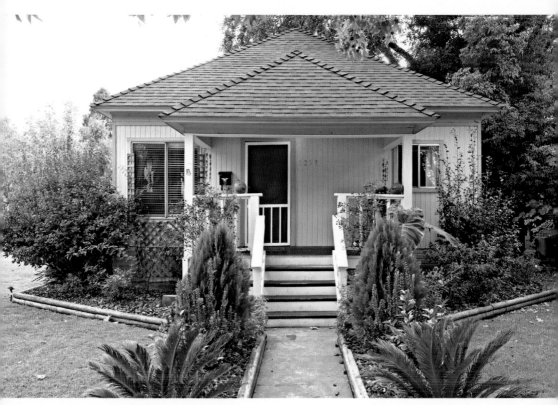

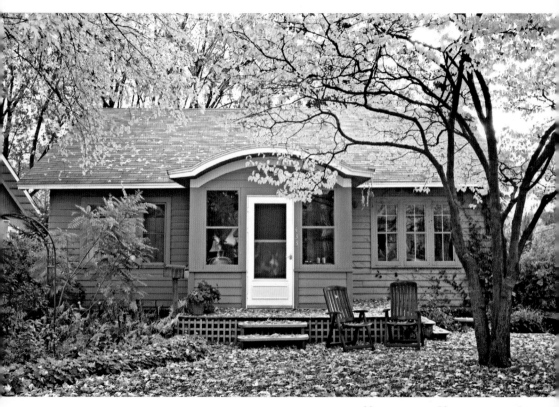

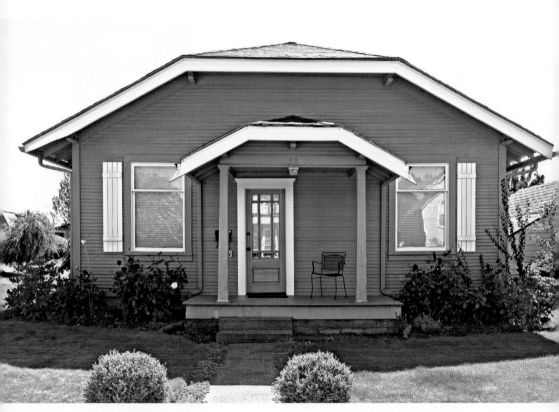

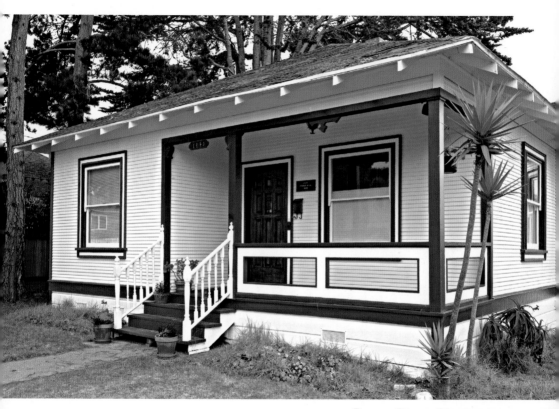

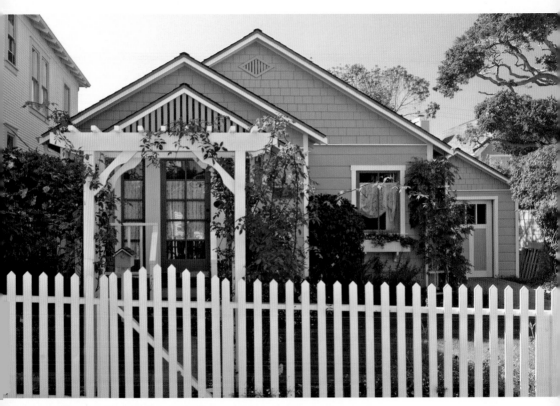

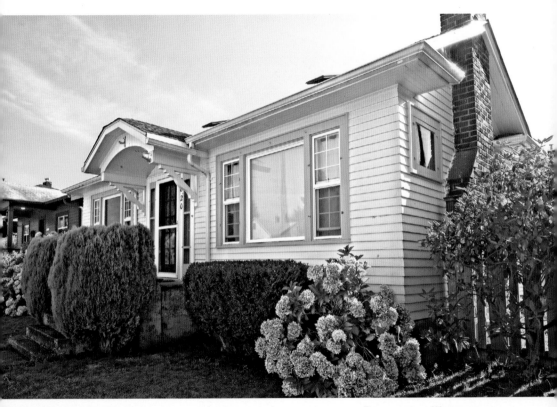

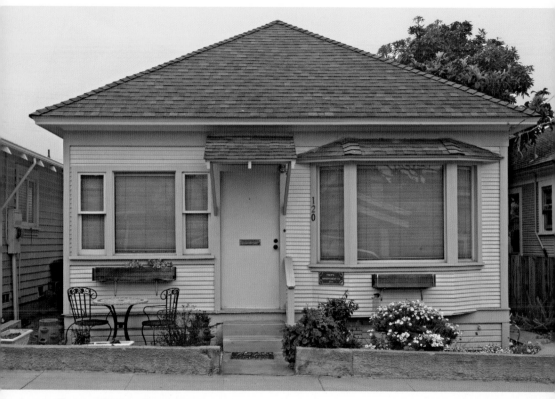

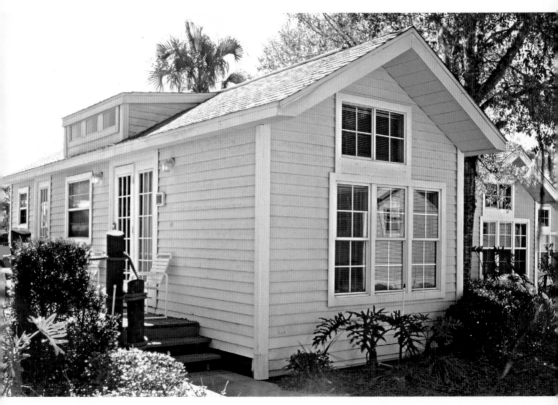

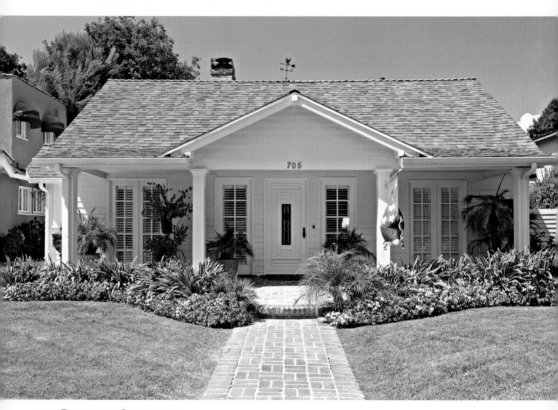

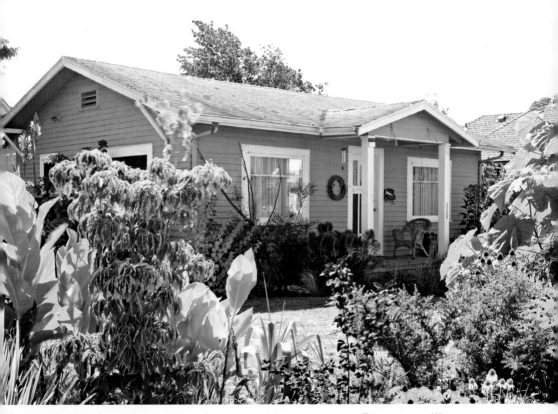

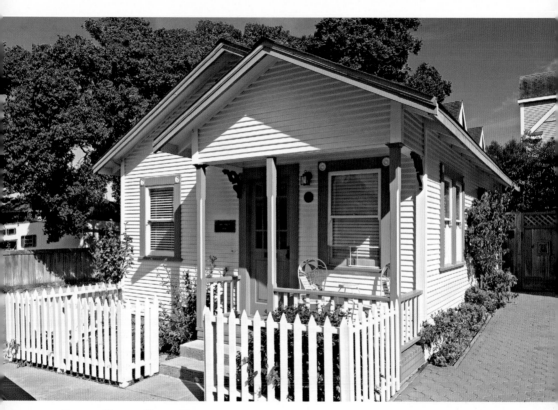

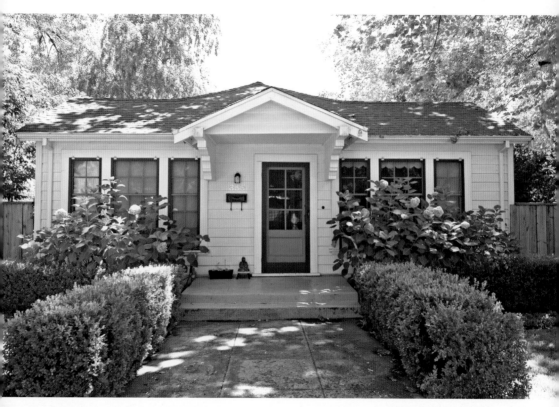

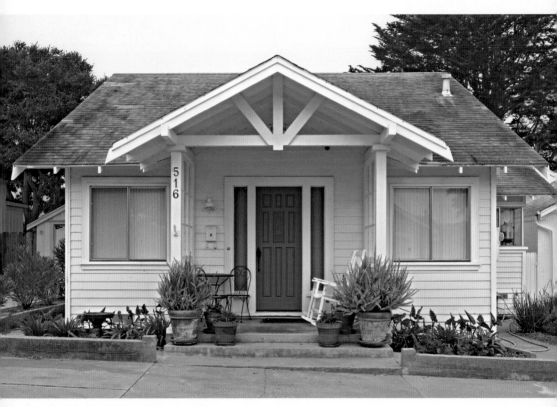

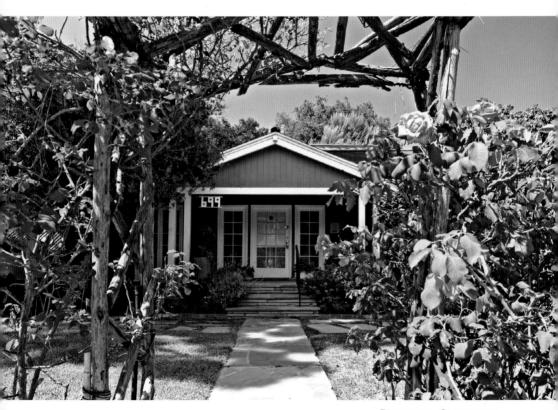

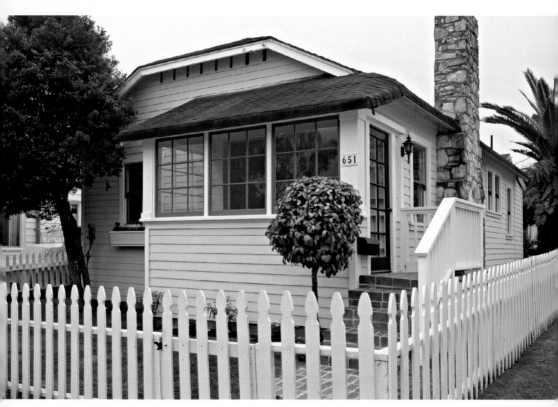

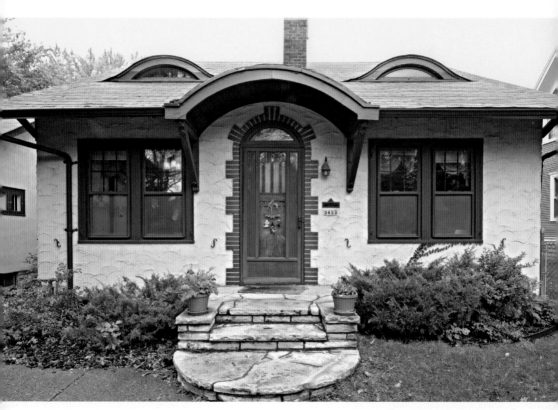

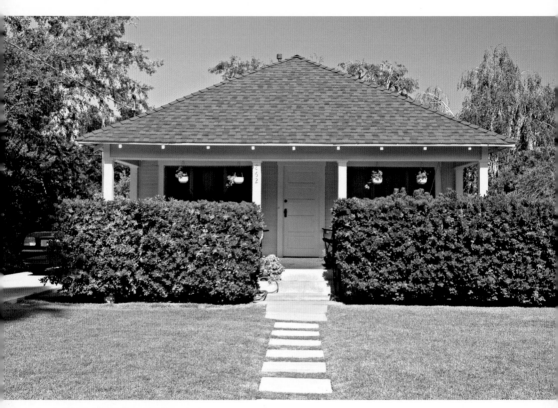

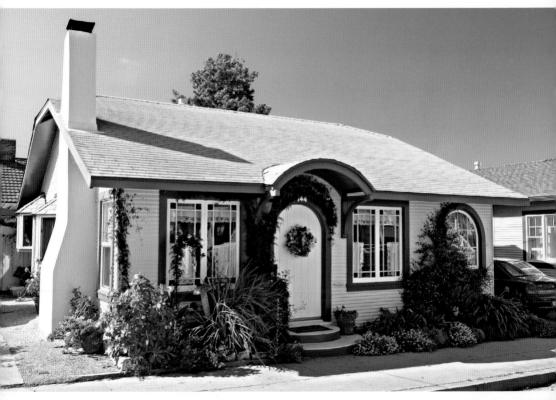

PERIOD REVIVAL COTTAGES

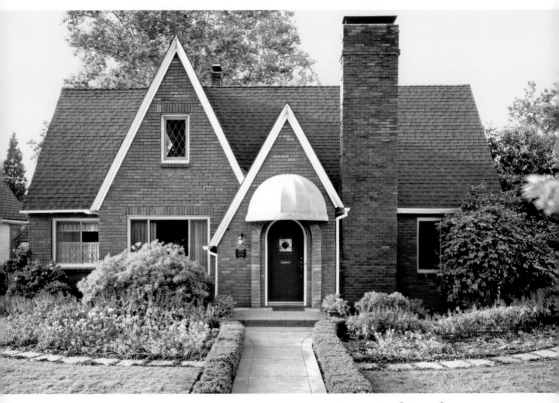

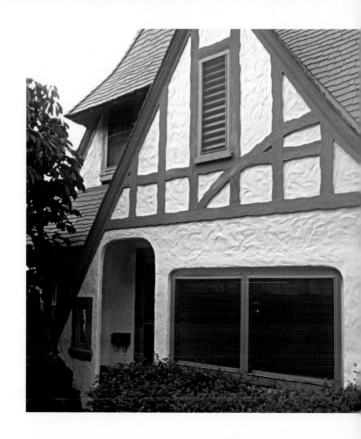

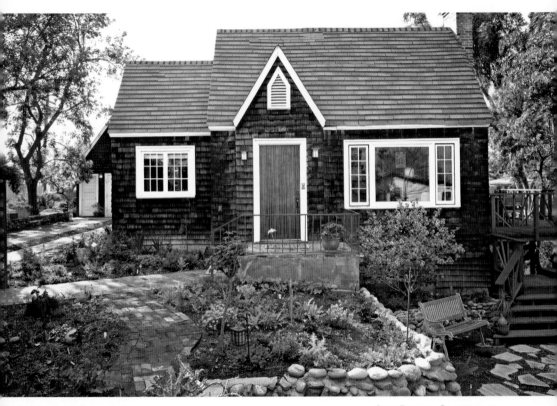

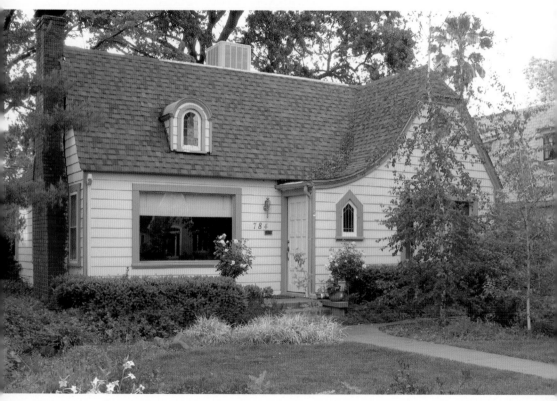

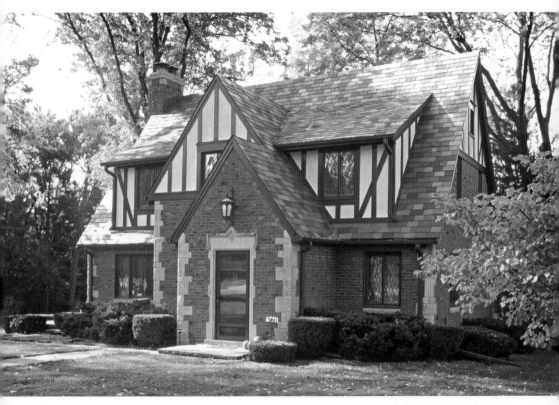

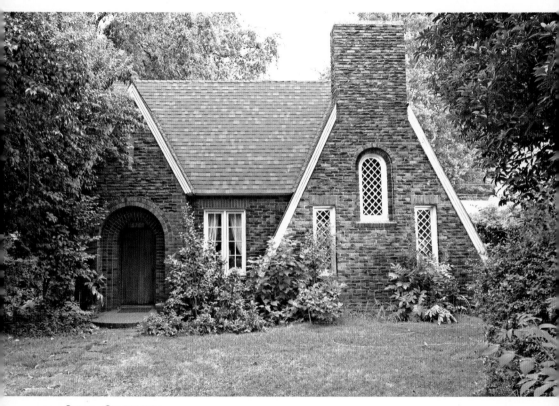

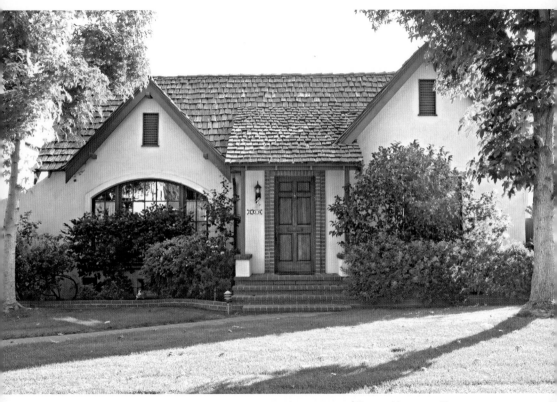

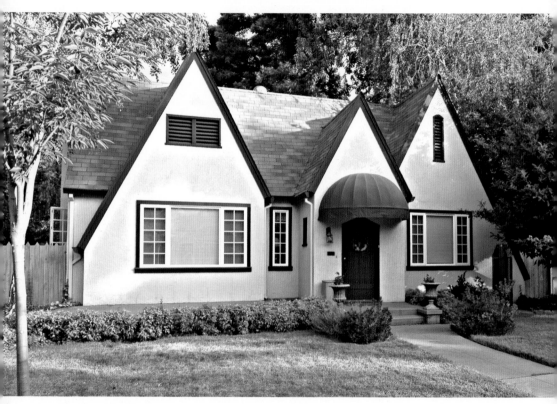

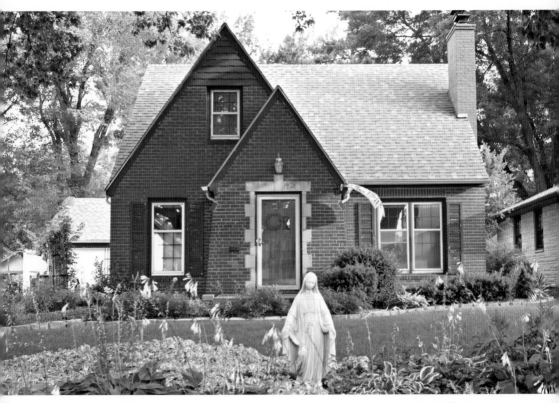

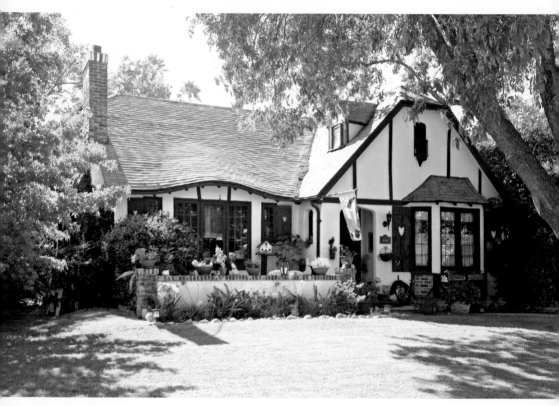

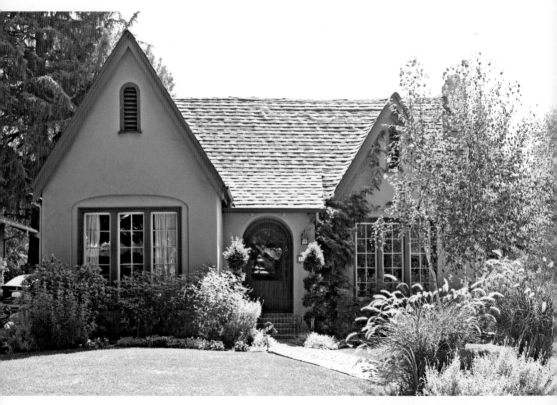

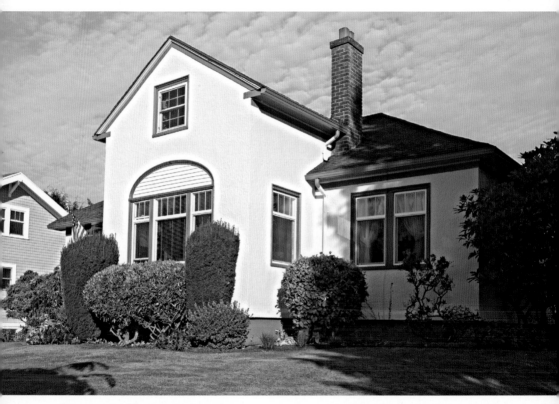

258 BELLINGHAM, WASHINGTON

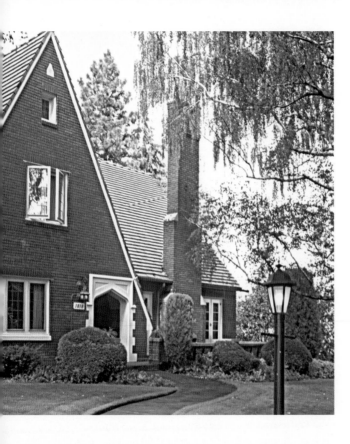

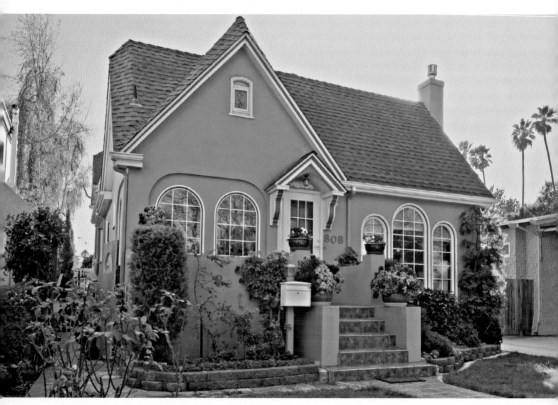

ALAMEDA, CALIFORNIA

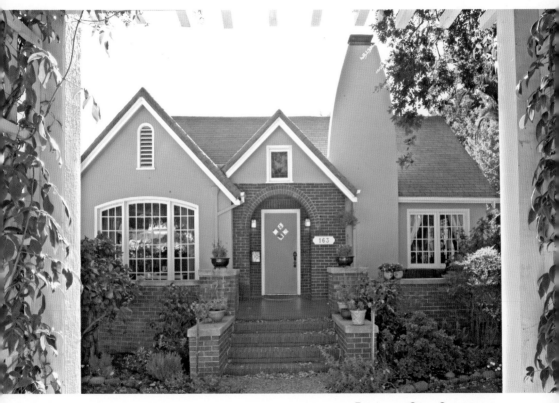

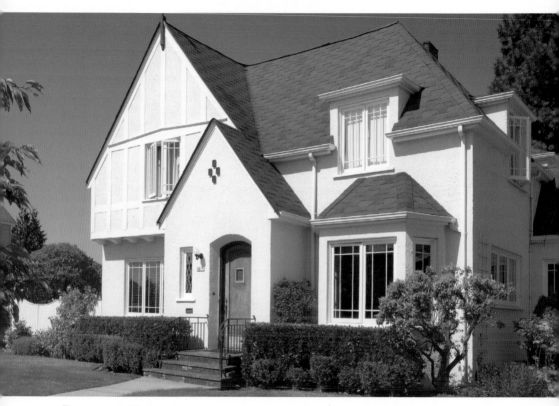

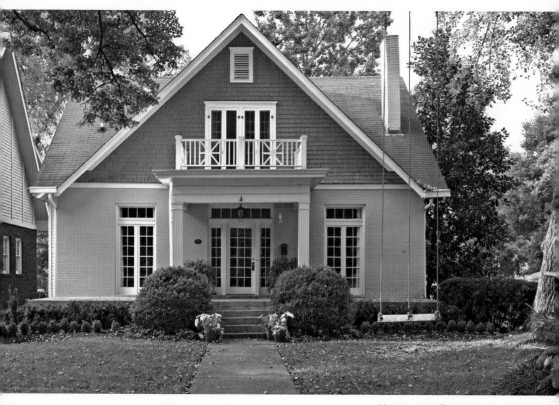

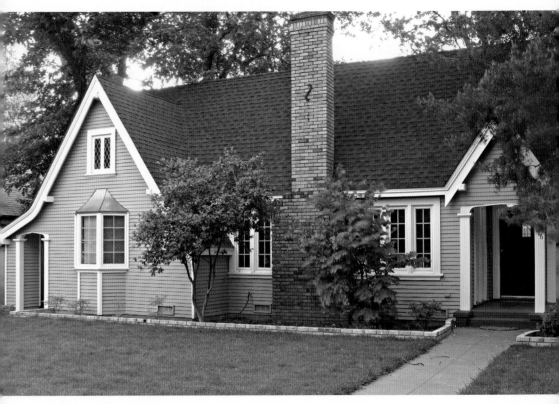

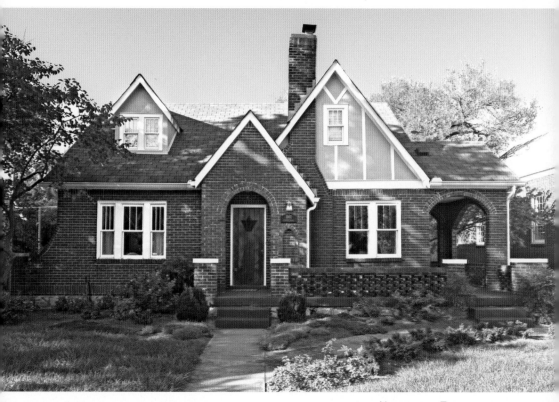

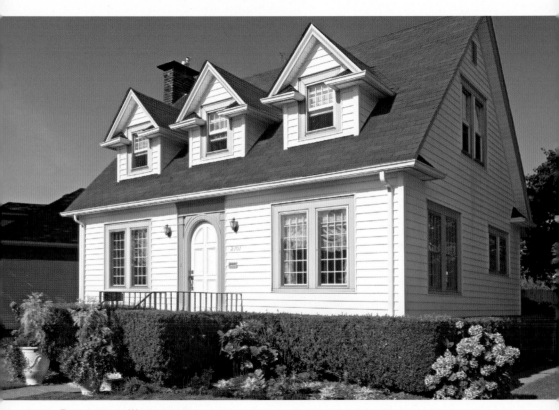

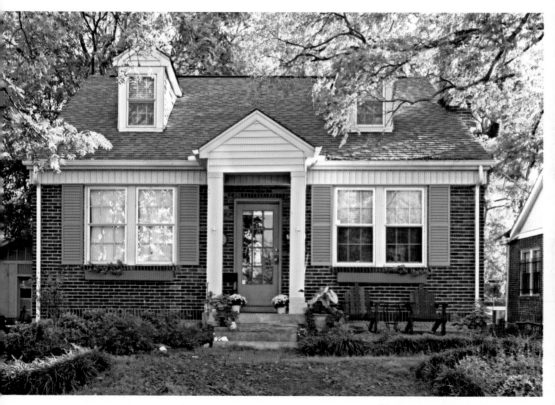

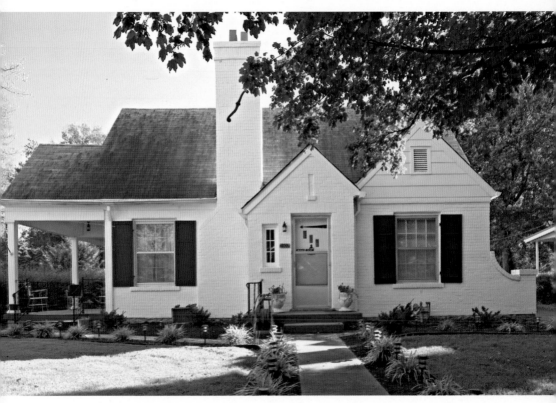

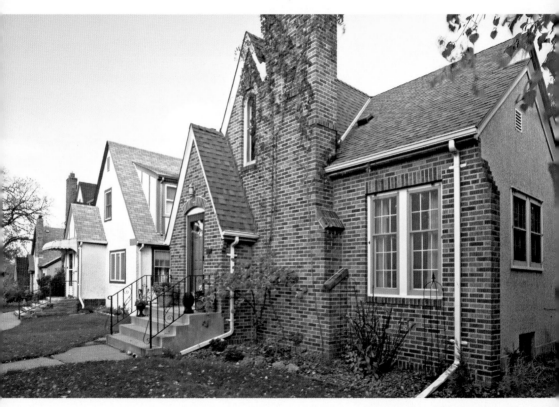

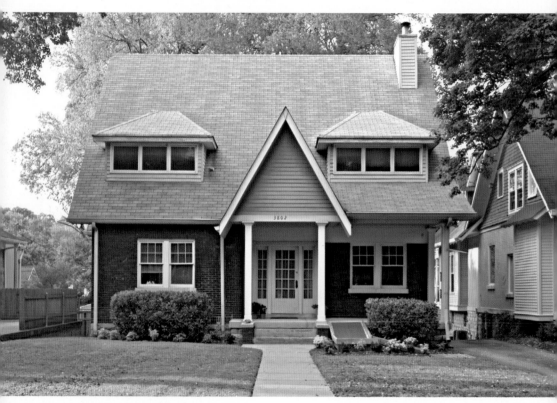

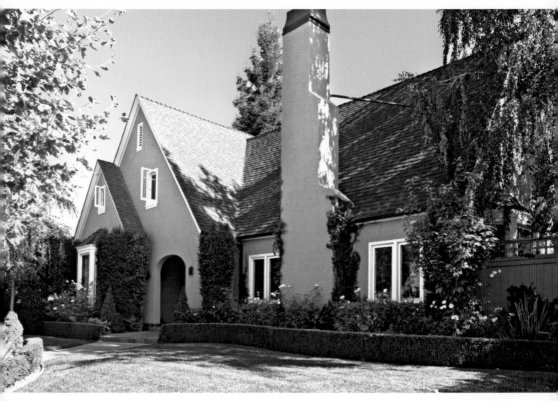

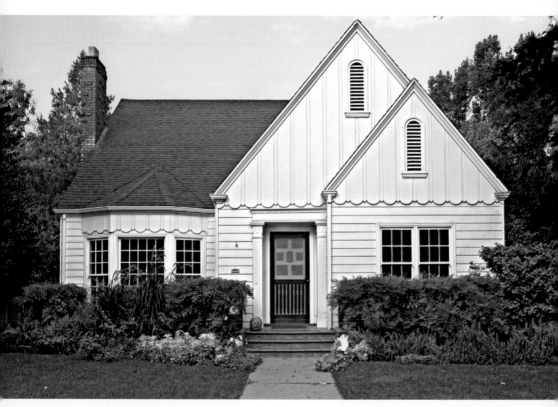

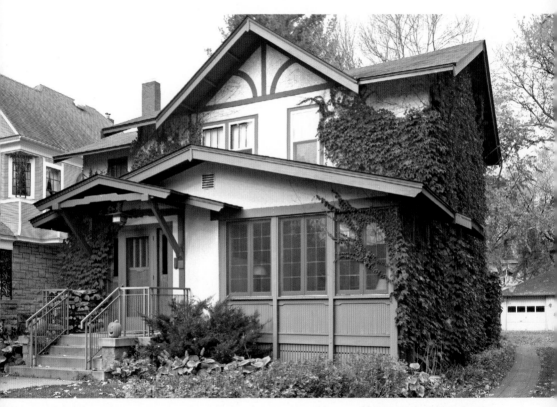

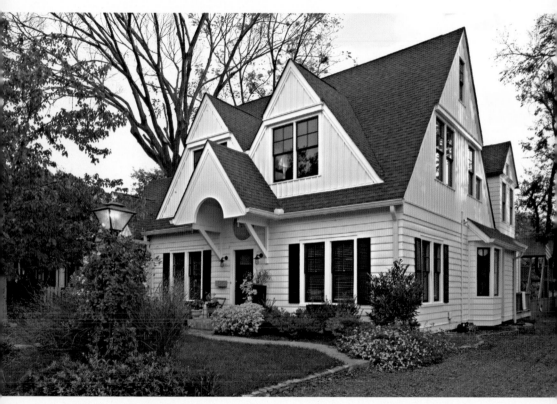

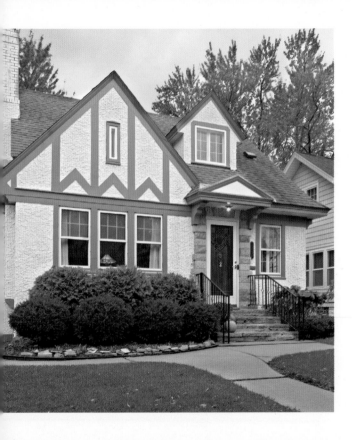

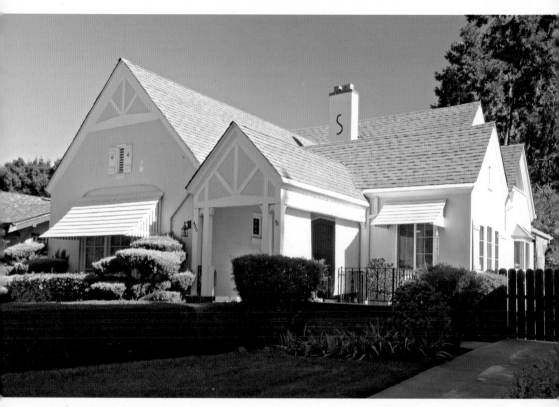

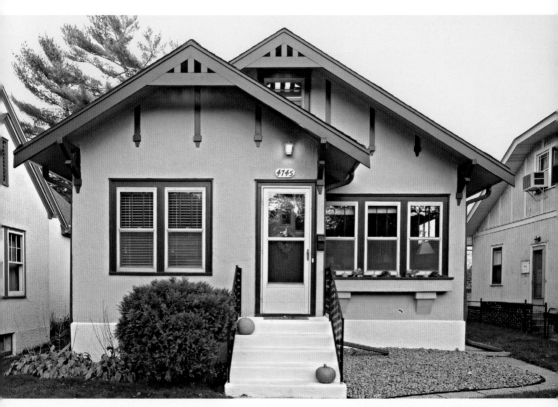

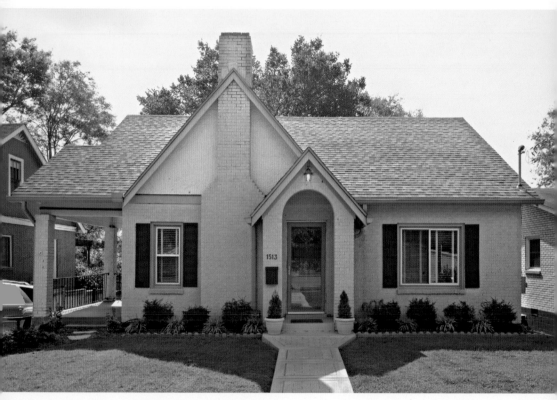

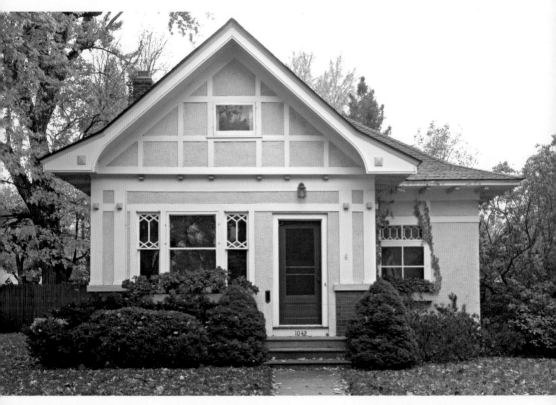

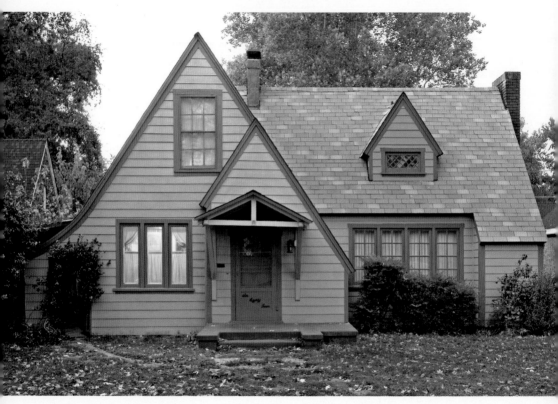

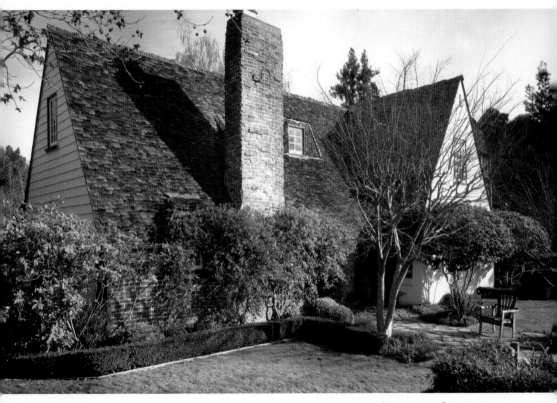

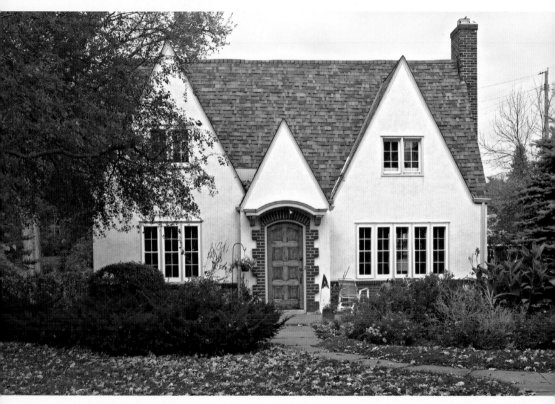

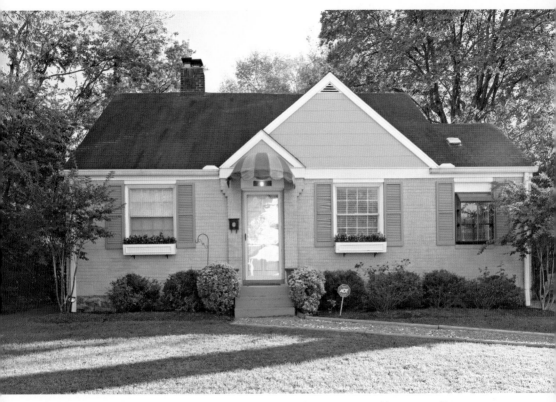

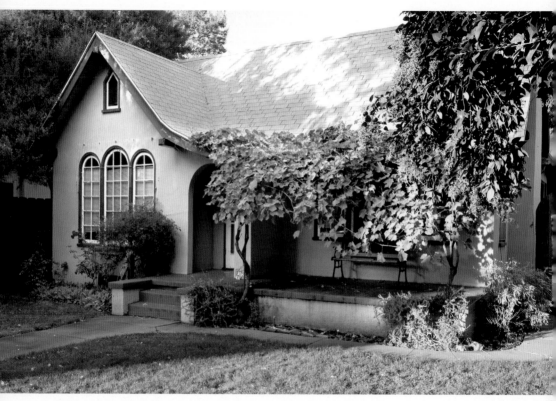

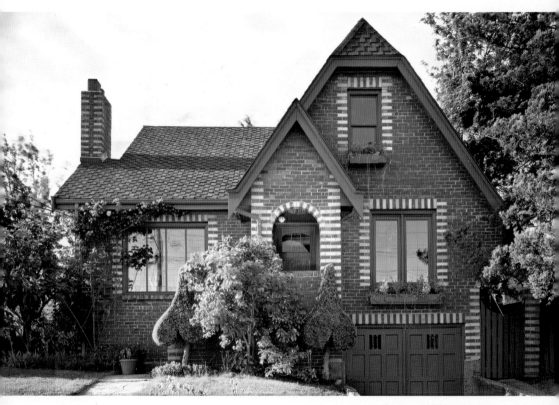

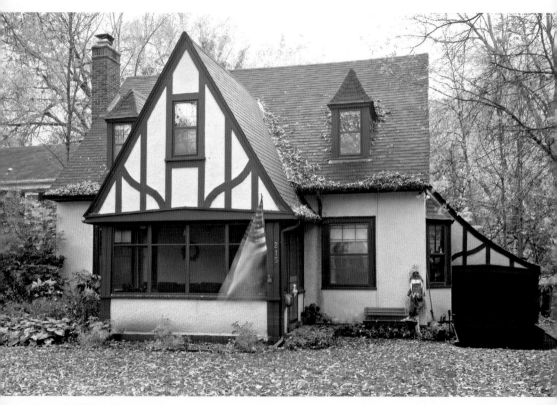

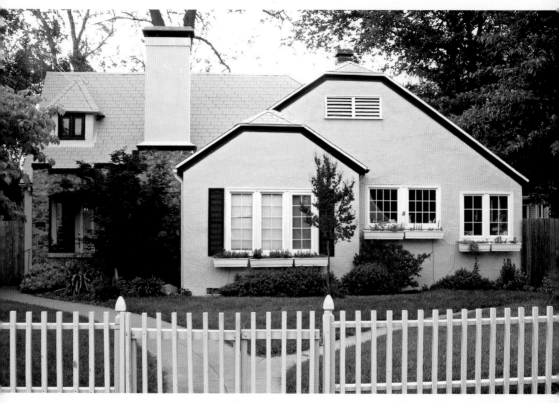

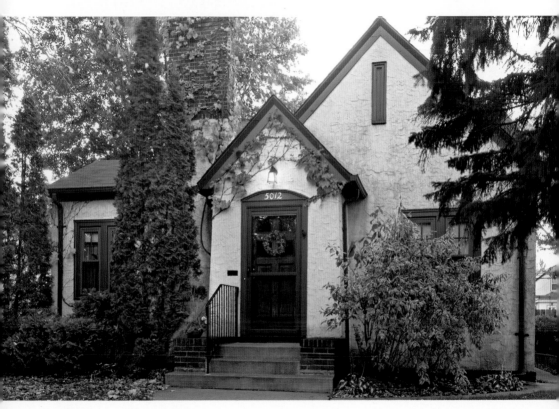

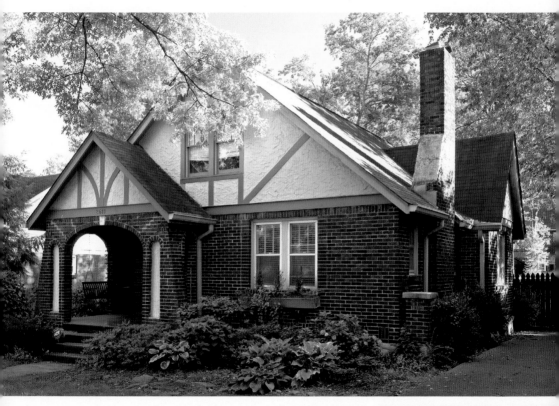

VICTORIAN COTTAGES

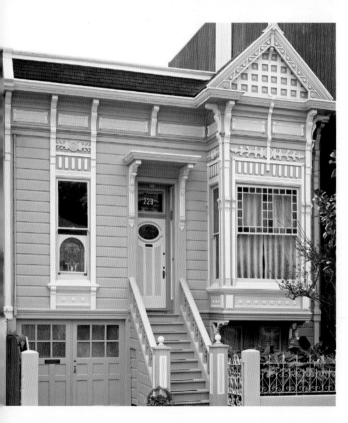

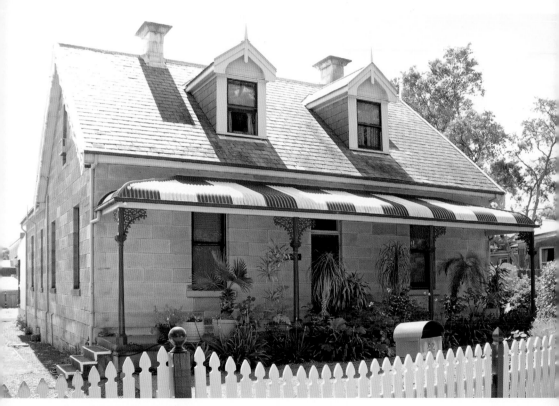

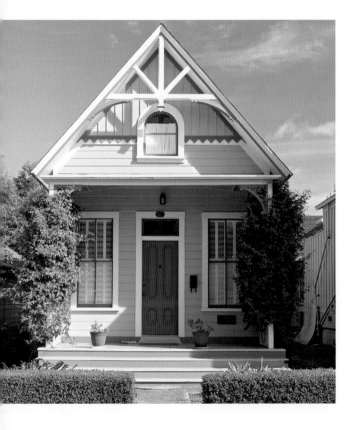

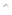

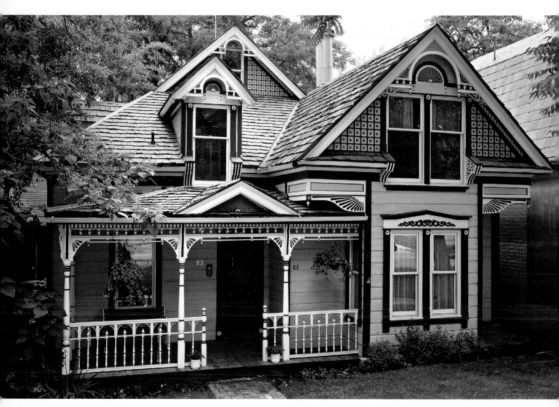

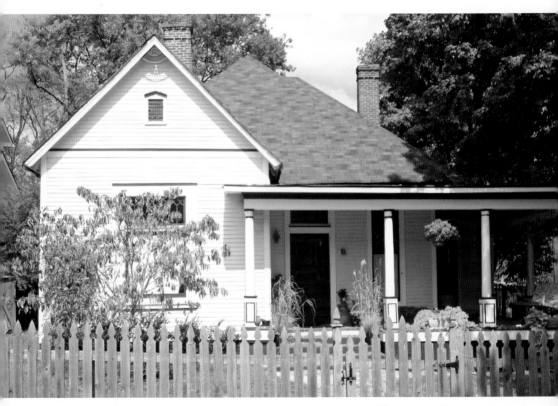

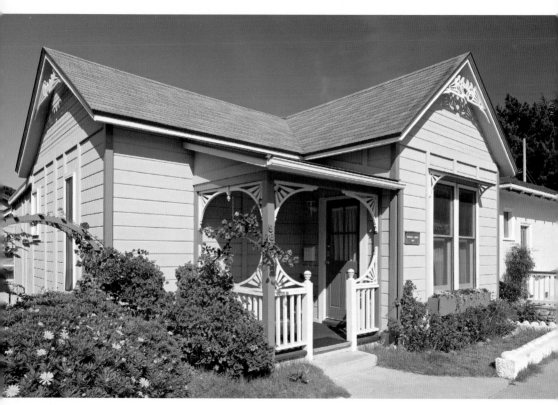

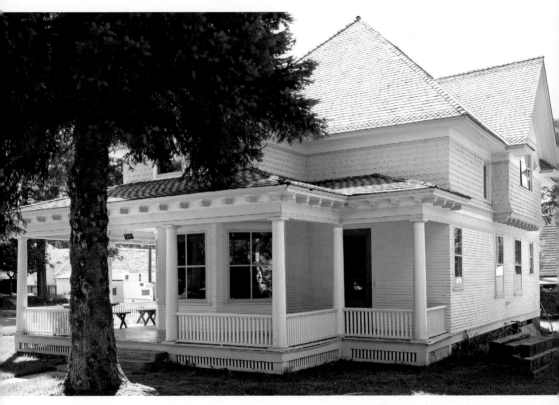

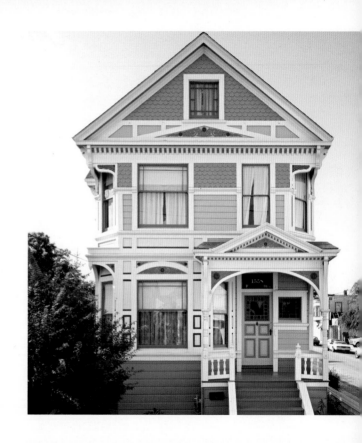

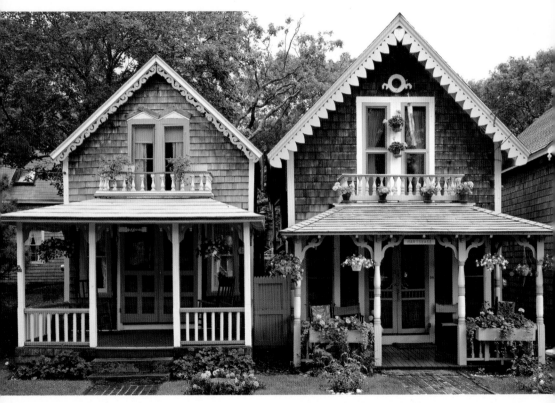

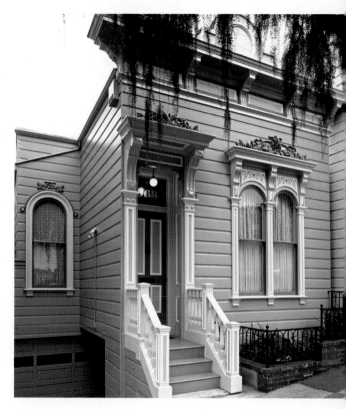

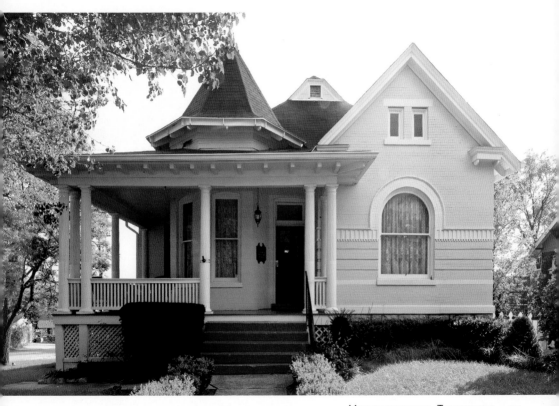

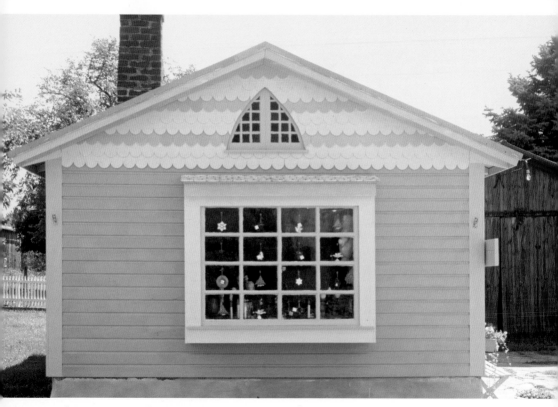

302 SHARTLESVILLE, PENNSYLVANIA

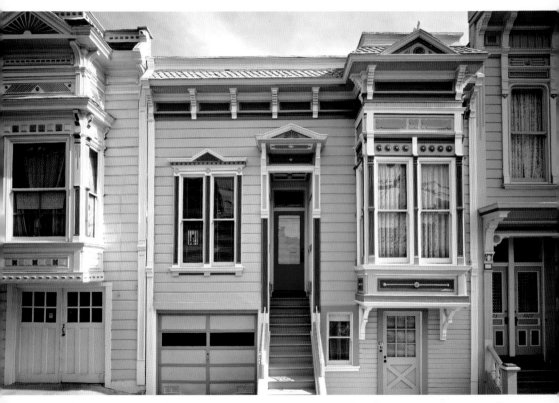

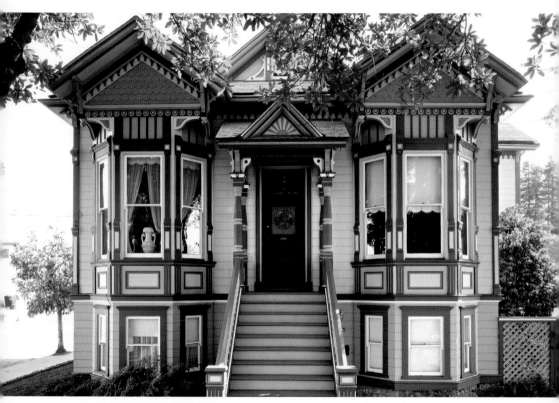

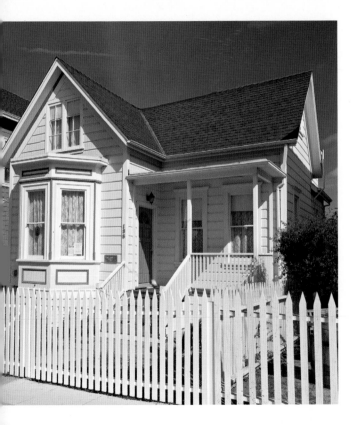

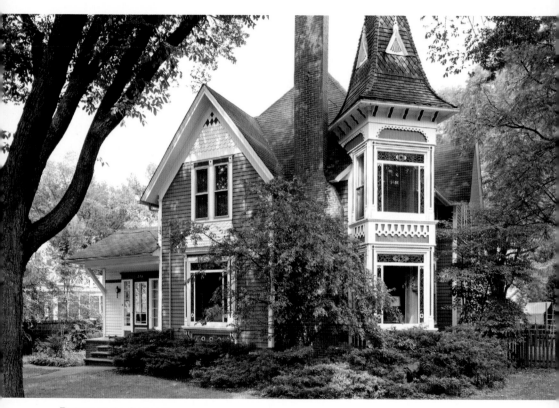

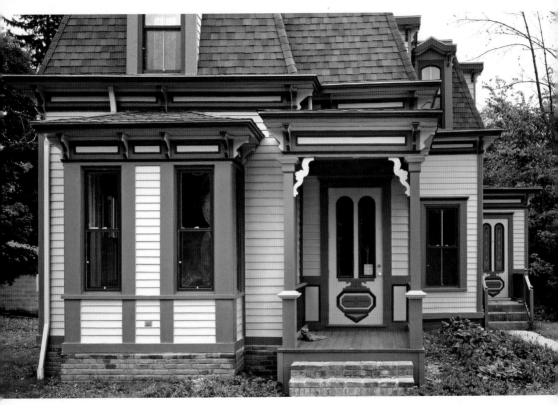

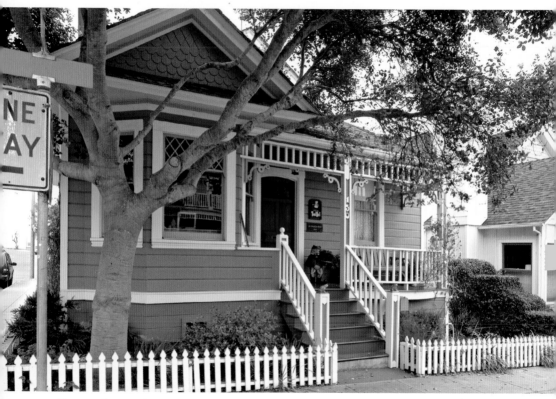

308 PACIFIC GROVE, CALIFORNIA

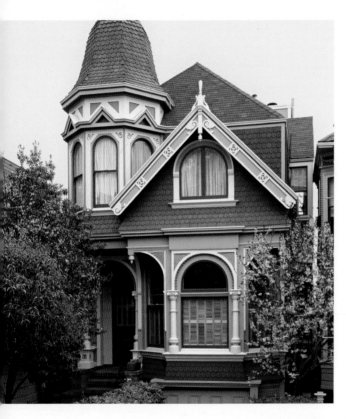

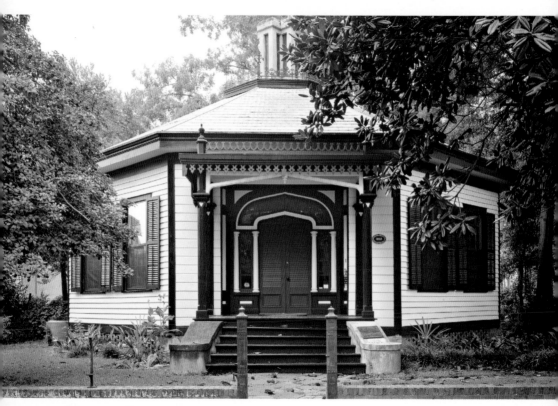

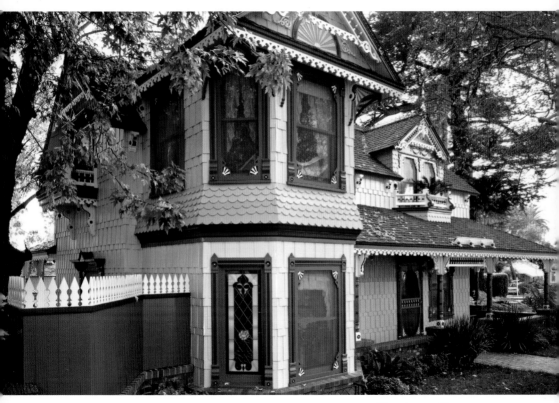

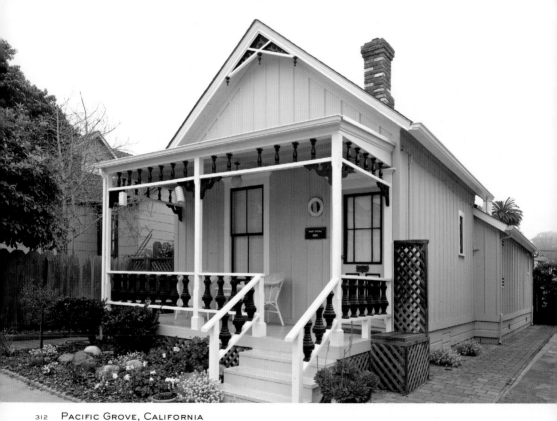

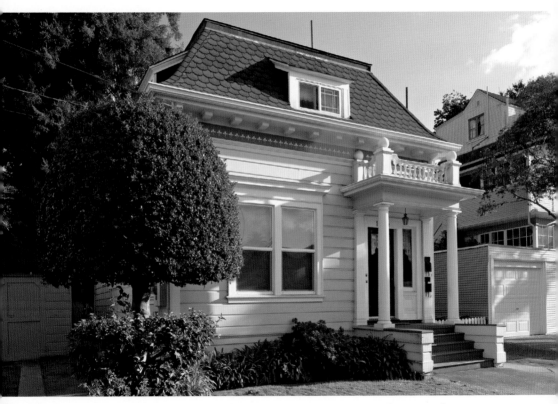

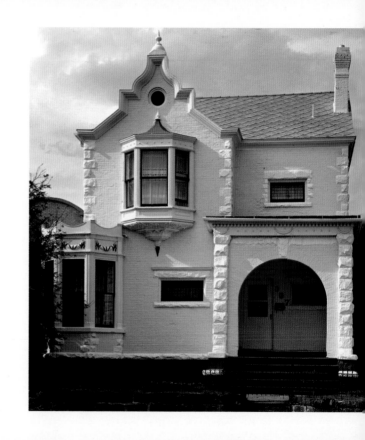

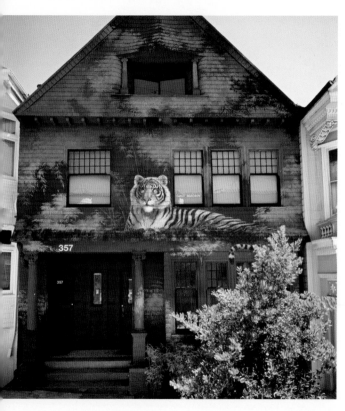

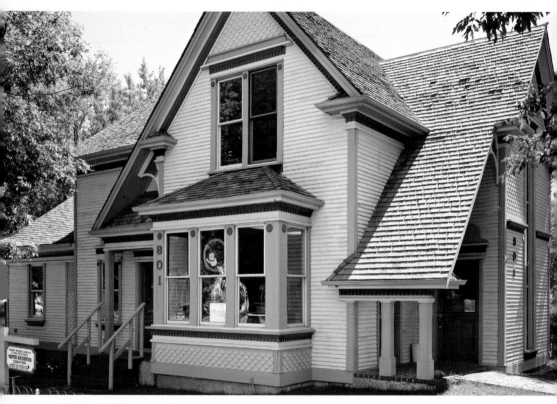

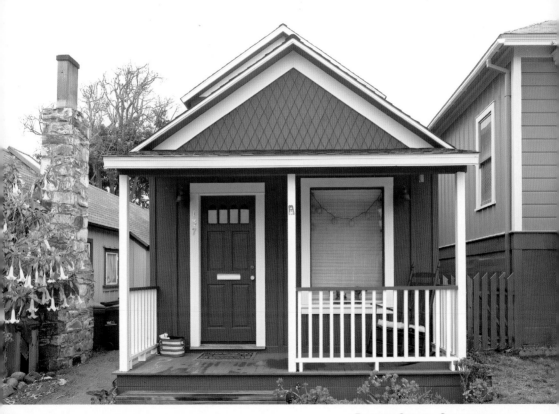

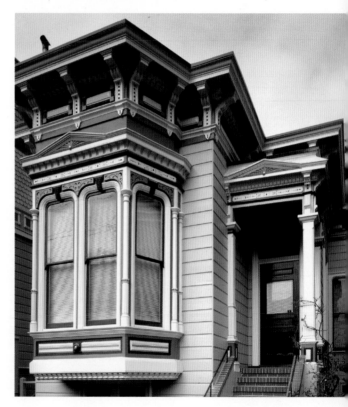

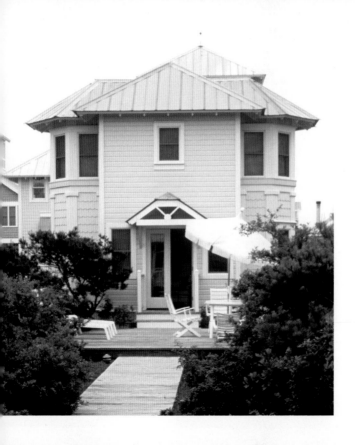

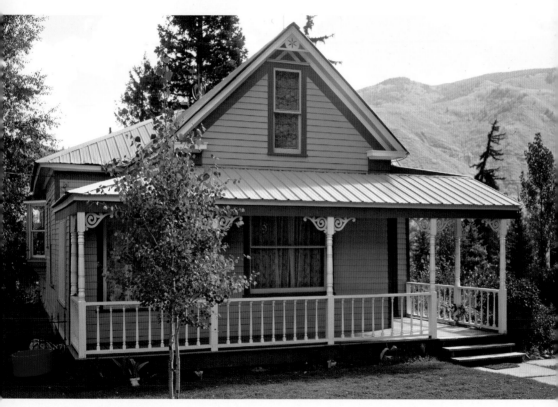

320 ASPEN, COLORADO

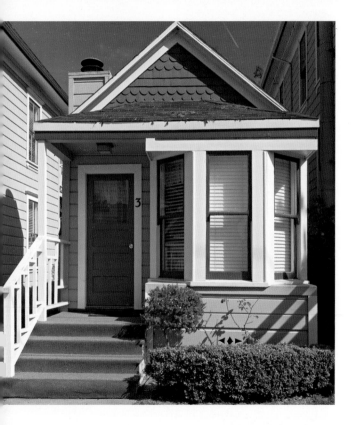

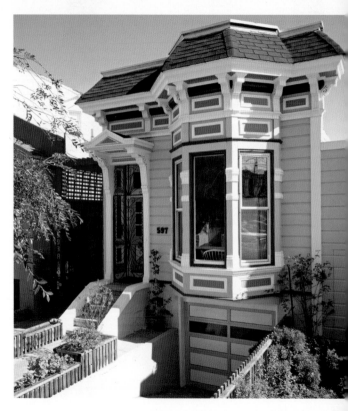

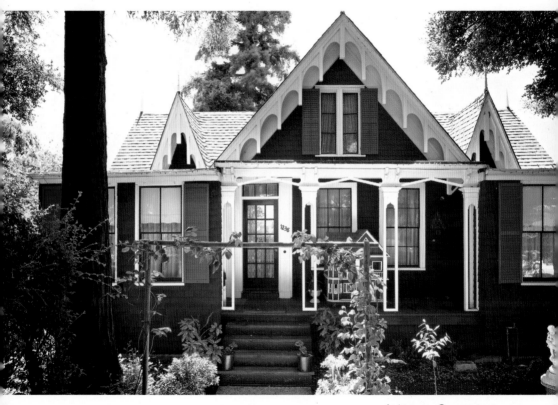

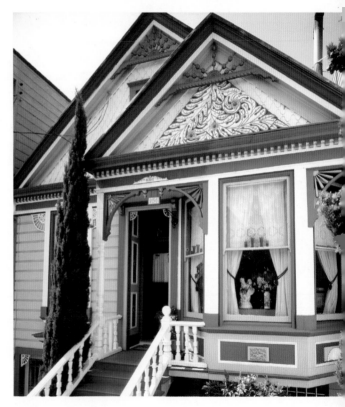

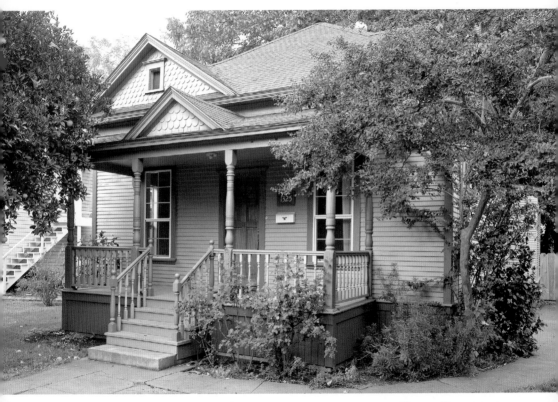

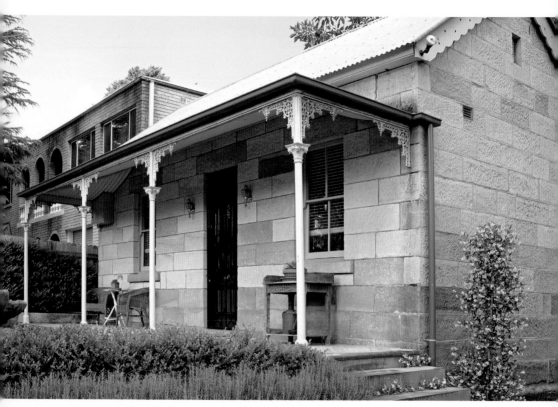

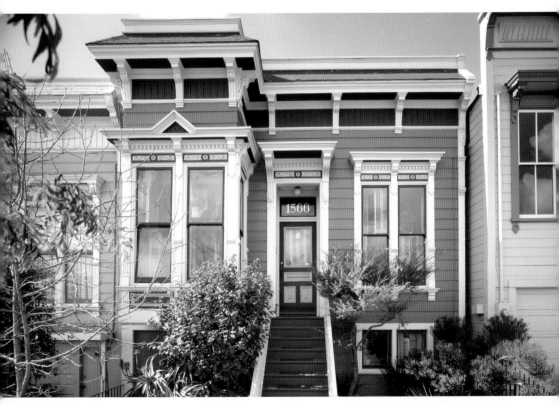

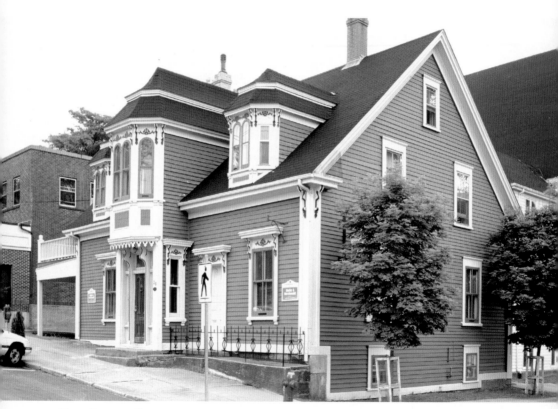

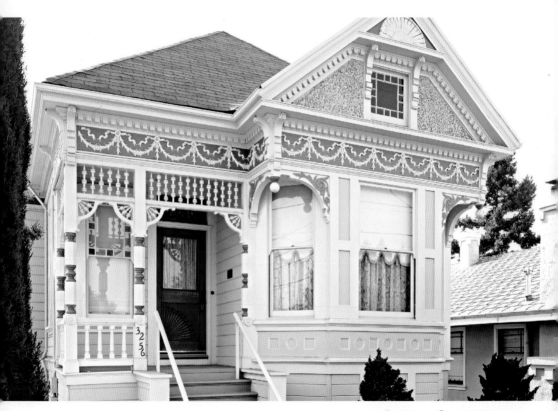

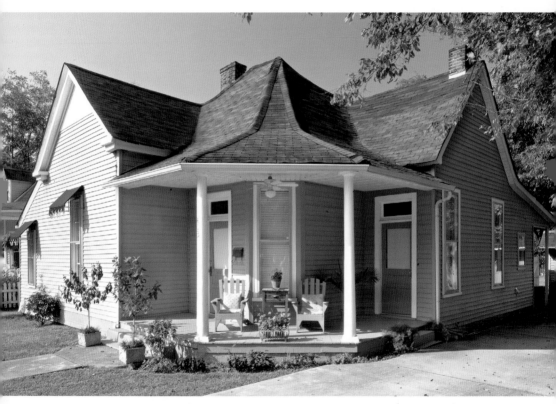

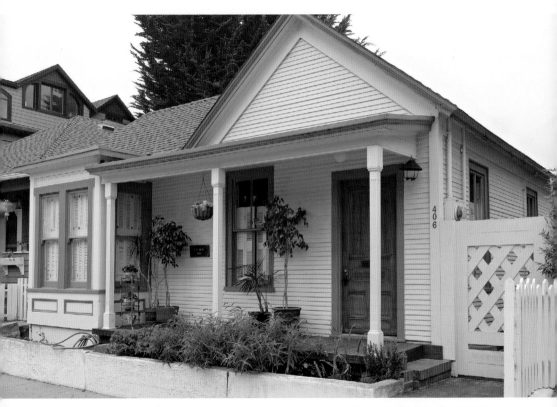

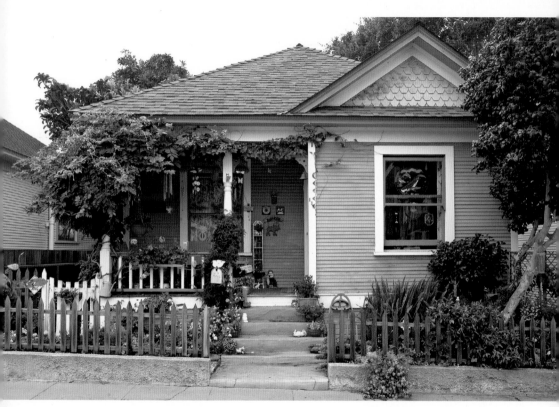

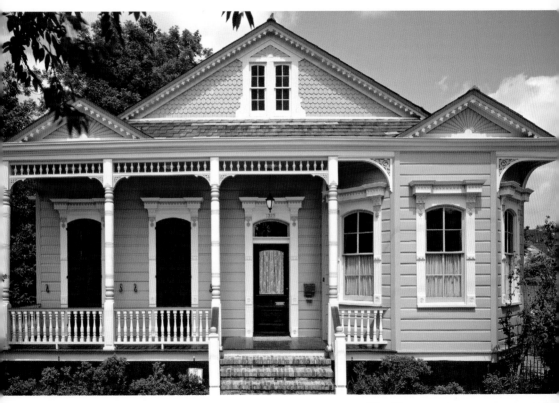

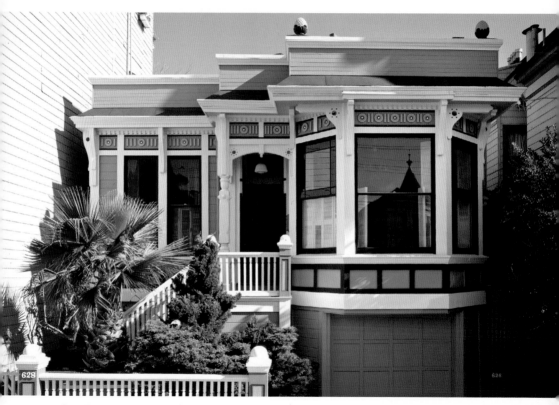

334　San Francisco, California

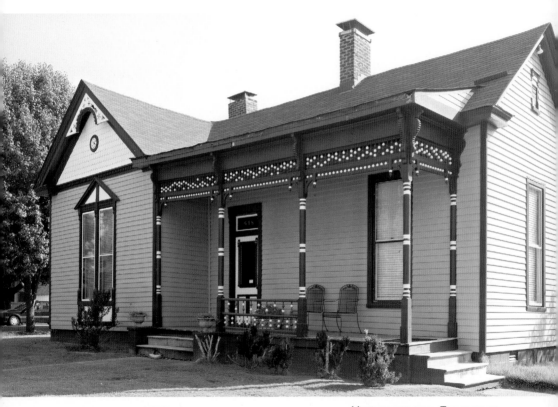

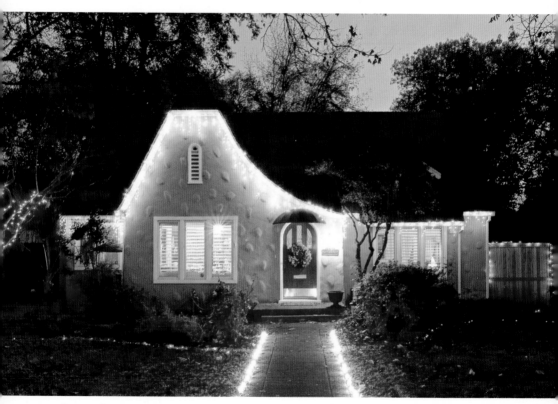

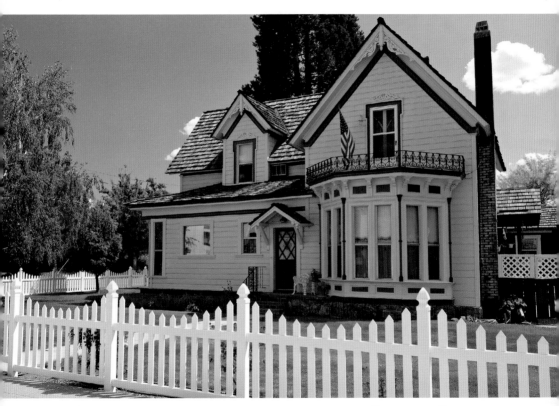

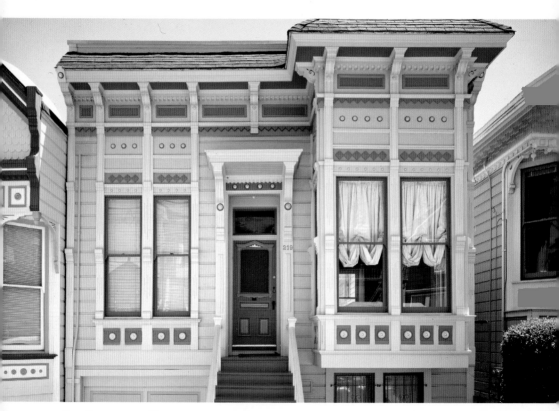

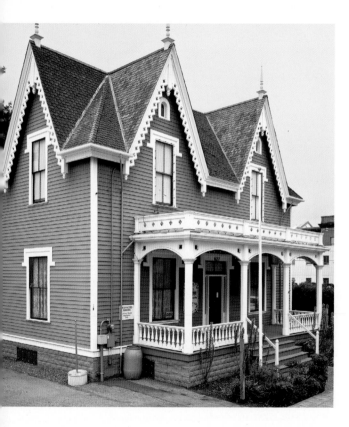

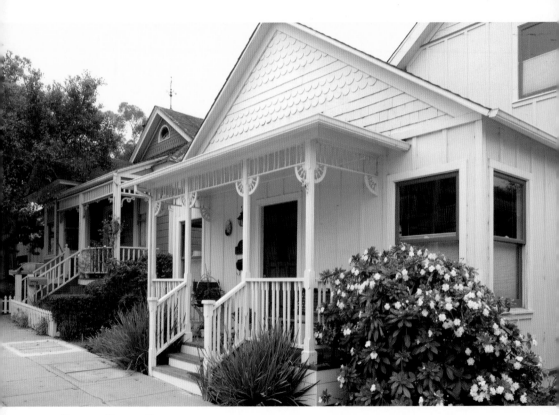

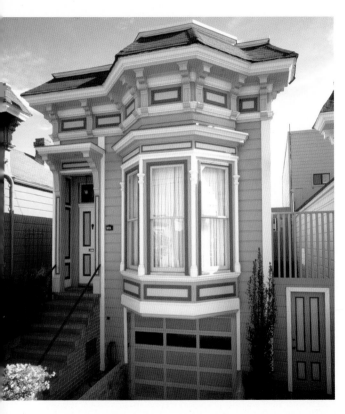

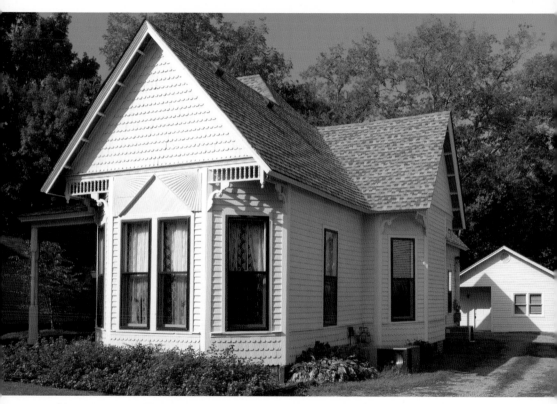

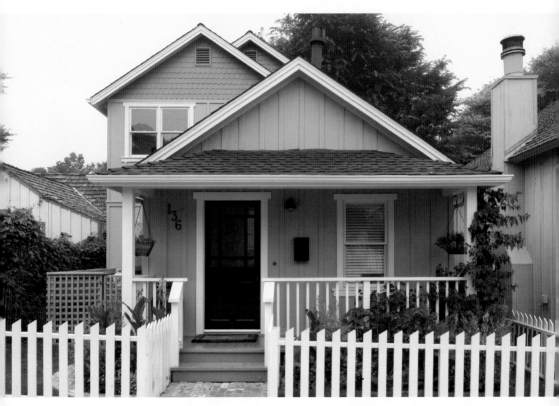

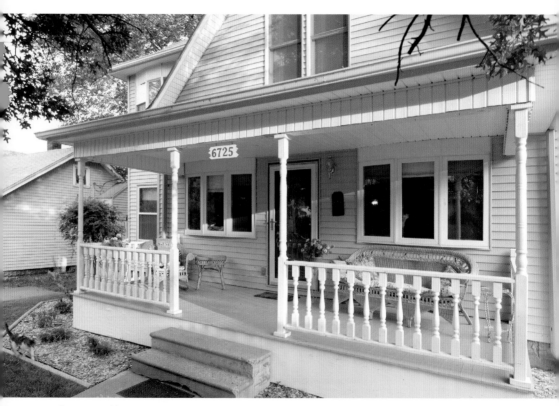

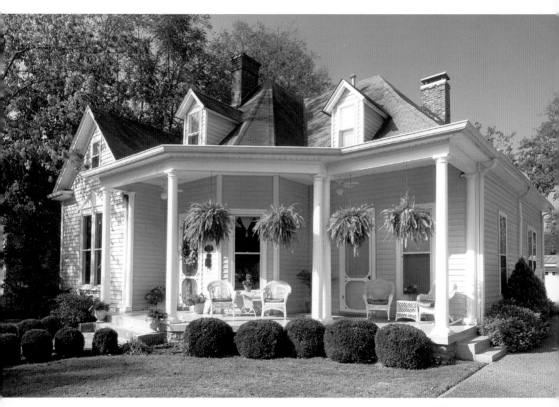

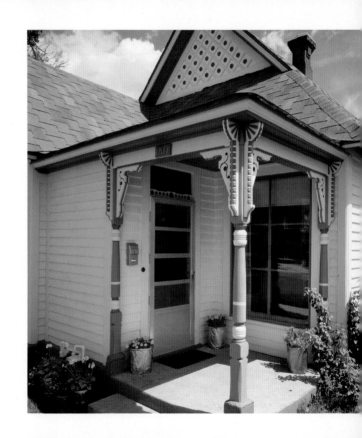

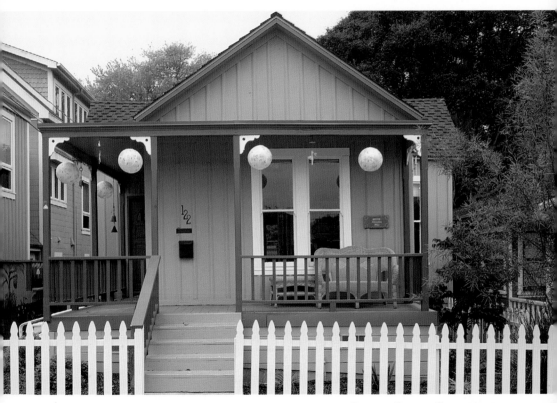

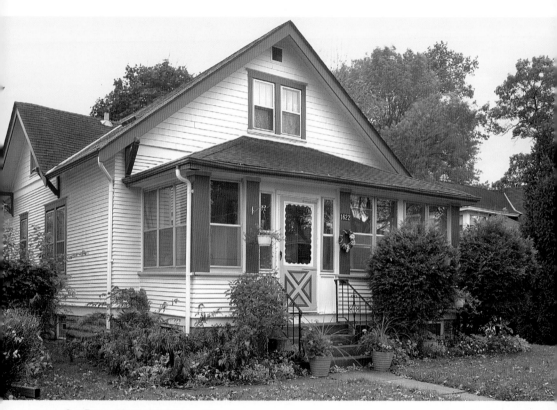

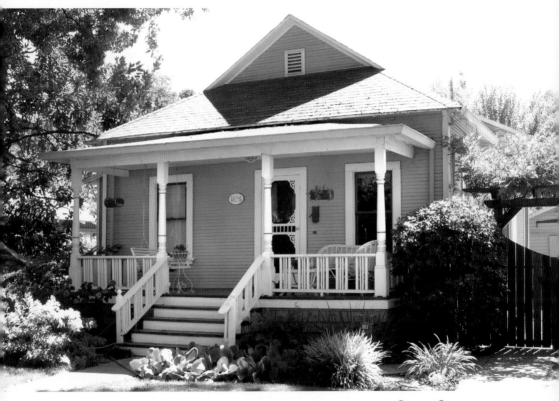

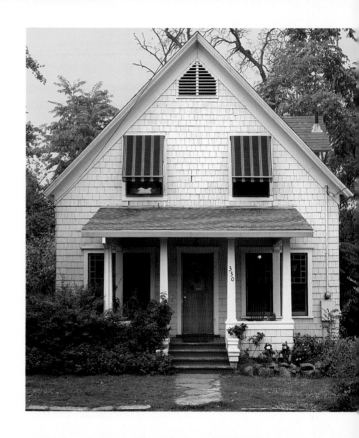

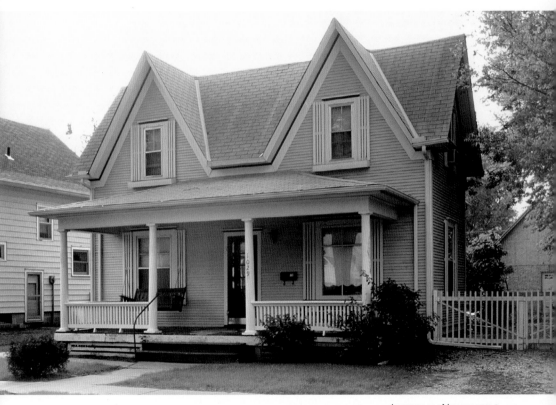

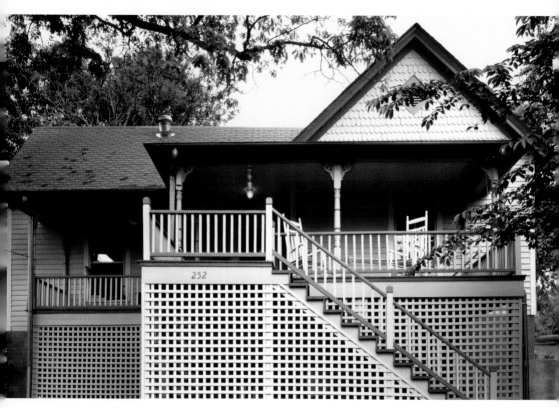

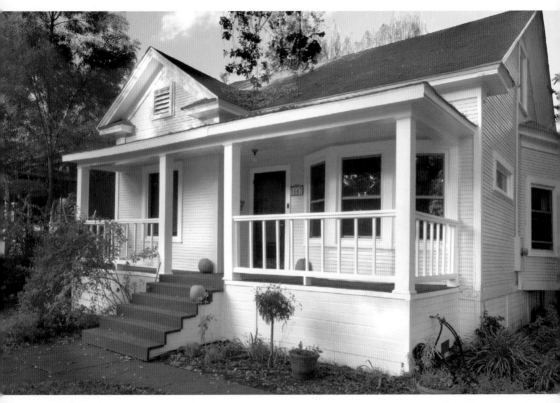

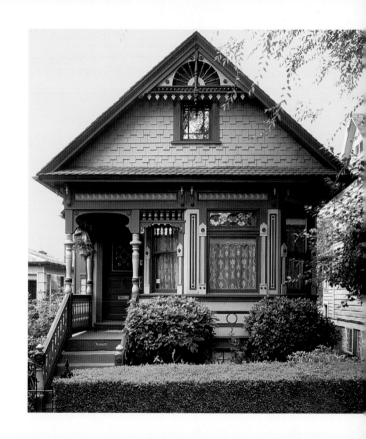

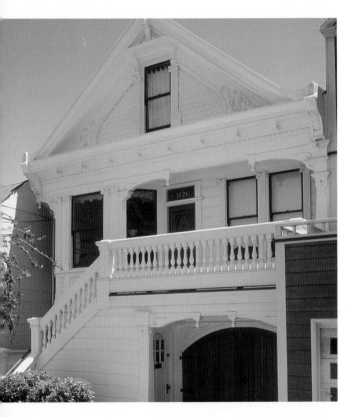

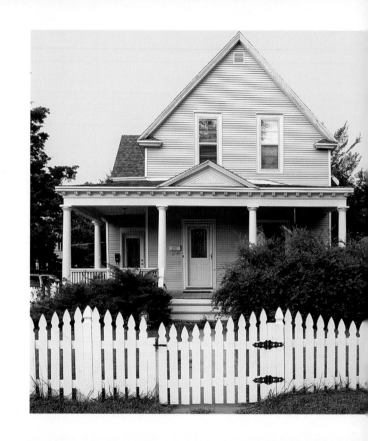

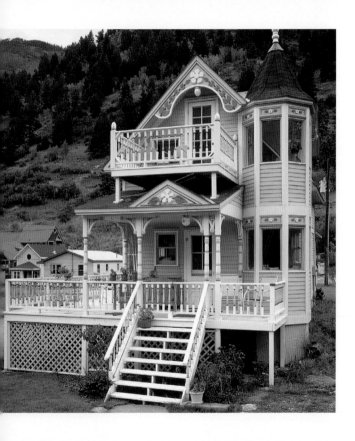

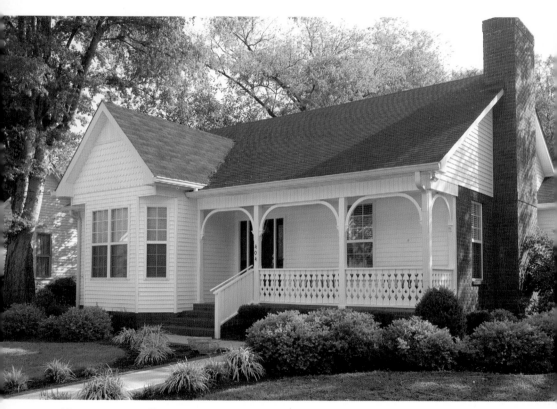

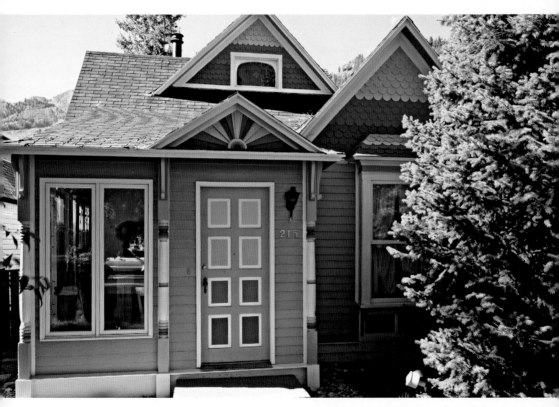

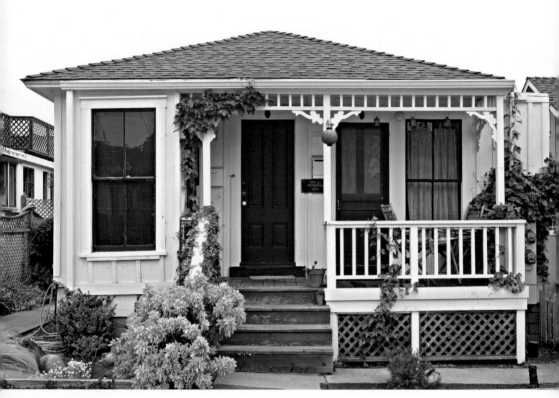

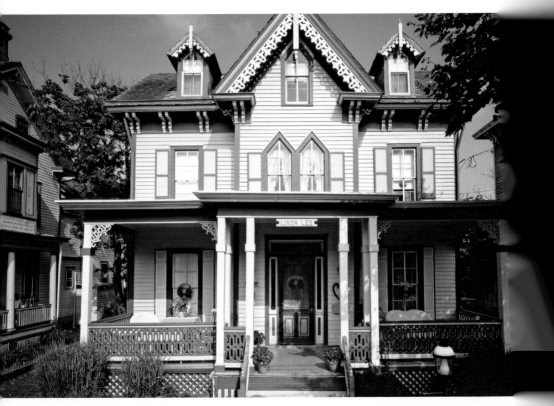

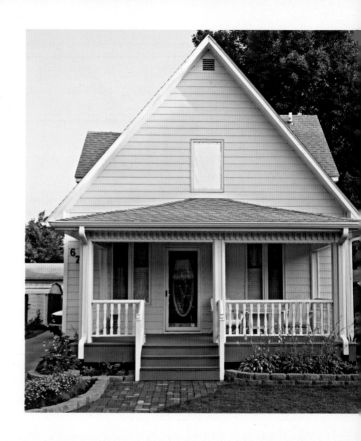

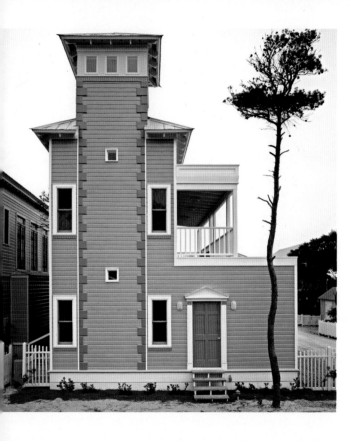

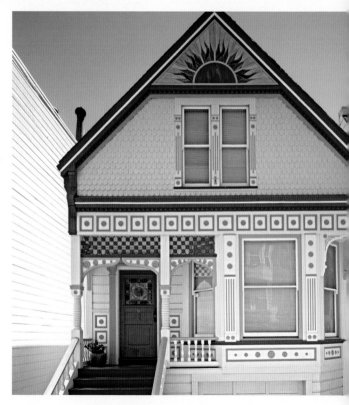

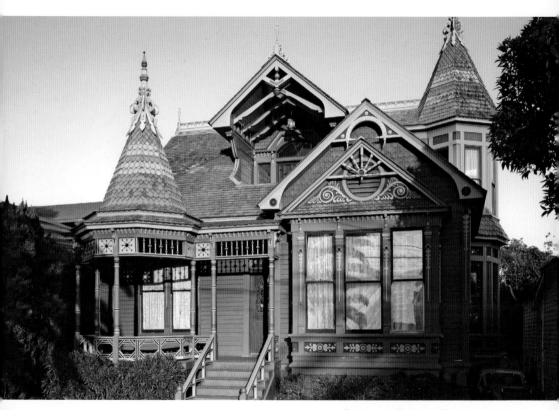

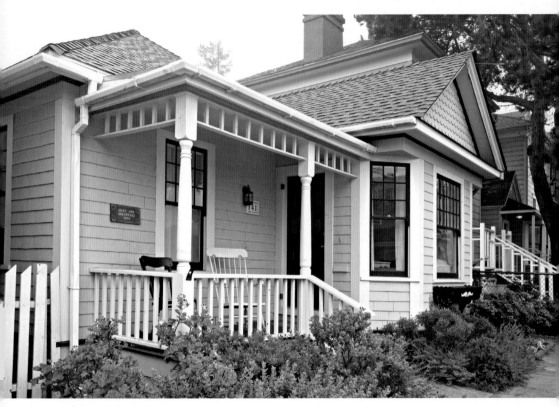

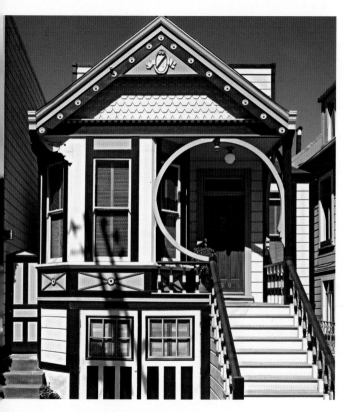

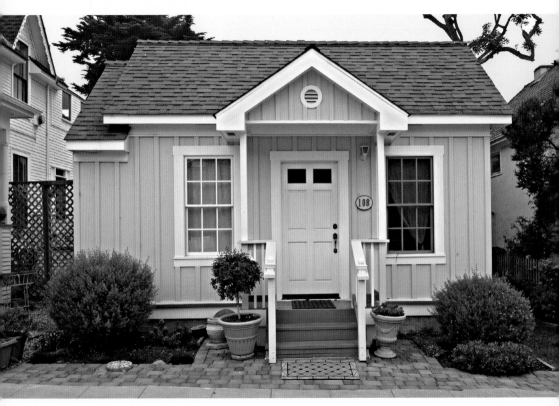

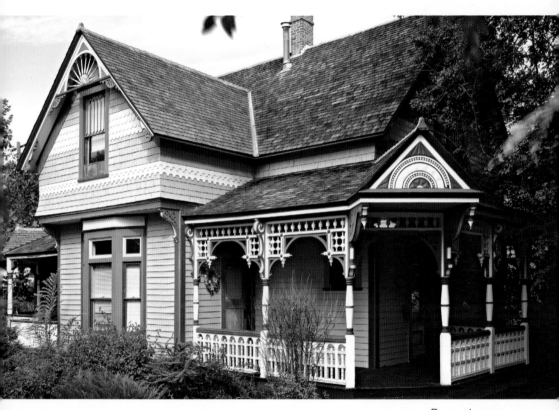

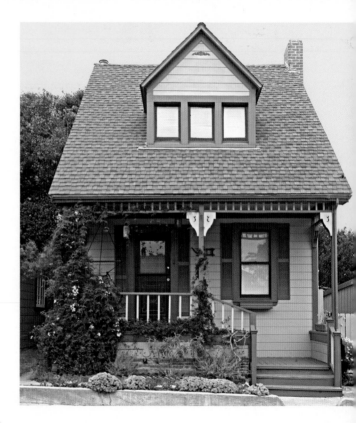

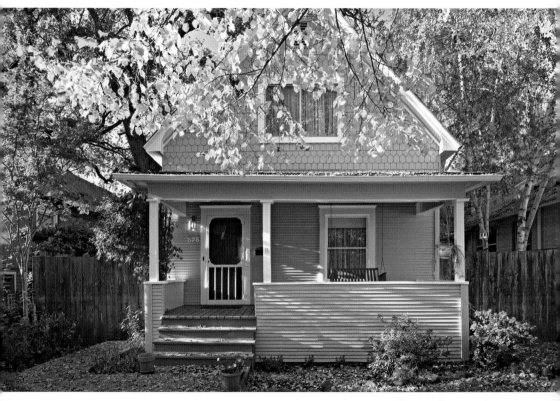

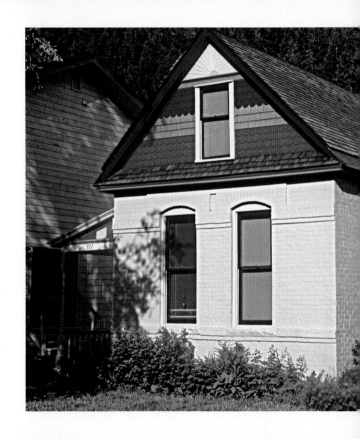

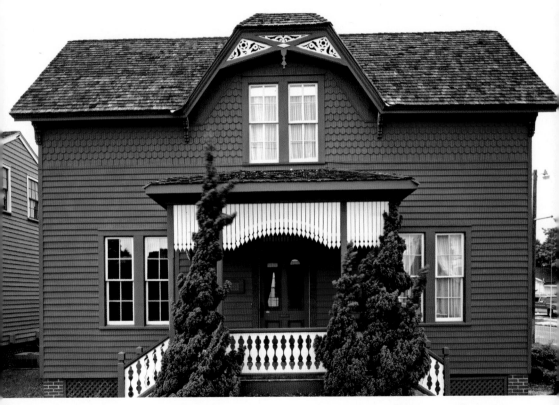

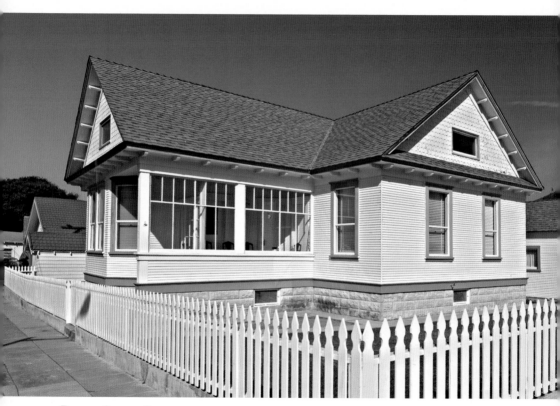

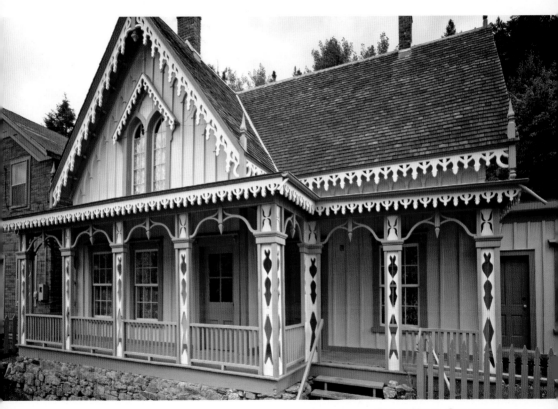

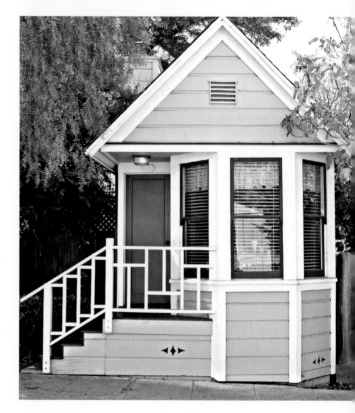

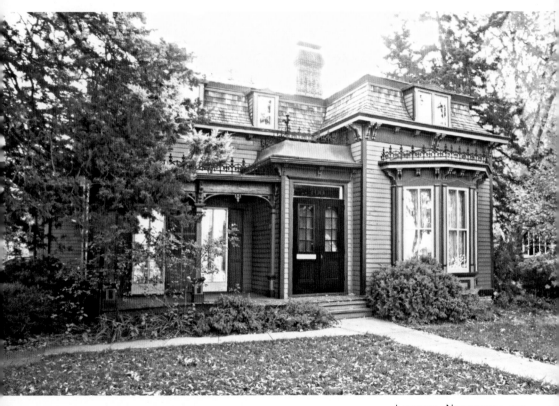

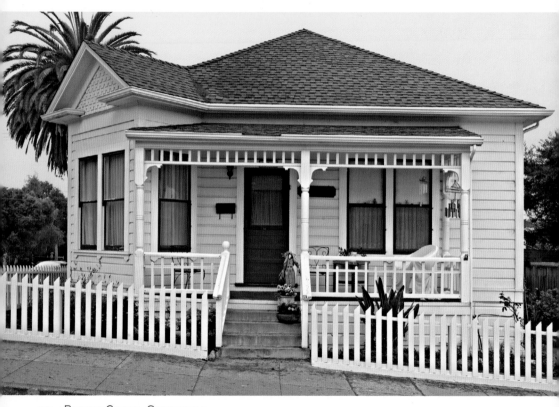

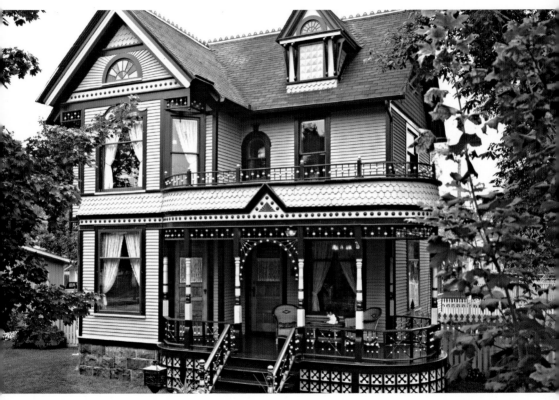

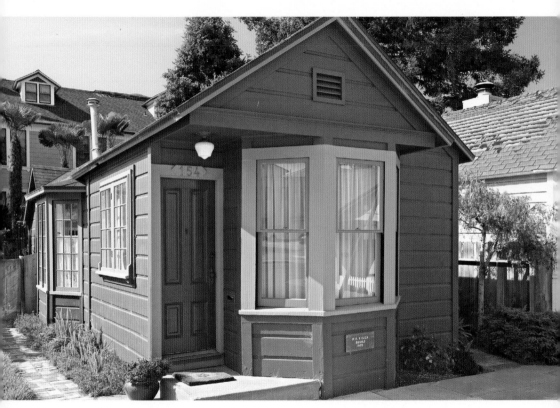

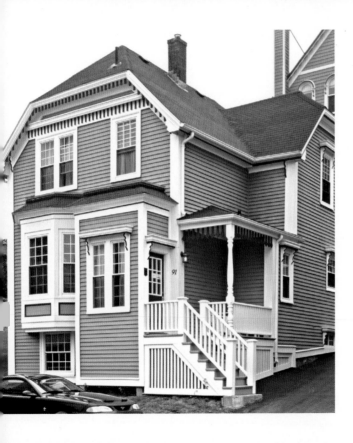

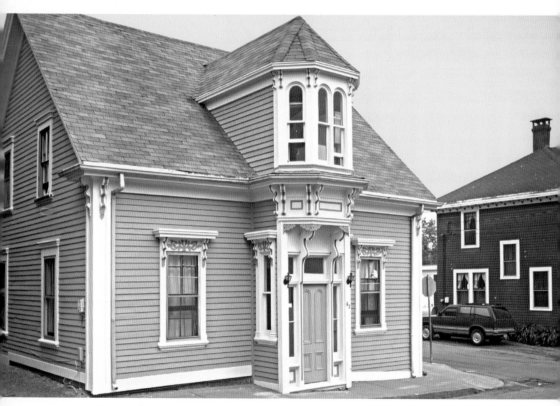

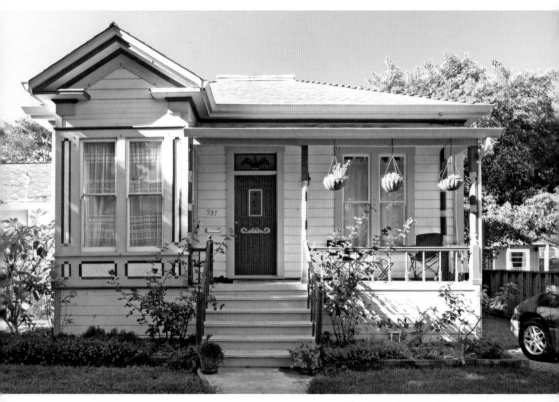

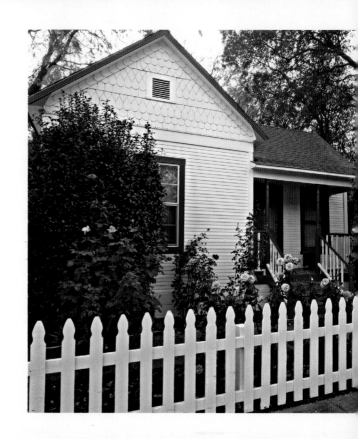

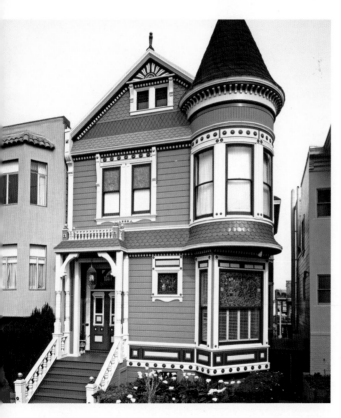

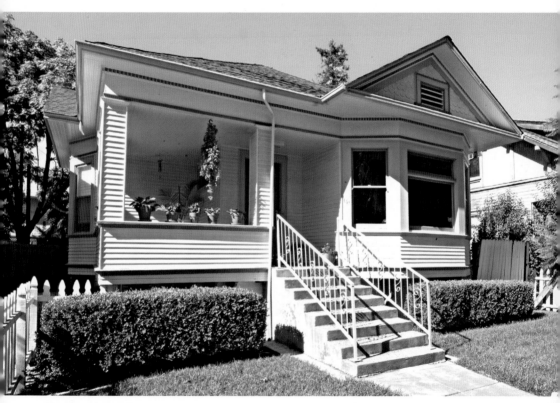

386 SAN JOSE, CALIFORNIA

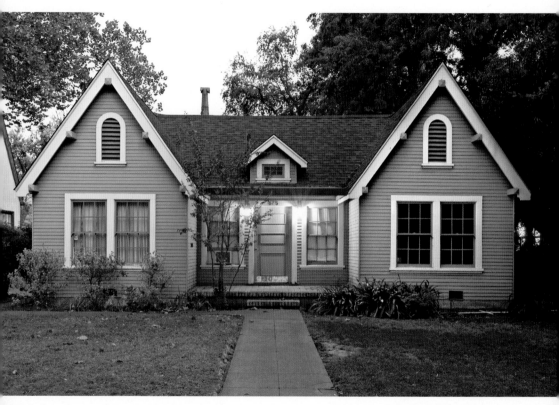

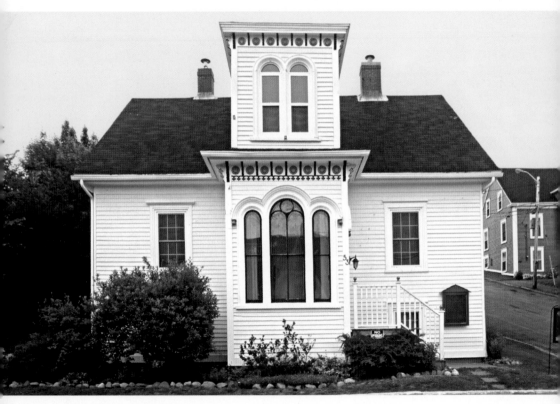

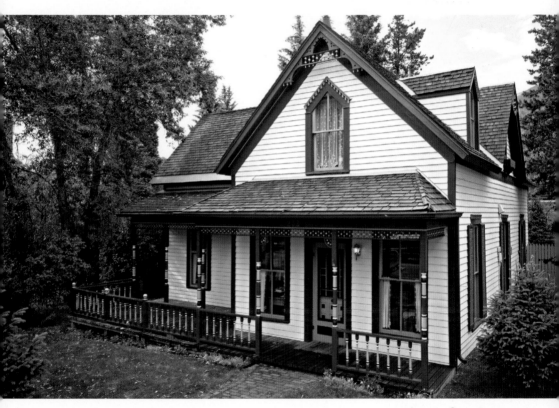

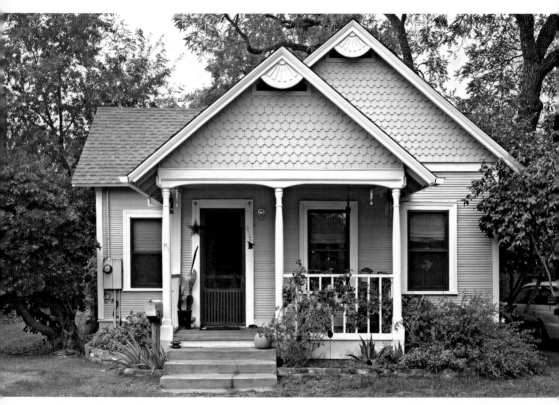

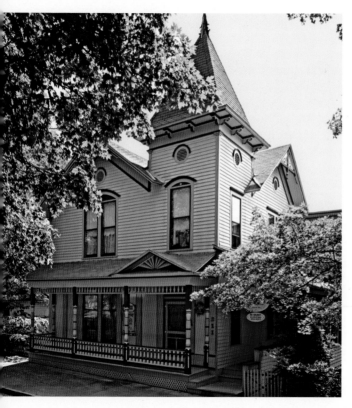

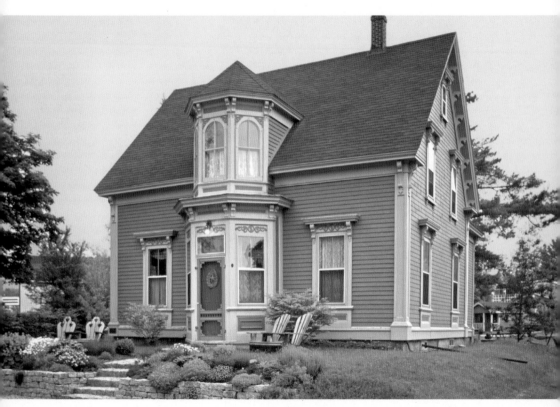

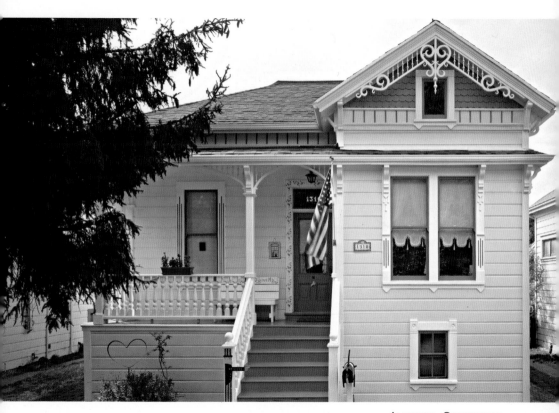

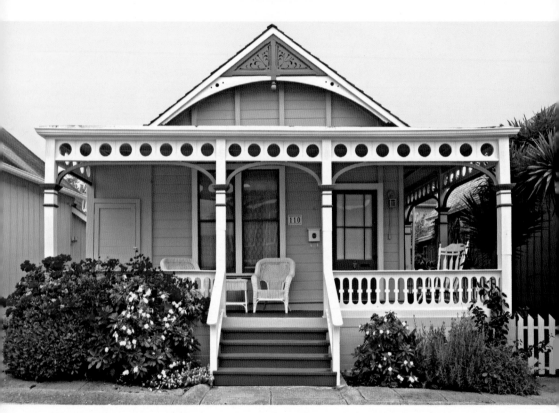

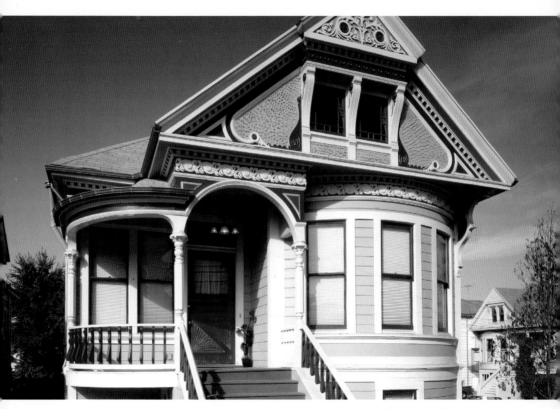

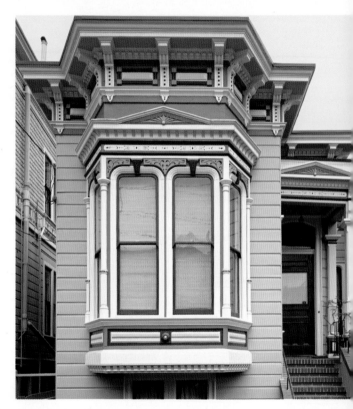

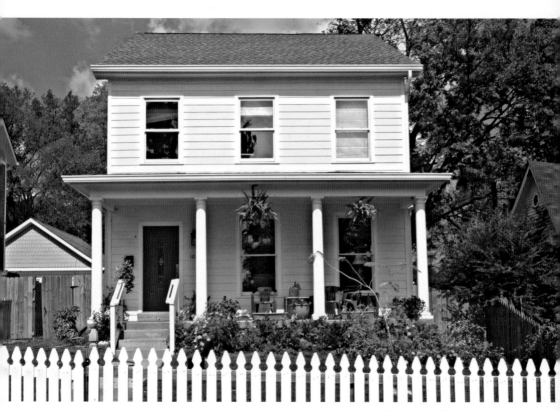

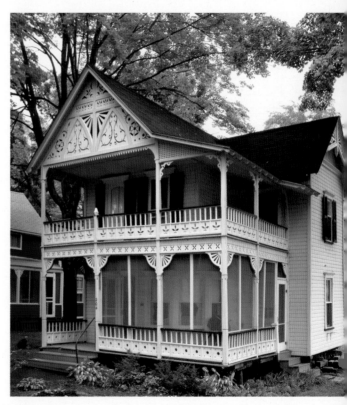

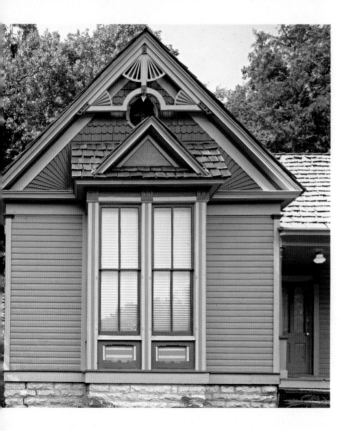

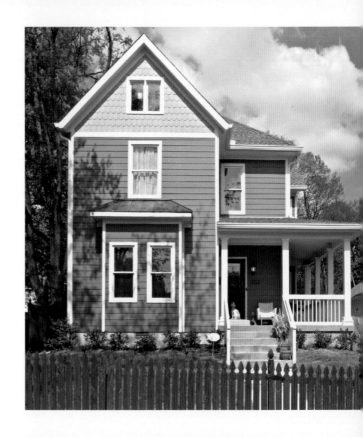

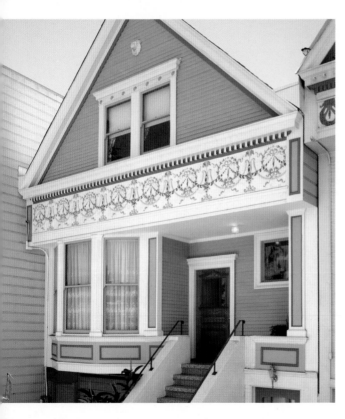

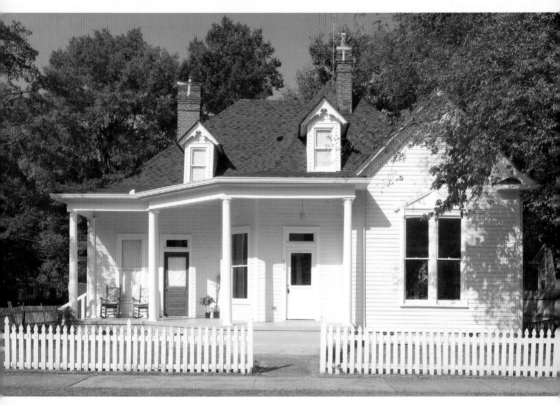

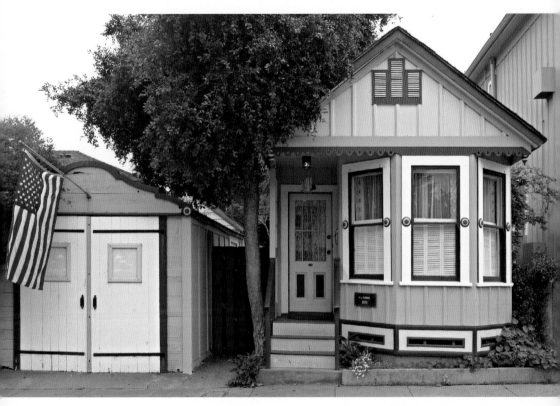

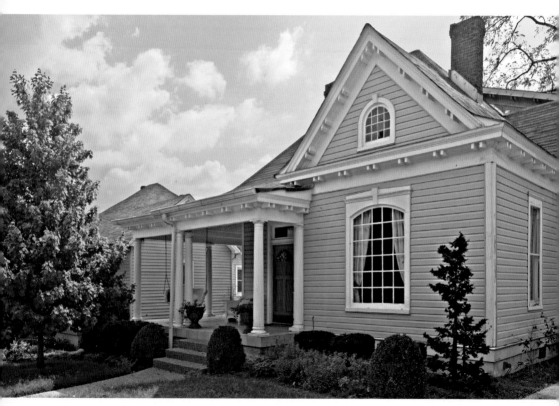

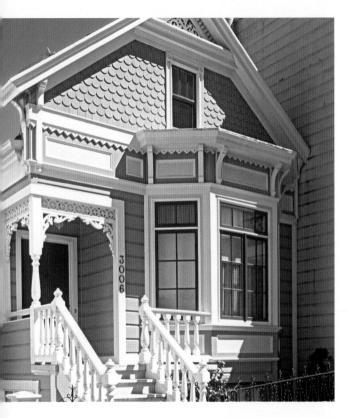

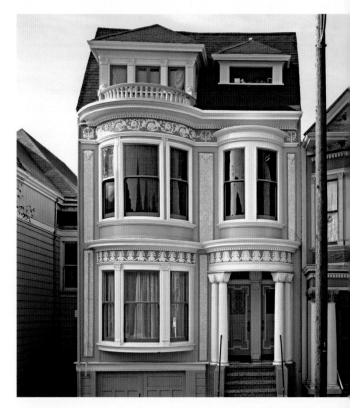

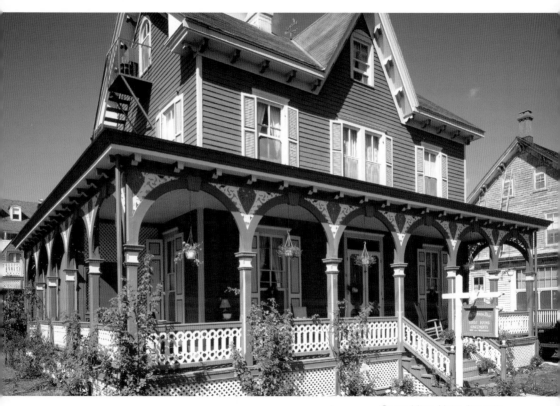

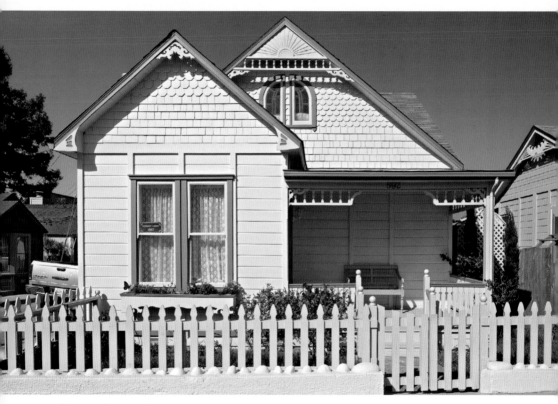

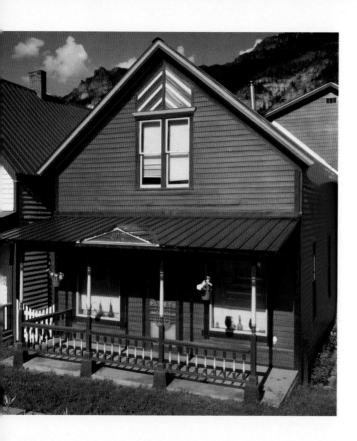

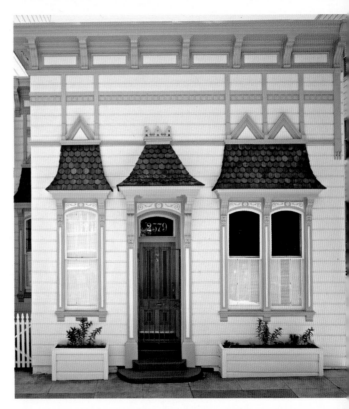

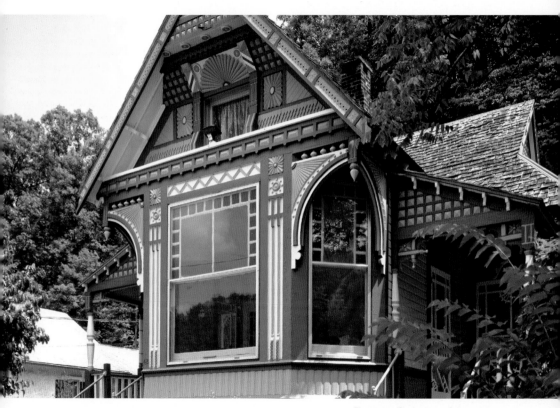

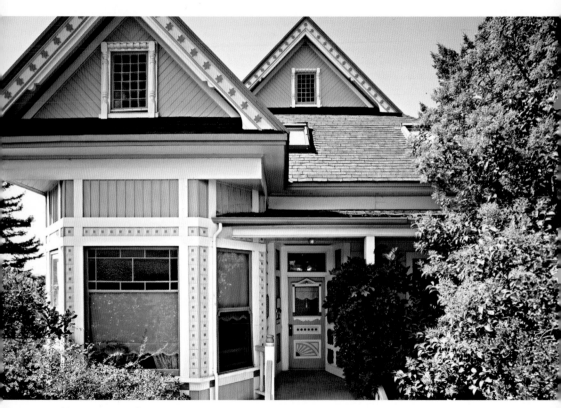

412 HEALDSBURG, CALIFORNIA

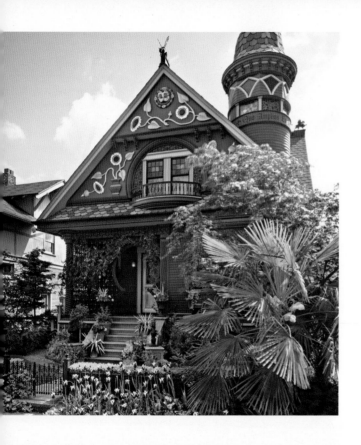

ECLECTIC COTTAGES

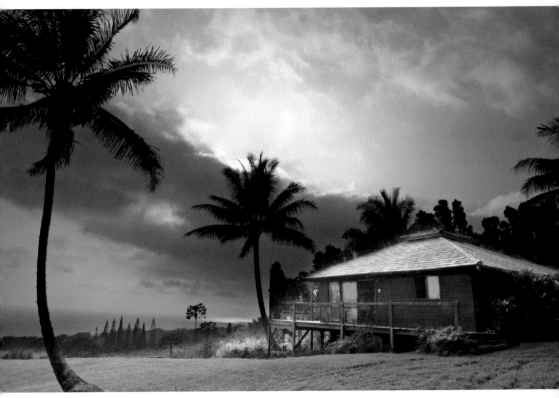

ANYA'S HOUSE COTTAGE | Hana, Maui, Hawaii

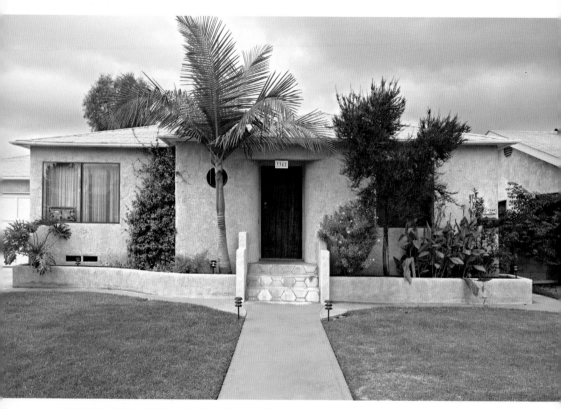

416 MODERN-STYLE COTTAGE | SAN DIEGO, CALIFORNIA

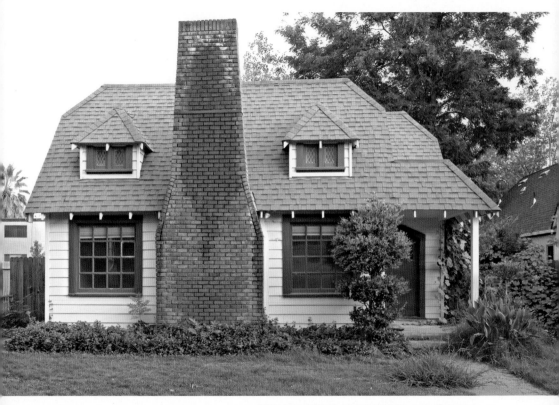

ENGLISH-STYLE COTTAGE | CHICO, CALIFORNIA 417

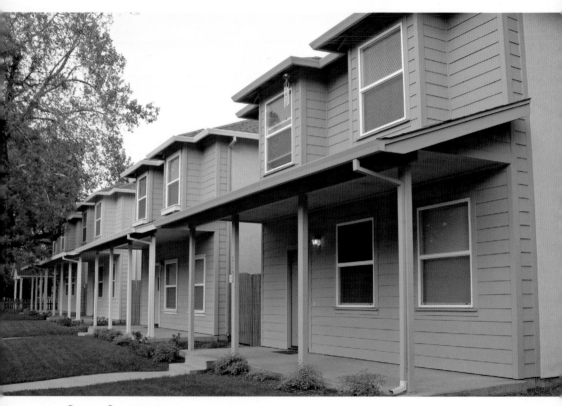

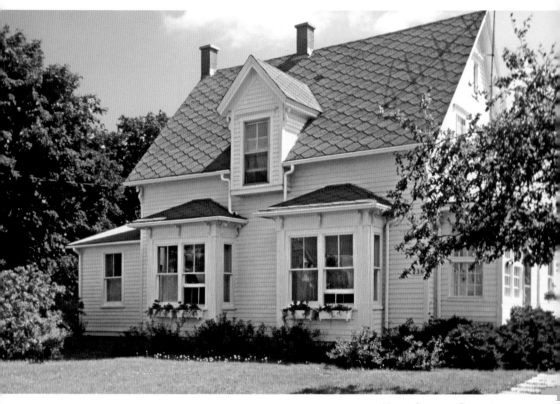

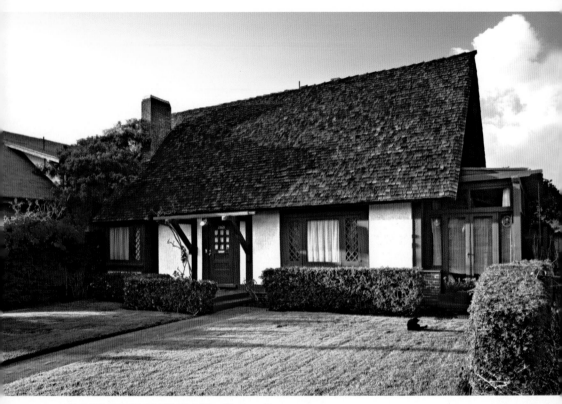

420 ENGLISH-STYLE COTTAGE | San Diego, California

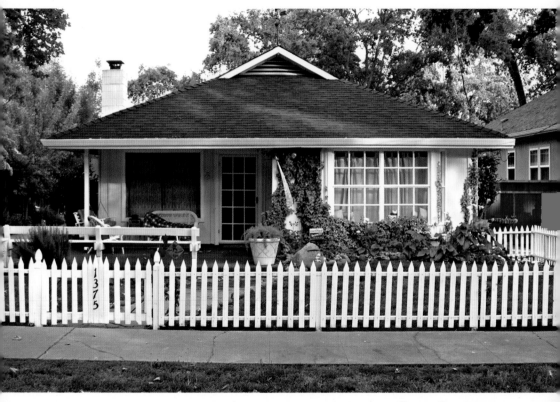

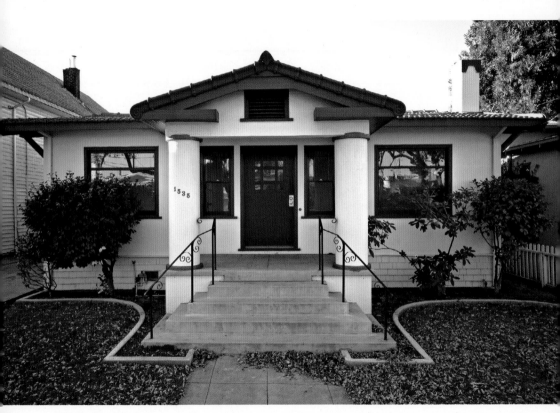

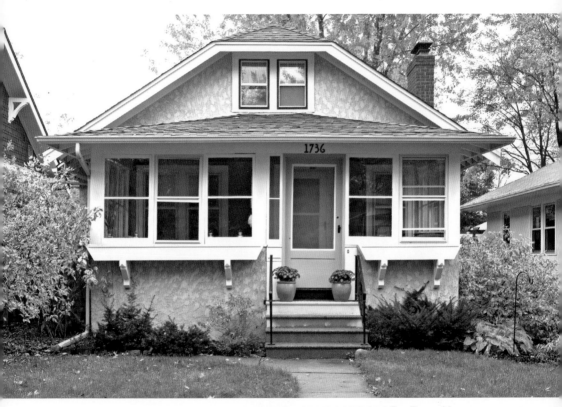

ENGLISH-STYLE COTTAGE | St. Paul, Minnesota 423

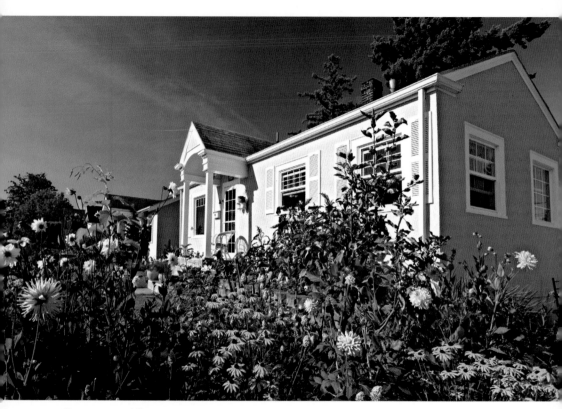

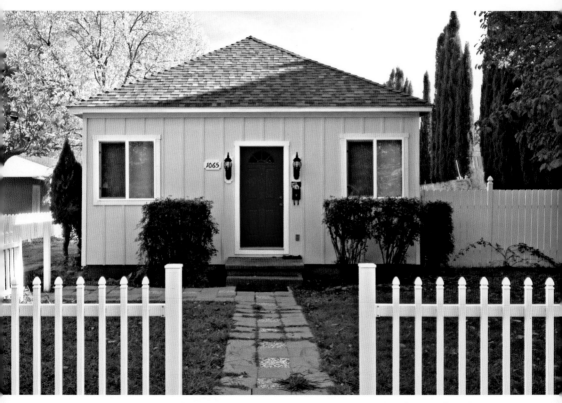

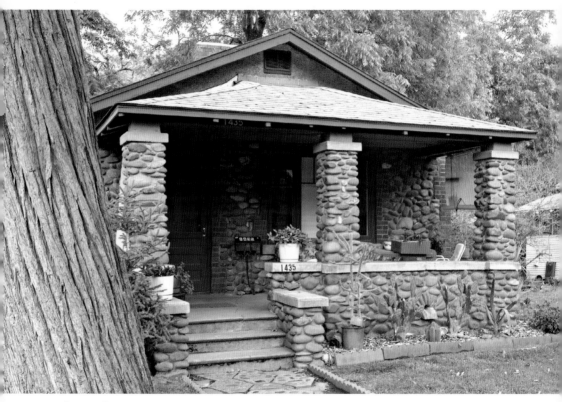

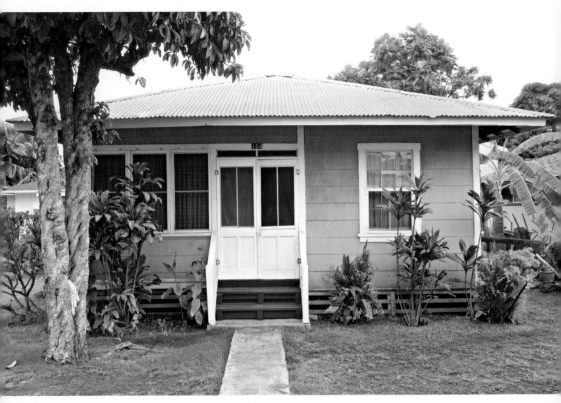

PLANTATION-STYLE COTTAGE | Lahaina, Maui, Hawaii

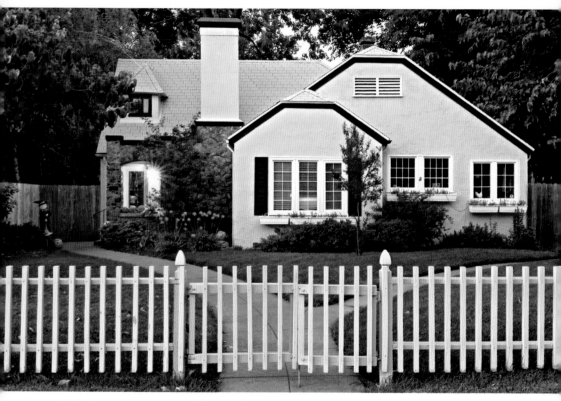

ENGLISH-STYLE COTTAGE | CHICO, CALIFORNIA

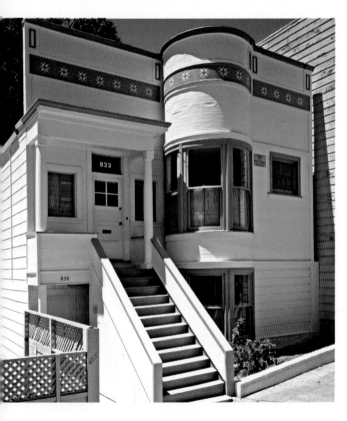

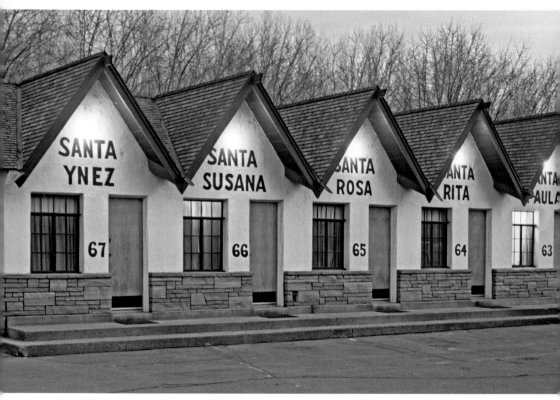

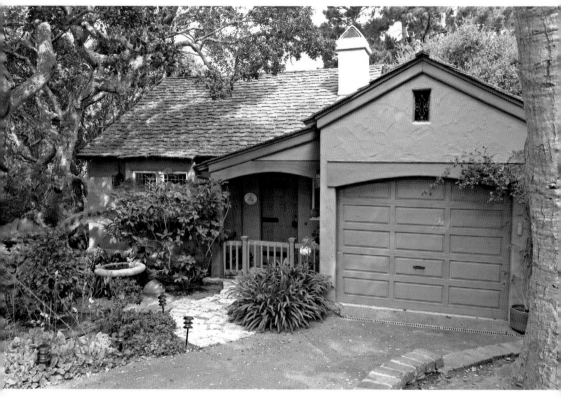

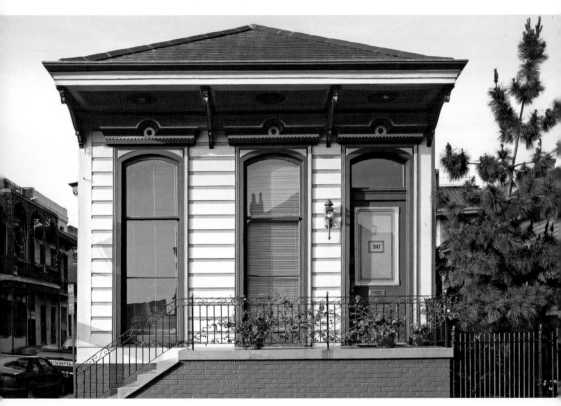

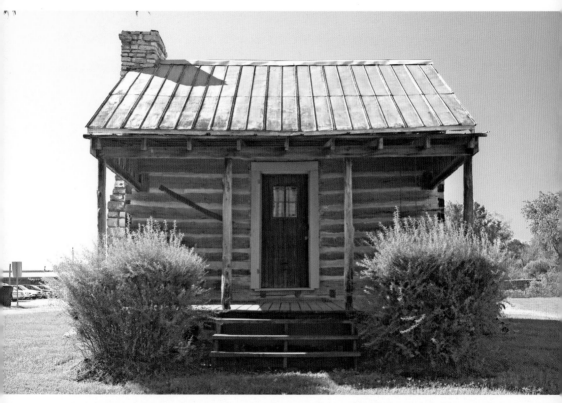

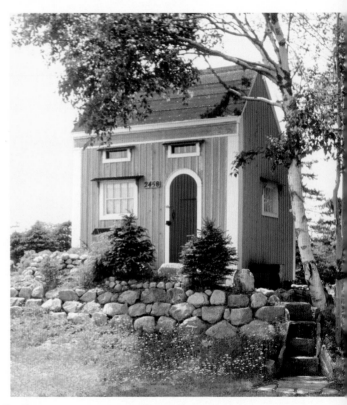

434 BAY OF FUNDY, NOVA SCOTIA, CANADA

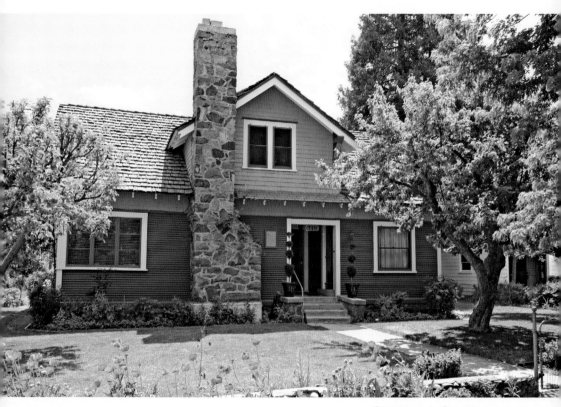

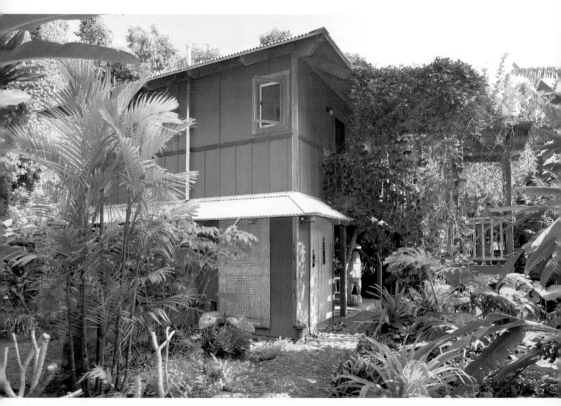

HAMOA BEACH COTTAGE | Hana, Maui, Hawaii

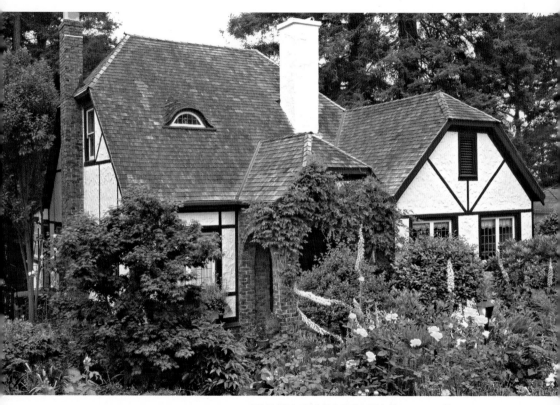

ENGLISH-STYLE COTTAGE | OAKLAND, CALIFORNIA 437

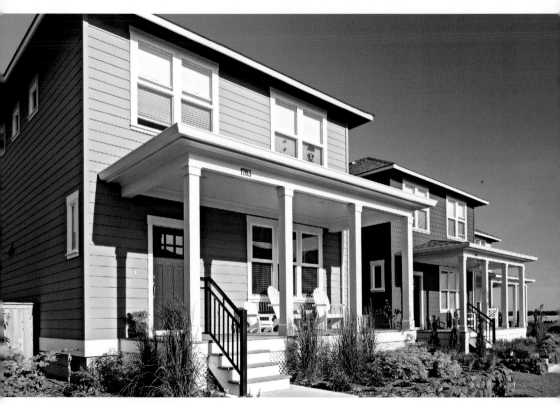

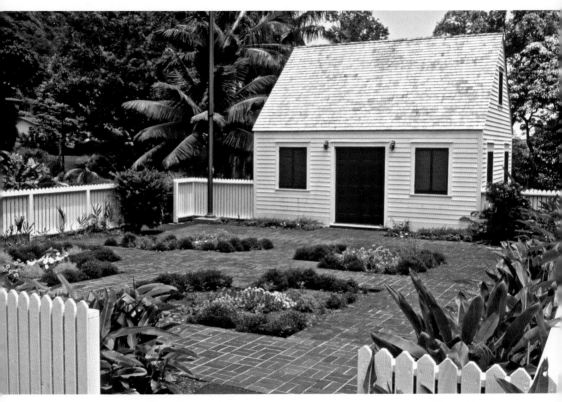

440 SLAVE COTTAGE | LAURA PLANTATION, LOUISIANA

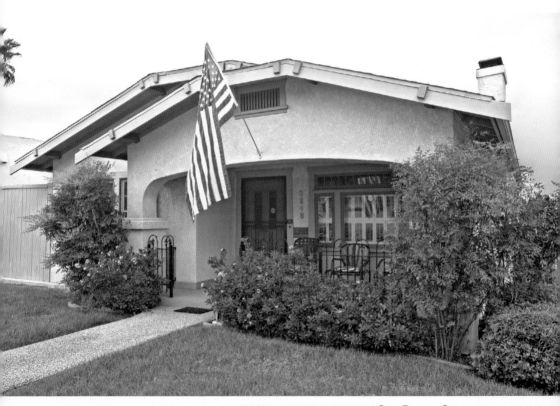

ENGLISH-STYLE COTTAGE | SAN DIEGO, CALIFORNIA 441

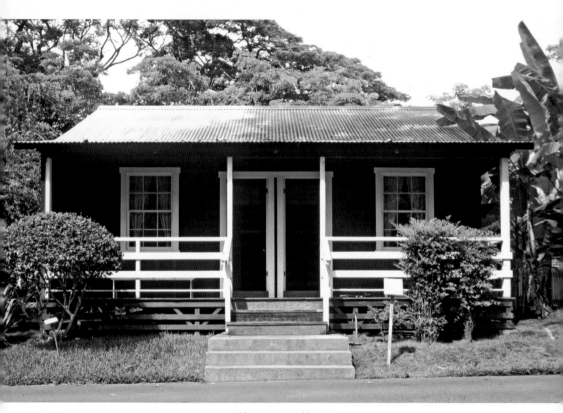

442 JAPANESE PLANTATION COTTAGE | Honolulu, Hawaii

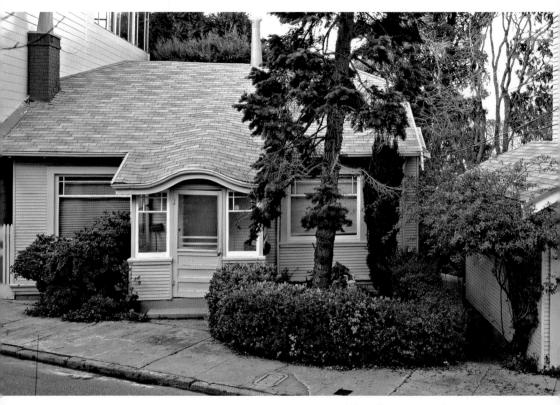

ENGLISH-STYLE COTTAGE | San Francisco, California 443

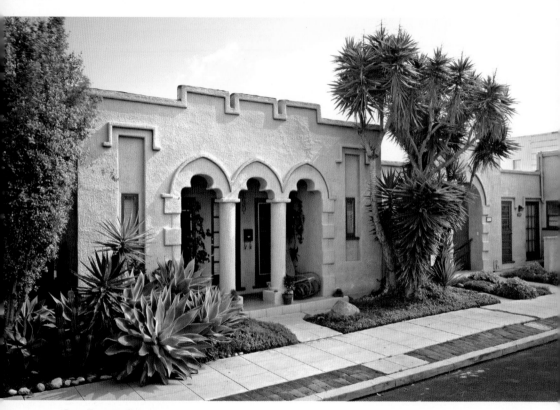

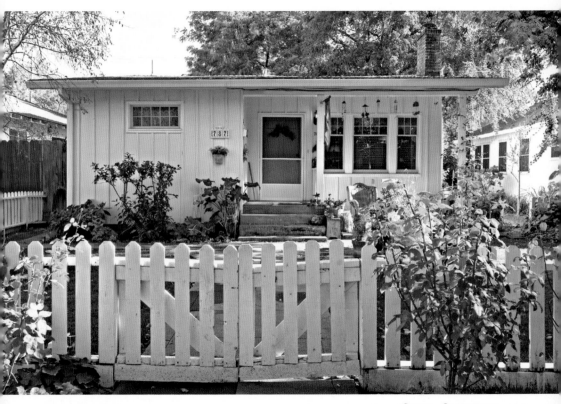

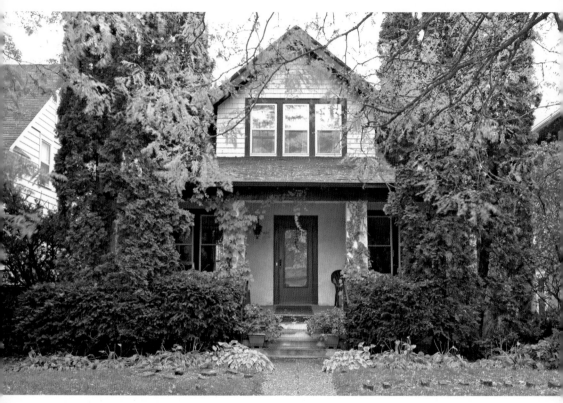

446 ST. PAUL, MINNESOTA

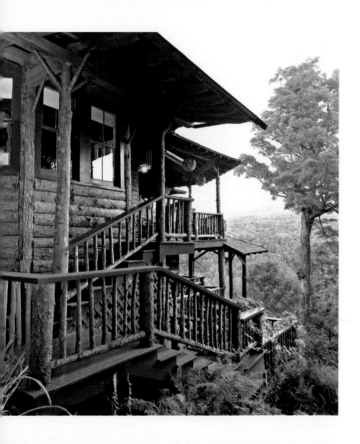

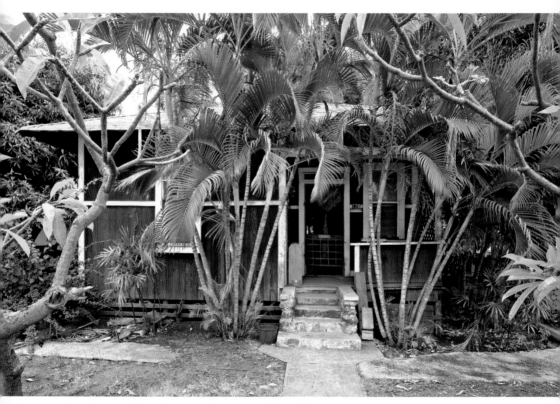

PLANTATION-STYLE COTTAGE | LAHAINA, MAUI, HAWAII

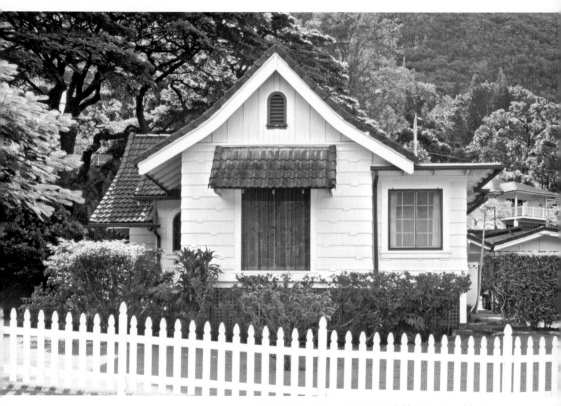

ORIENTAL-STYLE COTTAGE | HONOLULU, HAWAII 449

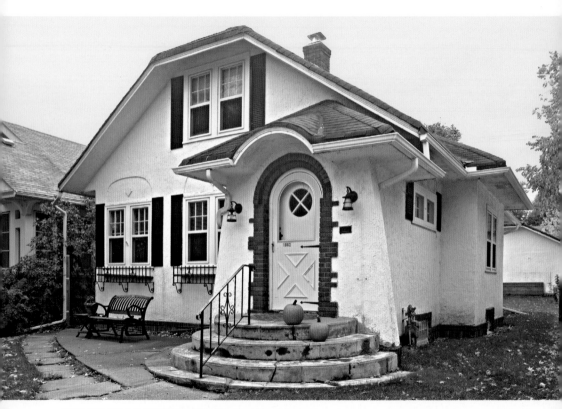

ENGLISH-STYLE COTTAGE | St. Paul, Minnesota

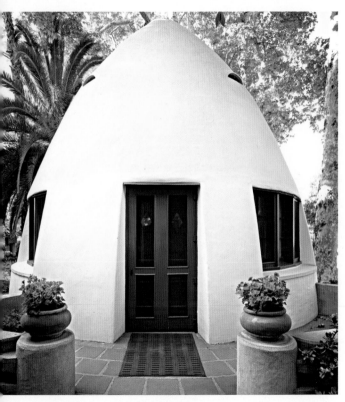

TEEPEE COTTAGE | WORKMAN TEMPLE HOMESTEAD INDUSTRY, CITY OF INDUSTRY, CALIFORNIA

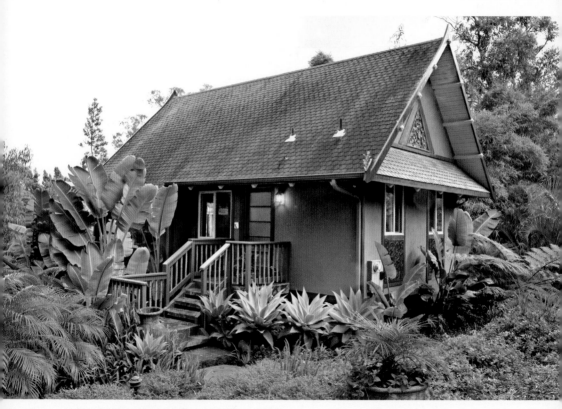

ALOHA BALI COTTAGE | OLINDA, MAUI, HAWAII

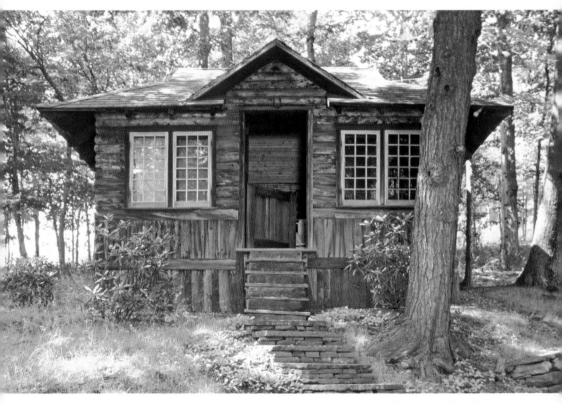

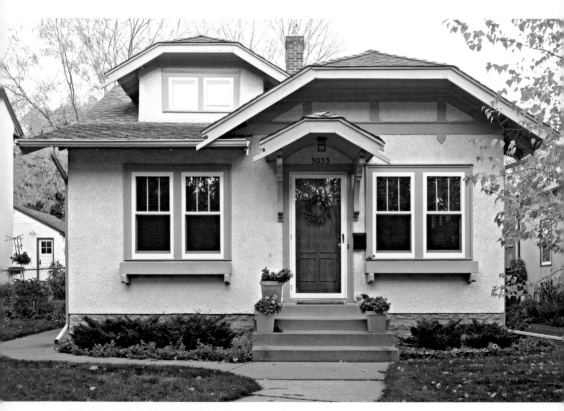

ENGLISH-STYLE COTTAGE | MINNEAPOLIS, MINNESOTA

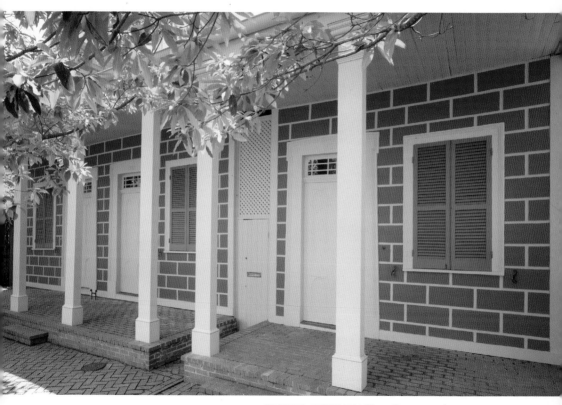

CREOLE COTTAGE | New Orleans, Louisiana 455

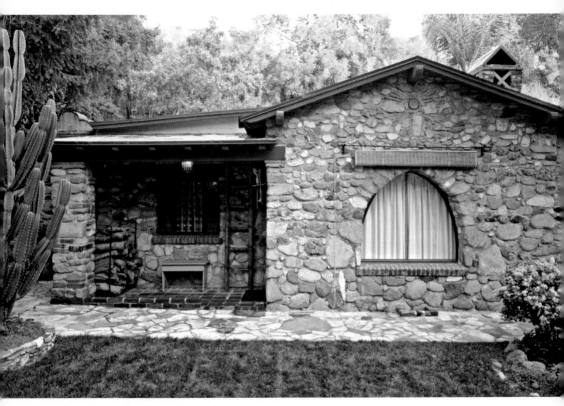

456 PASADENA, CALIFORNIA

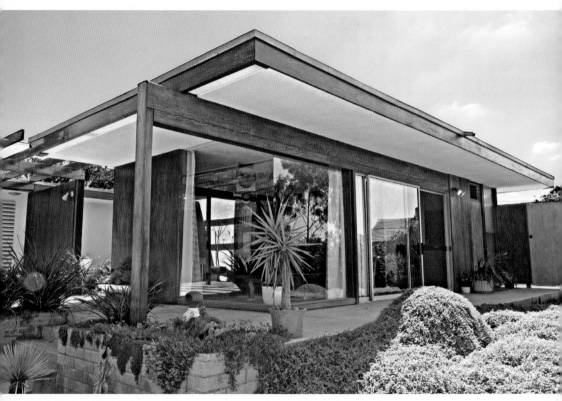

NEUTRA COTTAGE | SAN DIEGO, CALIFORNIA 457

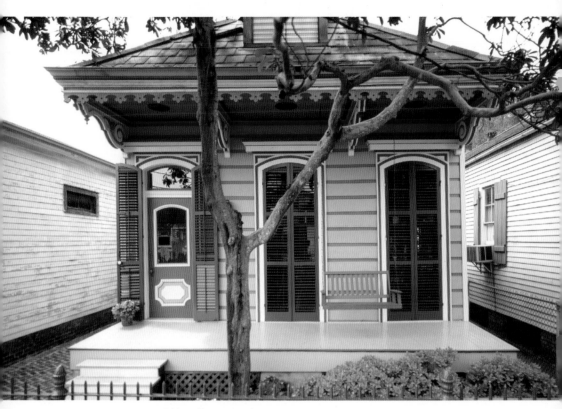

SHOTGUN COTTAGE | NEW ORLEANS, LOUISIANA

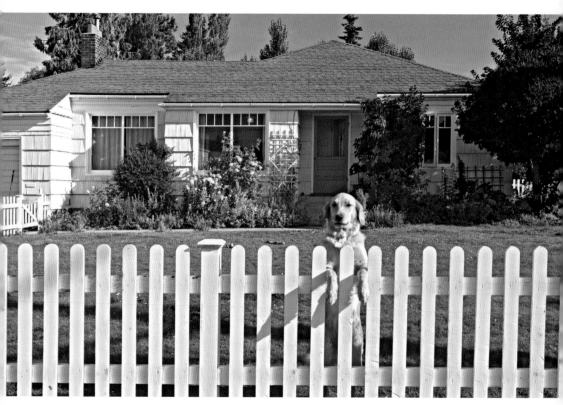

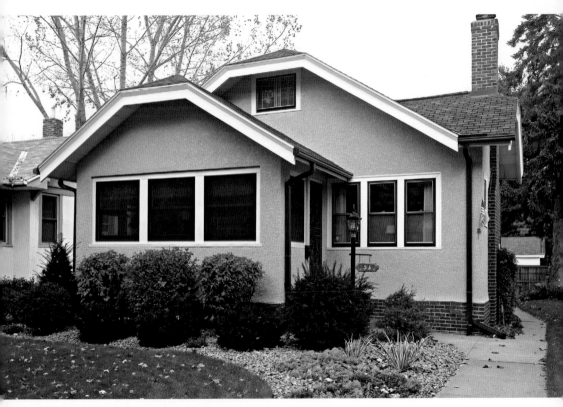

ENGLISH-STYLE COTTAGE | MINNEAPOLIS, MINNESOTA

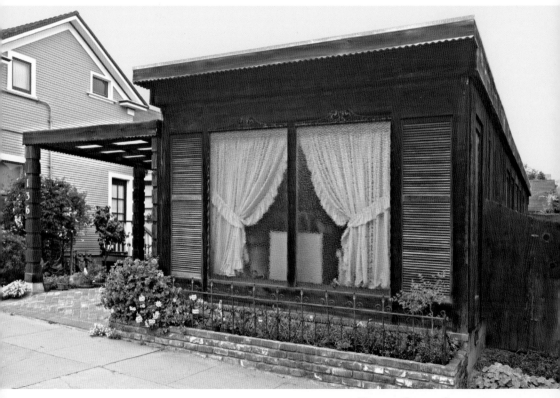

PACIFIC GROVE, CALIFORNIA 461

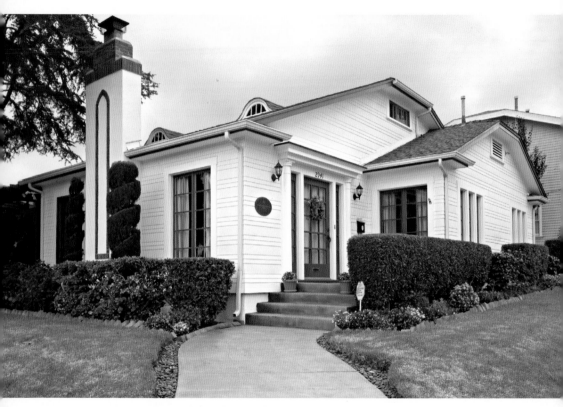

462 ENGLISH-STYLE COTTAGE | SAN DIEGO, CALIFORNIA

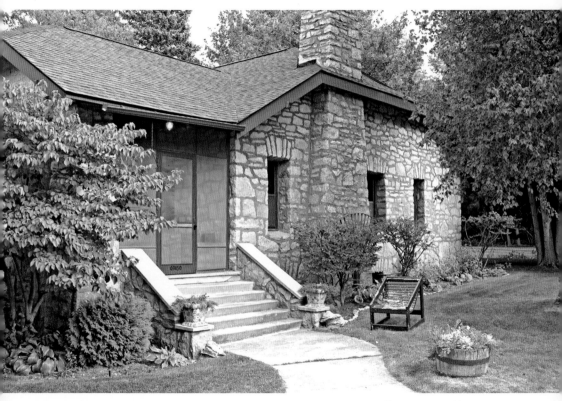

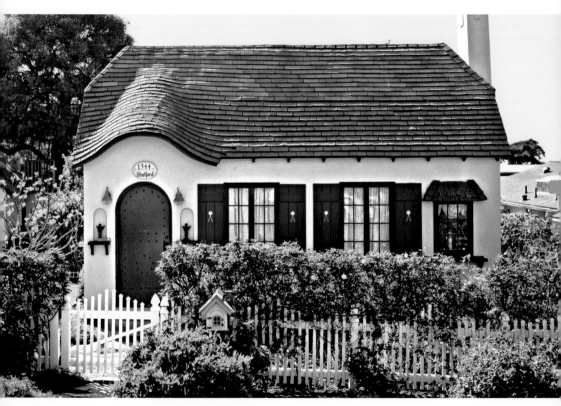

464 ENGLISH-STYLE COTTAGE | DEL MAR, CALIFORNIA

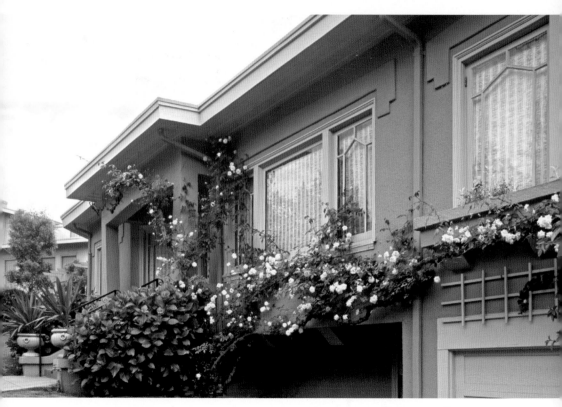

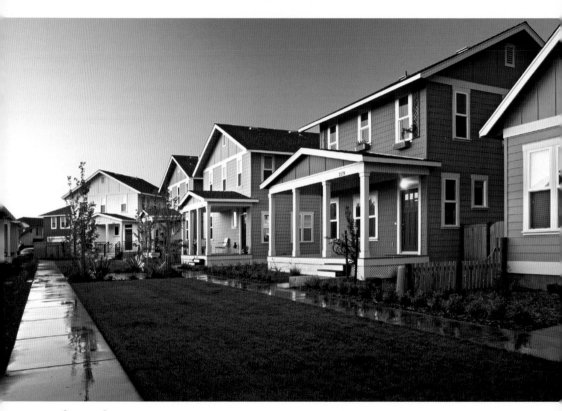

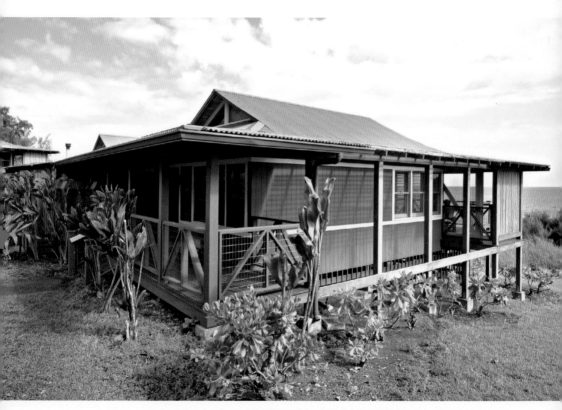

HOTEL HANA-MAUI COTTAGE | Hana, Maui, Hawaii 467

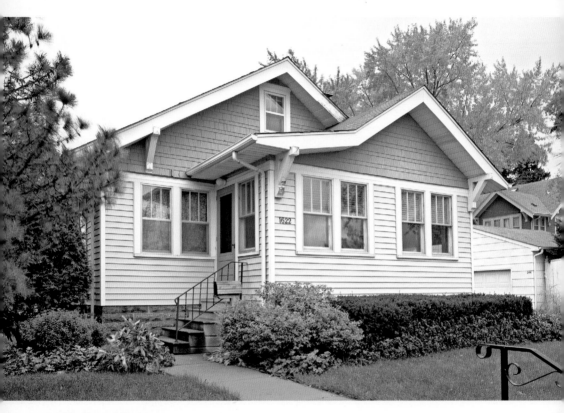

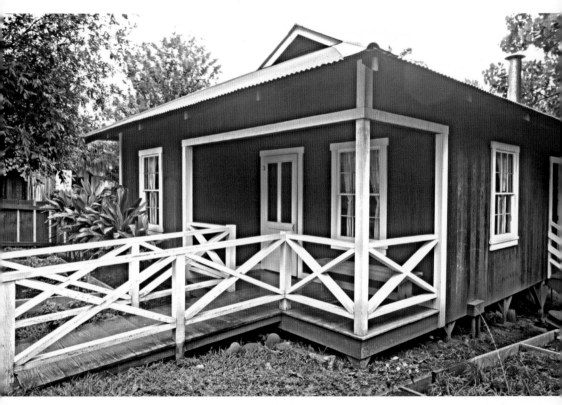

KOREAN-STYLE COTTAGE | HONOLULU, HAWAII 469

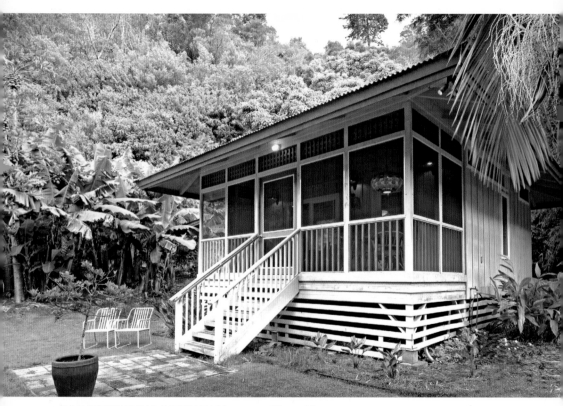

WILD GINGER FALLS COTTAGE | Makawao, Maui, Hawaii

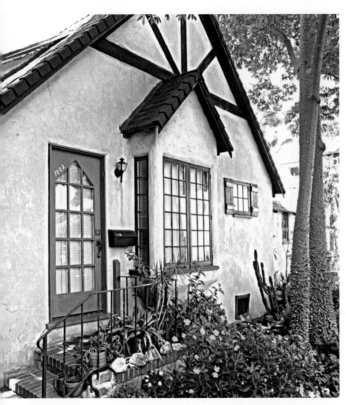

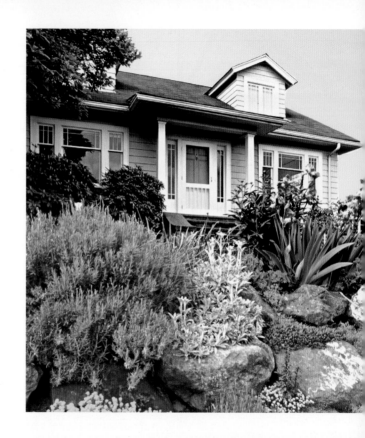

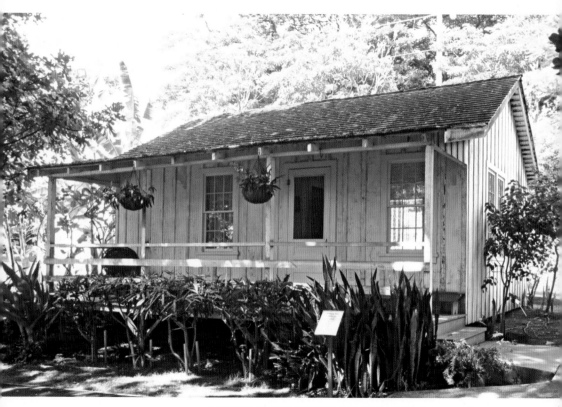

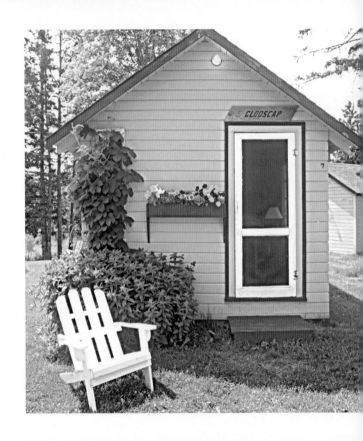

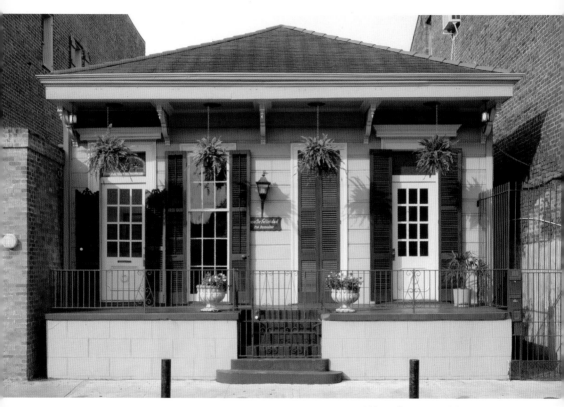

SHOTGUN COTTAGE | New Orleans, Louisiana 475

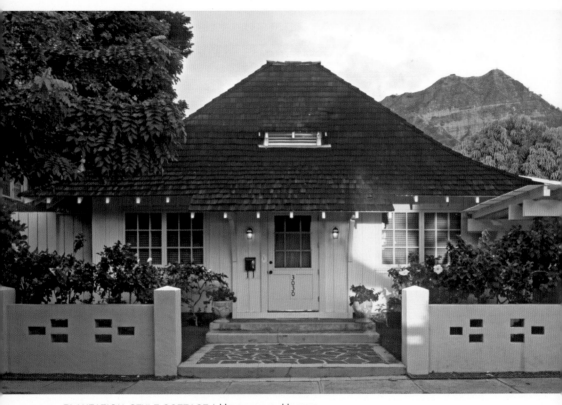

PLANTATION-STYLE COTTAGE | Honolulu, Hawaii

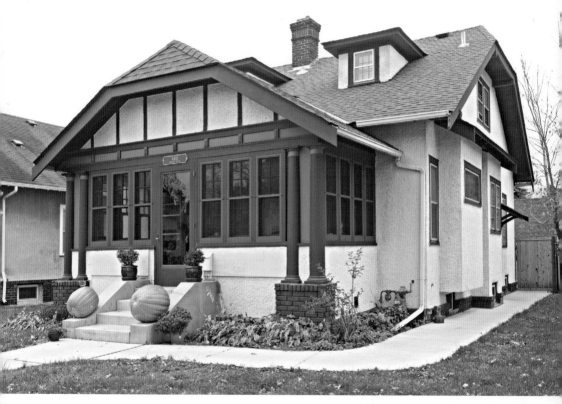

ENGLISH-STYLE COTTAGE | MINNEAPOLIS, MINNESOTA 477

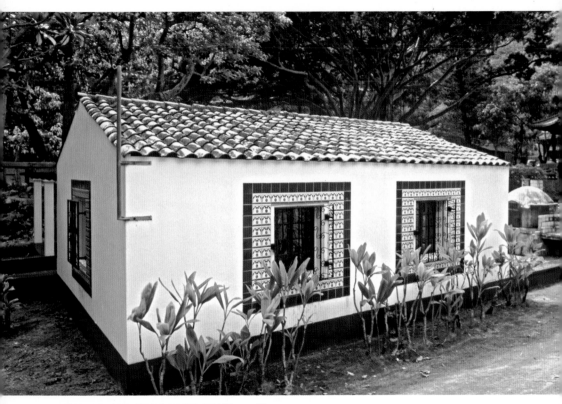

478 PORTUGUESE-STYLE COTTAGE | Maui, Hawaii

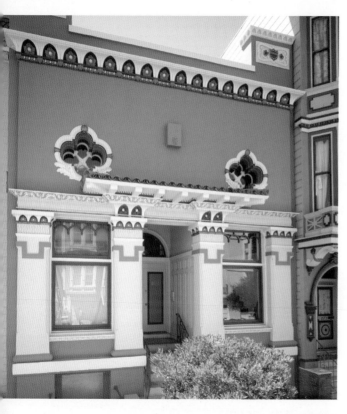

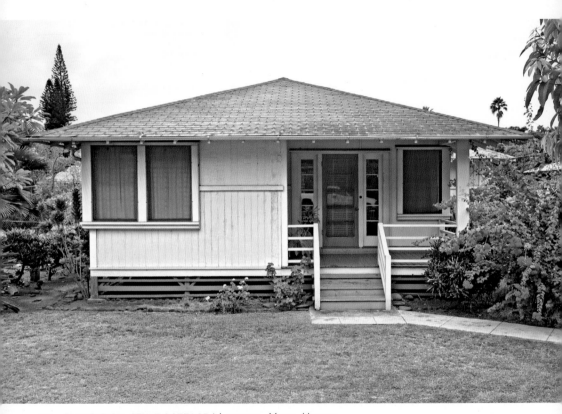

PLANTATION-STYLE COTTAGE | Lahaina, Maui, Hawaii

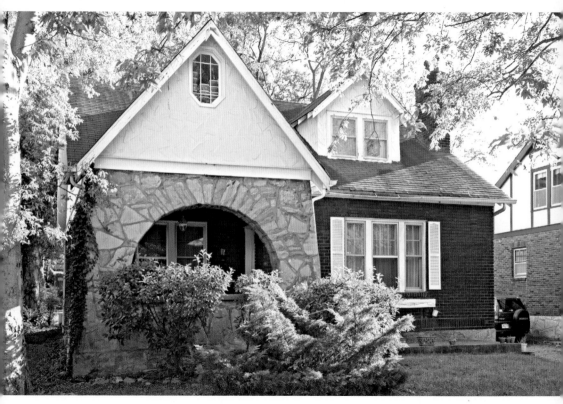

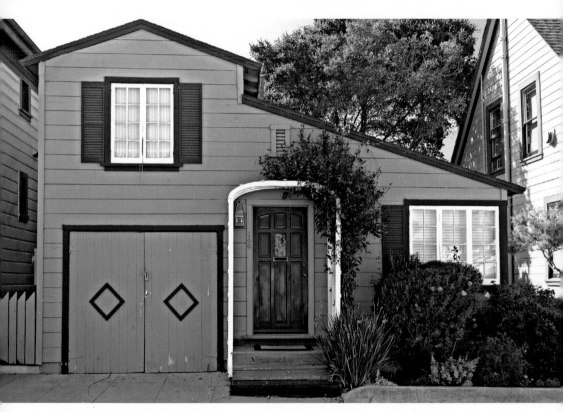

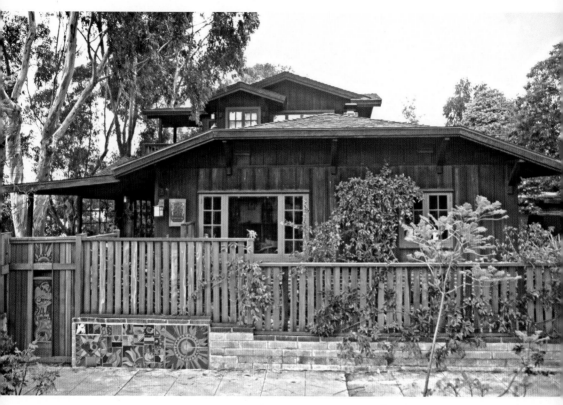

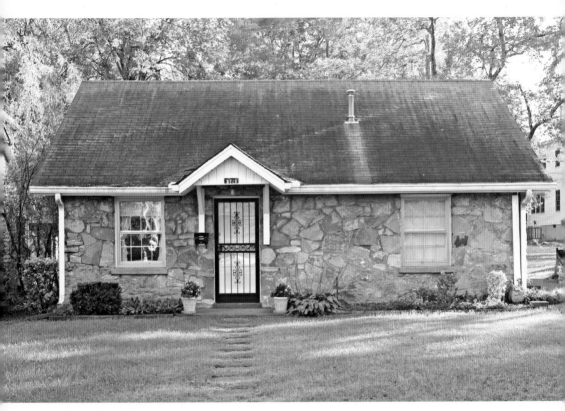

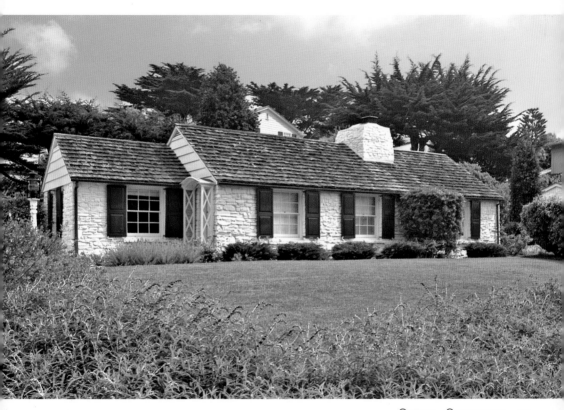

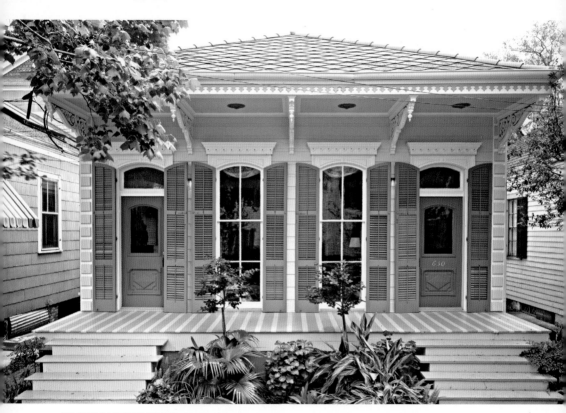

SHOTGUN COTTAGE | ALGIERS, LOUISIANA

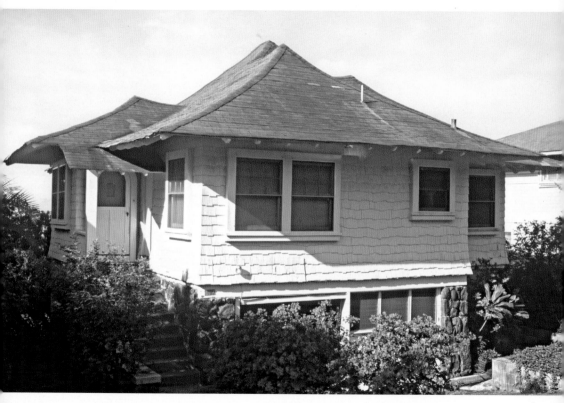

ORIENTAL-STYLE COTTAGE | HONOLULU, HAWAII 487

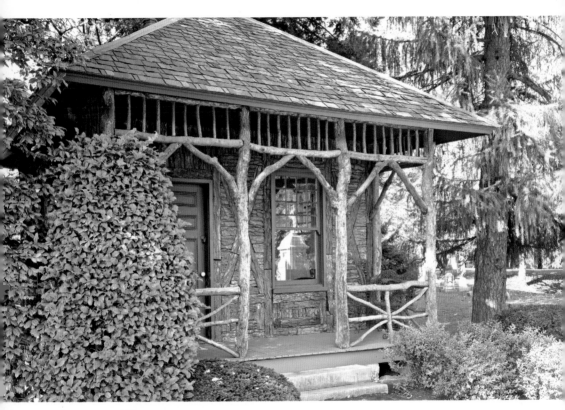

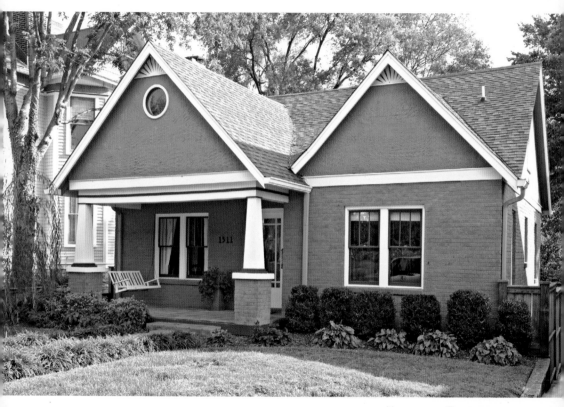

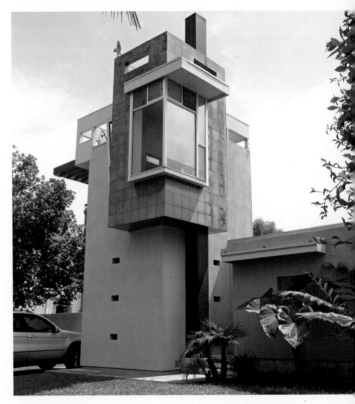

490　MODERN-STYLE COTTAGE | SAN DIEGO, CALIFORNIA

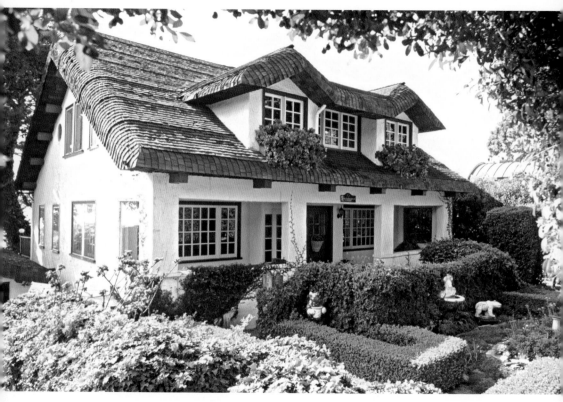

ENGLISH-STYLE COTTAGE | DEL MAR, CALIFORNIA 491

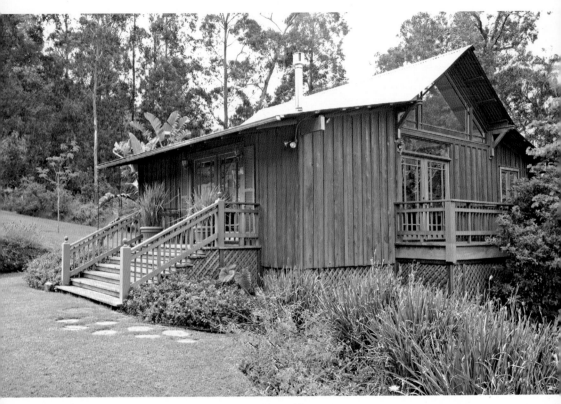

PLANTATION-STYLE COTTAGE | OLINDA, MAUI, HAWAII

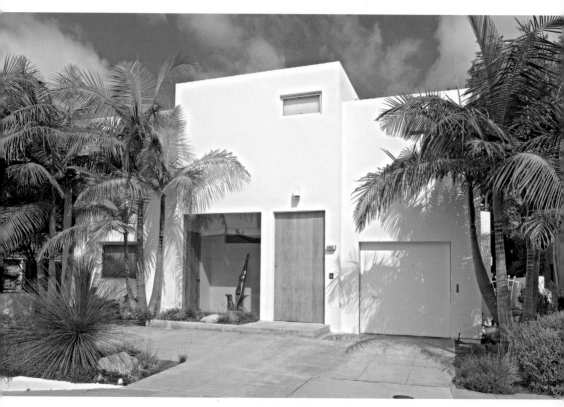

MODERN-STYLE COTTAGE | SAN DIEGO, CALIFORNIA 493

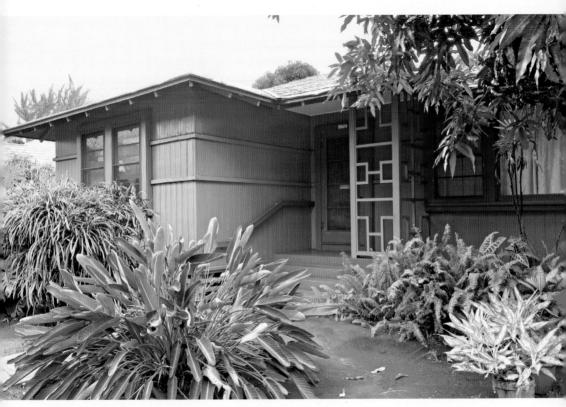

PLANTATION-STYLE COTTAGE | LAHAINA, MAUI, HAWAII

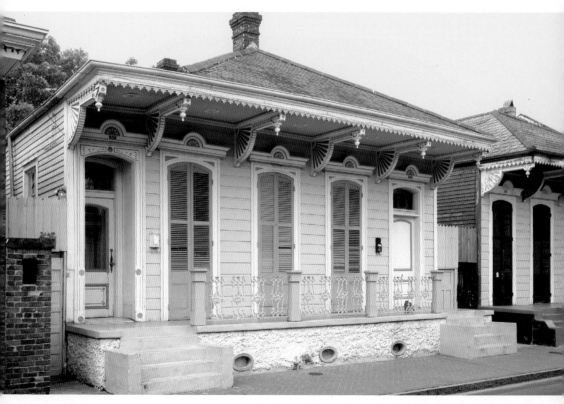

SHOTGUN COTTAGE | New Orleans, Louisiana 495

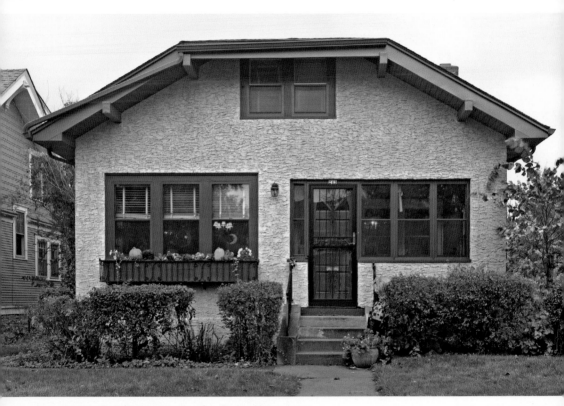

496 ENGLISH-STYLE COTTAGE | St. Paul, Minnesota

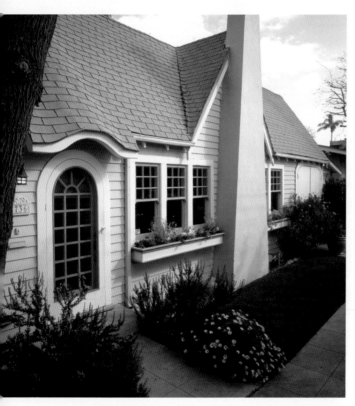

ENGLISH-STYLE COTTAGE | SAN DIEGO, CALIFORNIA 497

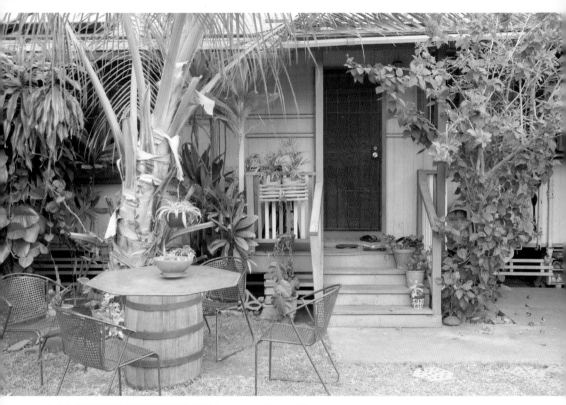

PLANTATION-STYLE COTTAGE | Lahaina, Maui, Hawaii

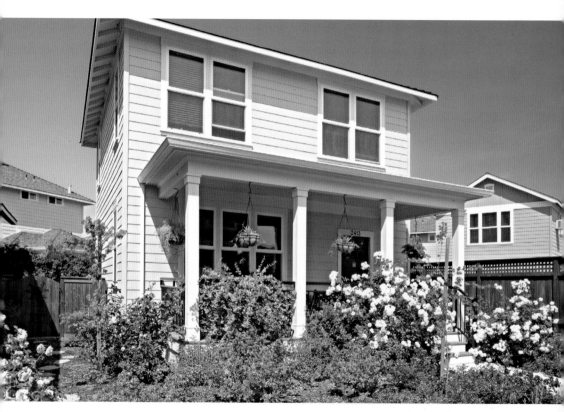

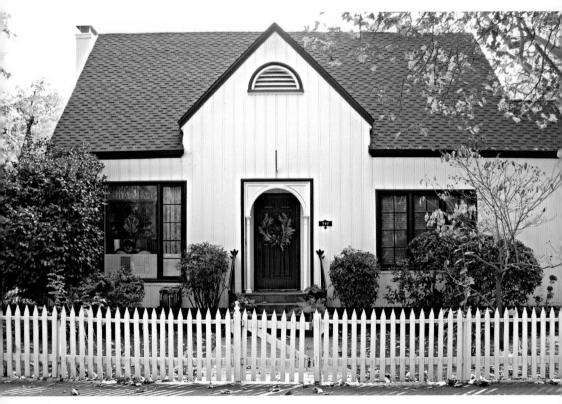

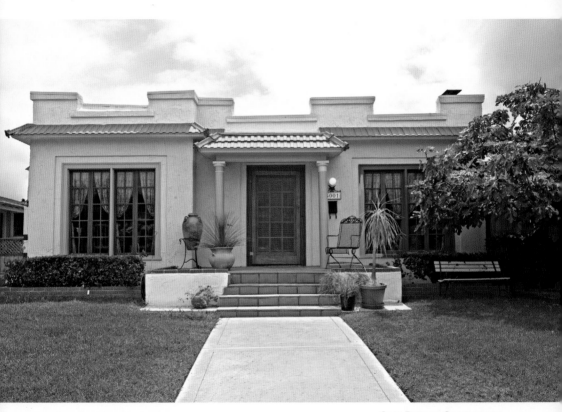

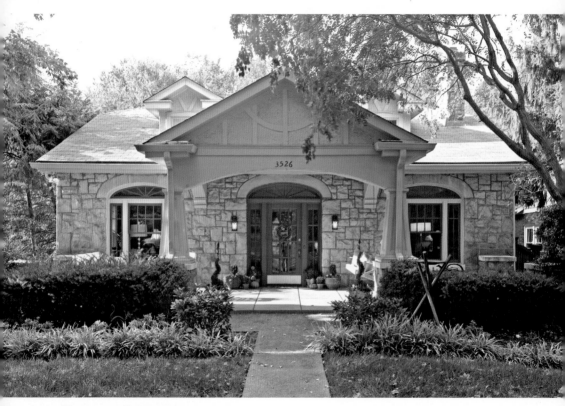

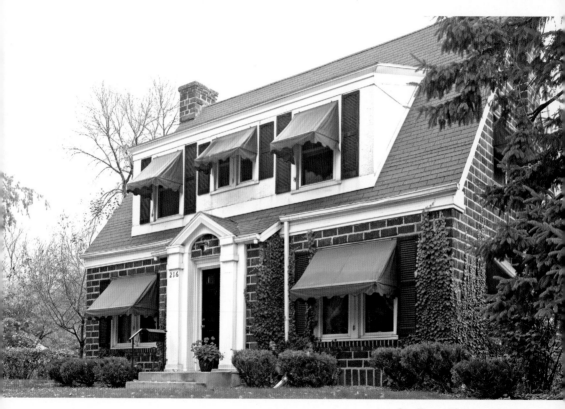

ST. PAUL, MINNESOTA 503

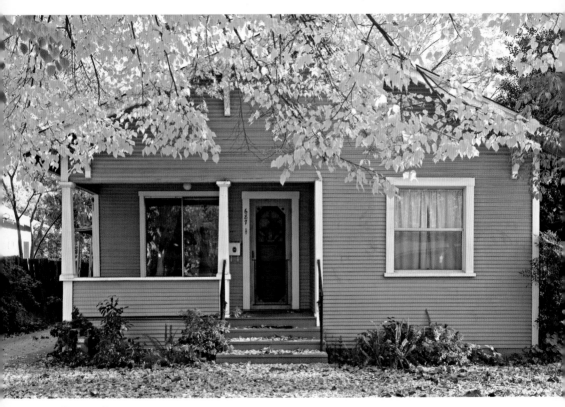

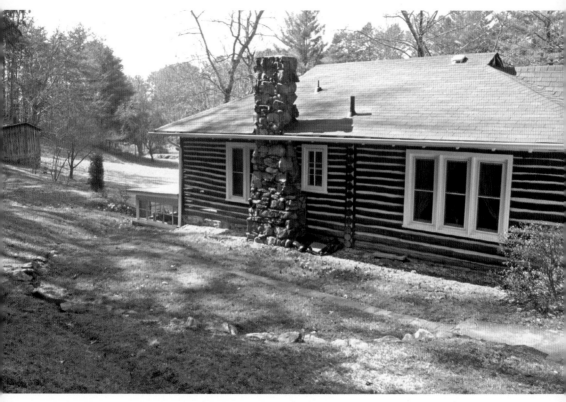

ASHEVILLE, NORTH CAROLINA 505

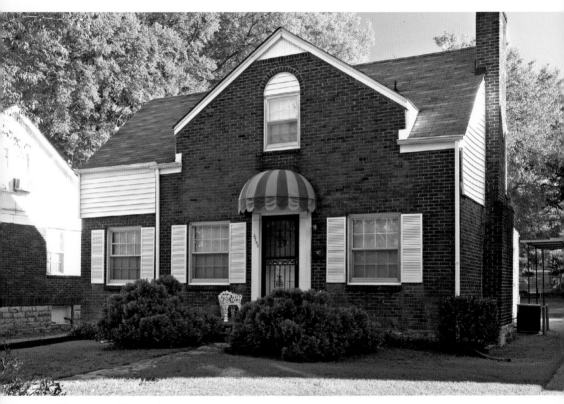

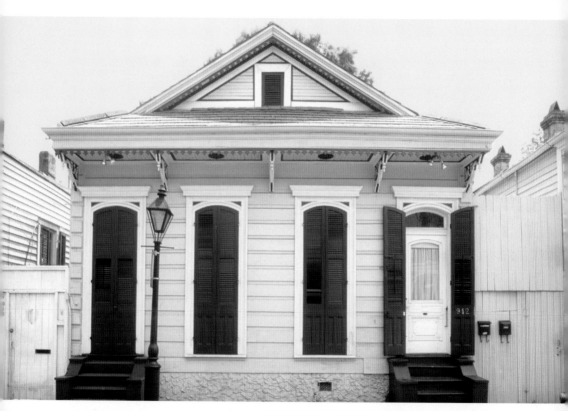

SHOTGUN COTTAGE | New Orleans, Louisiana

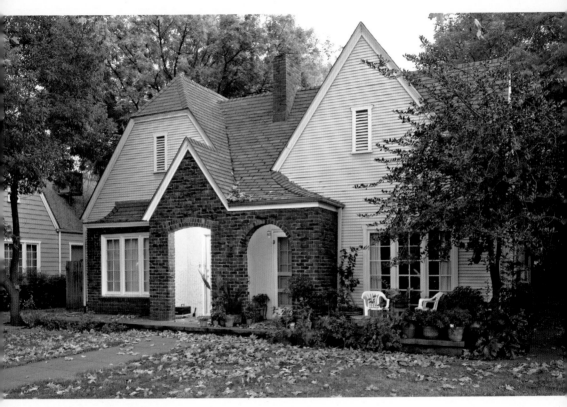

508 CHICO, CALIFORNIA

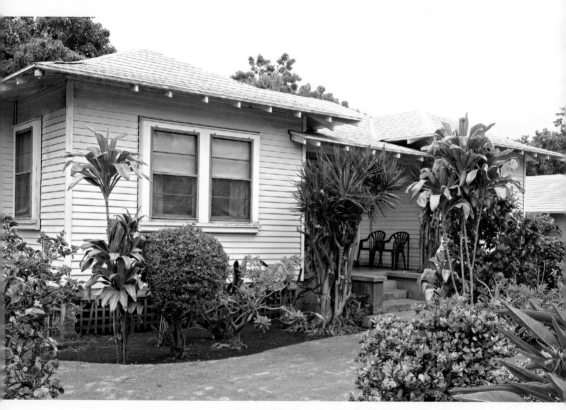

PLANTATION-STYLE COTTAGE | Lahaina, Maui, Hawaii 509

DOUGLAS KEISTER IS AMERICA'S MOST NOTED PHOTOGRAPHER OF HISTORIC RESIDENTIAL ARCHITECTURE. HIS 31 BOOKS INCLUDE 12 BOOKS ON BUNGALOWS, BOOKS ON COTTAGES, STORYBOOK-STYLE HOMES, SPANISH HOMES, AND CEMETERIES, AS WELL AS A CHILDREN'S BOOK AND TWO ART BOOKS. HE ALSO WRITES AND ILLUSTRATES MAGAZINE ARTICLES FOR A VARIETY OF PUBLICATIONS. FIND HIM ON THE WEB AT WWW.KEISTERPHOTO.COM. HE LIVES IN CHICO, CALIFORNIA, WITH HIS WIFE, SANDY.